So There's Hope

Deborah Rolt

Bethnal Green . Whitechapel . Bow . Canary Wharf . St Katherine Docks . Shadwell . Wapping . Shoreditch

So There's Hope

Deborah Rolt

Dalston . Hackney . Hackney Wick . Bethnal Green . Whitechapel . Bow . Canary Wharf . St Katherine Docks

Published in 2016 by
Unicorn, an imprint of Unicorn Publishing Group LLP
101 Wardour Street
London
W1F 0UG
www.unicornpress.org

ISBN 978-1-910787-33-5

10 9 8 7 6 5 4 3 2 1

Designed by AH Design
Printed in Slovenia for Latitude Press

Foreword

Defining London's East End is a challenge for any artist. It is constantly changing, with hundreds of new developments replacing the old Victorian and Edwardian infrastructure and socially as one of the capital's most multicultural and diverse environments. There are no fixed parameters to mark the boundaries of the new East End, now hardly an end at all as London stretches outward into its once distinctly distant neighbouring towns.

Deborah Rolt's *So There's Hope* keeps to the core of the East End's origins. From the edges of the city of London westward, and northward from the River Thames up to Dalston and Hackney Wick, she photographed the East End's streets and people and their life stories to make this portrait of an area of old London still unique, still intact, a last pocket of resistance to the corporate consumerism swirling around its boundaries.

Any definition of the East End spirit is clearly linked to its people but also to its past. Although its history by far predates Victorian times, it is perhaps the nineteenth century's intense period of industrialisation and overseas trade that marked the birth of its modern life. The East End was the beating heart of Victorian London. The city's docks along the River Thames – once the largest port in the world – brought merchants and dealers from every corner of the globe and with them successive waves of immigration settling in the city. By the end of the nineteenth century the East End was the most densely populated area in the capital.

Photography was also synonymous with the Victorian age. The first images of London's East End can be traced almost to the very beginnings of photography in the 1840s, but it is the end of the century that really presents us with a myriad of photographers and studios. Not only photographers, but also many artists became infatuated with the spirit of the East End and the allure of the many cultures and backgrounds one could spot on the busy streets. The first Chinatown was established in Limehouse, and notable Jewish, Italian and Irish enclaves established themselves in Shoreditch and Whitechapel. This eclectic blend of cultures still survives – mainly represented by

trades and traditions – and can be found in many of the photographs in this book.

The change from the Victorian to the Edwardian era – the dawn of a bright new century – found living conditions in the East End at their very worst. Houses were desperately overcrowded and unhealthy, living conditions were cruel and spared no one, especially children and the elderly. Worse was to come during the First World War. Many of London's factories and its main port were located in the East End and the area was to witness the first aerial bombings and to endure them for the next four years along with a rationing programme that affected everyone's daily lives. The tough East End character became tougher still.

One of the early photographers working in the East End was John Galt. A missionary for the London City Mission, Galt used his camera as a tool for social justice, recording the stories of the East Enders and their struggles. He would project his images with a 'magic lantern' to show the appalling conditions of life in the East End to the wealthy classes of North and West London, hoping to raise funds and awareness for the relief of the poor. Looking at John Galt's work now one can find many connections with the images in Deborah Rolt's book a full century later.

After the First World War, the poor houses and slums that were not blitzed by German Zeppelins were demolished in an attempt to regulate and improve living conditions in the area. Urban regeneration along with many reformation initiatives were to come to a halt as England plunged into war for the second time at the end of 1939.

After the Second World War and throughout the 1950s and 1960s, the East End started to look not unlike it does now. At war's end the area was a decimated waste ground, criss-crossed by rubbled buildings, crated road, littered canals, dark pathways and rusting bridges. Rebuilding took the form of utilitarian concrete blocks, adding to the hopscotch of existing architectural styles from Victorian houses to neo-Georgian blocks. The people hopscotched too: the Jewish com-

munity that had settled in the East End was to move further north, leaving space open for the new Bangladeshi arrivals, a mass migration that resulted from the Bangladesh Liberation War of 1971. This gave the area of Whitechapel within Tower Hamlets and its now famous Brick Lane its distinct character and personality.

By the 1970s there was a new generation of photographers taking an interest on the East End. Steve Lewis, Bob Collins and a young David Bailey were drawn to this part of London and its people. The area was a sort of palimpsest, a scattered array of the remains of an arduous history. But beyond anything what still prevailed was the convergence of so many migration waves, which by then also included many countries in Africa and the Middle East.

Following in the footsteps of Galt, Lewis, Bailey and many of the photographers that delved into the heart of this exceptional place, Deborah Rolt distils the essence of the contemporary East End by focusing on the people that make it so special. Through her portraits one can feel the hustle and bustle of the streets, the smell of the food at many of its household eateries – legends like E. Pellicci's or G. Kelley's, the excitement of the street markets, the very heart of East End life. She bravely ventures along alleyways and into warehouses to set her gaze on colours, textures and curious objects. She finds connections between people and place, crooked cockney smiles and rusty pipes, pie shops, empty fields and old brewery chimneys.

Even if the old tram sheds have now been converted into expensive restaurants and the area is feeling the pressure of development and gentrification, the communities of the old East End grow stronger and more united in their fight for survival. The flower market on Columbia Road is still standing strong after 300 years; its roots also stretching to Victorian times. It keeps secrets under layers of paint and graffiti and like many of the East End streets has now earned a new lease of life. The Repton boxing club, also featured in this book, an East End institution in its own right, was founded in Victorian times to give support to young boys in one of the poorest communities in the country.

Deborah Rolt's journey of discovery takes us into places only frequented by locals, showing us the hidden faces of the East End night. From the most fashionable cocktail bars and restaurants to tattoo parlours, hairdressers and park benches, Rolt shows us this area is equally eclectic after hours. She captures the boisterous parties as well as the hardship of the streets, meeting people whose lives have gone astray, finding hope in a conversation late on a cold winter night.

Words are also a key component to her work. Through her many walks Rolt recorded notable quotes, sometimes just loose words, gradually crafting a parallel map of her experience. When put together these words and phrases become something like a song, the soundtrack to the every-day life of the East End streets. Pairing images and text, one can feel the characters on her portraits coming to life, laughing, swearing and shouting, a cacophony of accents from all over the world.

Finally we reach the river and here everything changes. We leave the intensity of the graffiti walls and second hand shops. Streets are quieter. There's a different gaze, a contemplation of time and all the stories the river has seen. Walking the riverbank at ebb tide, Rolt finds some of the East End's oldest pubs, along with objects that tell stories of a by-gone age.

It is a calm and insightful end to this remarkable journey, mud-larking on a crisp spring morning. This is perhaps an interesting way to view her work as a photographer, the observer with the sharp eyes, the fresh eyes, finding precious people and moments hidden in the gritty East End streets and realising that – like the tree growing through layers of litter – hope does spring out from the most unexpected places.

Rodrigo Orrantia
Art Historian, MA Contemporary and Historical Photography,
Sotheby's Institute of Art, London

Introduction

Nowhere else in London do I feel frustrated when I don't have a camera in my hand, than in the East End. There is always something interesting, touching or funny to see.

For this book I carried my camera with no theme in mind just wanting to absorb and capture what caught my eye. I love the openness, the 'in your face' interactivity of the local East Ender, the mixture of the old and new, the sense of history, the colourful vibrancy of this multi cultural area. Everyone has a view, an edge, an attitude.

It is a changing world with exciting new buildings, and a place where restaurants and bars play on innovative and surprising elements. In contrast there are harsh conditions for those whose aim is survival but whose stories hold the heart of the East End. Walking the streets with Ryan, an evangelist, meeting people and hearing these stories opened up my eyes. He showed me a tree that he felt was symbolic of the broken people he works with. Despite the rubbish that is strangling it and the inability of the garbage to get free, the tree still continues to grow.

'So There's Hope', Ryan feels, for everyone. He explains 'No one is born on the streets in this country, everyone has a story and most are unbelievable.' Meeting some of these people either at Arch 76, or the Good Shepherd Mission, or the Addiction Bus at Whitechapel, or just chatting with them on the streets, I discovered this to be so true. I also learnt what a strong community there is here which offers so much love and compassion to those who need it. I was moved and humbled.

The ladies of Arch 76 showed me their East End and let me into their lives. This Charity helps women who have been abandoned, abused and feel ignored by society. It gives them an understanding of friendship, love and being part of a family; something that they have not experienced before.

Perhaps my most moving time was on a bitterly cold evening in Whitechapel on the Teen Challenge bus. I was told not to take photos unless permission was given, making it hard to capture moments. I felt very out of my comfort zone and stood by one of

the helpers handing out leaflets as people hurried home from work, unaware of what was going on around them. I knew I could easily have been one of them brushing the literature aside. Help consisted of a hot meal or drink, and advice. A very cold, lost young woman had nowhere to sleep. It was too late to get her into a hostel and so she was told where she could find 'hot air vents' to sleep by. I met a Spaniard who came looking for work two years ago but found how 'hard life is here.' He had had such expectations. I wished him luck as he left but felt so flippant as he looked at me with dead eyes and said 'I don't believe in luck.' Ryan spoke quietly with him of his faith and slowly a glimmer of hope came into his eyes. The sense of isolation caused by modern life was so apparent here.

In complete contrast to this isolation I had many a cappuccino or cannelloni in Pellicci's in Bethnal Green Road. There the noise and banter is continuous. It is a family restaurant founded in 1902 and run by Nev. This is a meeting place for all. Thanks to Nev I was introduced to Wendell who arranged for me to visit the Repton Boxing club,

another old institution of the area dating back to 1884. I walked in and was hit by the sense of history, the intensity of belief, of maleness. Boxing has always been a pathway to success for young hopefuls in the East End. Young boys are given a month's trial to prove themselves and the waiting list is long. Now I believe women are being encouraged to box too.

Then there were difficult times photographing when I was told to 'Eff off you Scandinavian tourist' and threatened with 'You wipe that.' At such moments I would reassure myself by remembering Cartier-Bresson's words, 'Enjoy being there recording, steal in order to give.'

The 'Stream of Conversation' at the beginning of the book are all words said to me while photographing and relate to the pictures. 'An image needs a text to protect it, and every text needs someone to decode it', as Marlene Dumas said.

Despite the hardship found here, there seems to be such a sense of living. Walking down Brick Lane

on a Sunday evening, it is easy to absorb the sense of fun and vibrancy and an involvement of all. The graffiti tells its own stories, sometimes new, sometimes with history. The allotments are not just rows of vegetables but are full of nature's sculptures and the inviting 'Roving Café.' Everything has a twist, an energy, that makes the East End an exciting place.

Different parts of the East End hold such different atmospheres. Walking from the Tower of London to Shadwell through Wapping was a peaceful experience in comparison to Bethnal Green; cobbled stone roads, warehouses turned into smart apartments with mostly joggers on the streets. This is a gentrification that has not yet reached such places as Whitechapel and Bethnal Green. Even Hackney, now a desirable area, has the vitality and character intrinsic to the core of the East End. Wapping is such a historic area that once was full of life and vibrancy. Alleyways take you down to the now peaceful Thames. Looking carefully around there is so much history reminding us of the hectic life it once spawned. The lady mud-larking (a form of gentle archeology allowing you to dig only

7.5cms deep by licence) was looking for this past world.

Through making friendships and gaining trust my journey became much deeper than I had imagined. I felt myself concentrating on the whole structure of community and care amongst the harsh environment of old East London rather than dwelling on its vices. Making these connections helped me find something special, something that gives you hope.

Deborah Rolt

pigeons are survivors . trust . allowed to keep this one . shows I am clean . cranes are the unreachable . many English in my home town . none here . it's hard here . got a job worked but not paid . £40 a day . oldest café in East London . sense of community . born upstairs . cobbled roads . no atmosphere . people just run . licence 7½ cm deep . mud larking . last working warehouse . barges with Dutch history . evangelist . day and night so different . fuck off you bloody Scandinavian tourist . not my photo . when cold you walk all night . you wipe that . hot air vents . The London . took one of the trolleys . to move house . now so sterile . replaced . when I'm sorted . don't like being touched . under-standing . heart of Whitechapel . makeover . sad it's gone . problem go to The London got my sheets there . Blind Begger . Kray brother shot there . Sally Army . layered and complex . a Christian hindu . I talk a lot . give people a headache . a Henry Cooper splash it all over . a poet . an edge . gang fights . didn't walk there . 1970's . strength and resilience . job as a porter . brokenness . bus . Teen Challenge . addiction support . hot drinks and hot food . walk by in a hurry . oblivious . loneliness . charity shops disappearing catch a bus elsewhere . no good bacon and eggs . just waffles . dreamt of an elegant jacket . making gloves to keep me warm at night . big pants out of vests . no one's ever told me I have lovely features . no visa . left married and on my own . would like to have been an actress . changed faith . now an outcast . collect graffiti on mobile . no small talk straight from the gut . felt so flippant . said good luck . homeless . once a cook . the vine bears fruit . no . family might see . angry . why am I not a builder . a calling . complete . so white . testosterone . no guts no glory . 50 waiting . runs in families . months trial . Repton Boxing Club . how did you get in . challenging . energy . heart and soul . hate photos not me . 'Growth' shelter . networker . large bags . allowed 28 nights . too vulnerable hard . every microism needs a home . top floors never achievable . need to sort myself

out first . boss's clutches . subsistence living . old brewery . hostel . now flats . countryside

small parishes . how do you survive . it's their story, not mine . can't get free . tree symbolic

garbage . still growing . so there's hope . no one here is born on the streets . everyone

has a story . some unbelievable . many had money . judges, executives . 24 hours is a

long time . no hope . no work . lay low in daytime . crossrail . feeling of disempowerment

went ahead at a cost . bought jobs . growth . outside rough . inside trendy . when I first

came I was so dirty, could stick me to a wall . it gave me love and friendship . they're

a no win no fee lot . old libraries fought for . new IT . primary schools . all women

football to get dads involved . got knighted . got TB . sometimes sleep with 400

homeless . understanding . between two worlds . immigration . different when personal

Farage characterisation . speaks Bengali . has own stall . hardest . lost hope . they touch

his shoulder . with gratitude . with love . just a smile . arches . harsh environment . it's

home . can survive . new use . food . bringing together . you leaving auntie . a hug

it's all that's needed . a touch . money . that's the kindest anyone's been to me . just £20

we stole a train . Liverpool Street Station . feral children . champions . chasing celebrity

je suis Charlie . yesterday . self abuse . sense of fun . gentrification . rebuild . surprise

element . mum handed us over . had to . St Leonard's Home . no not kind . fastest

buffalo hunter . all generations . old market makeover . melting pot . Russians . Pellicci's

a greasy spoon . Bengali . ghost voters . Mayor gone . 50 percent under 20 . Caribbean

overhaul . Bethnal Green different to Hackney . shut my eyes on the bus . feel different

beat . different vibe . saddens me most . loss of hope . docks closed . empty warehouses

subsistence living . grassland . prostitutes . The London . a place to sleep . West End

that's where the power is . Whitechapel dark . Bethnal Green tough . lively . Hackney

hard . vibrant . serves a purpose . changing landscape

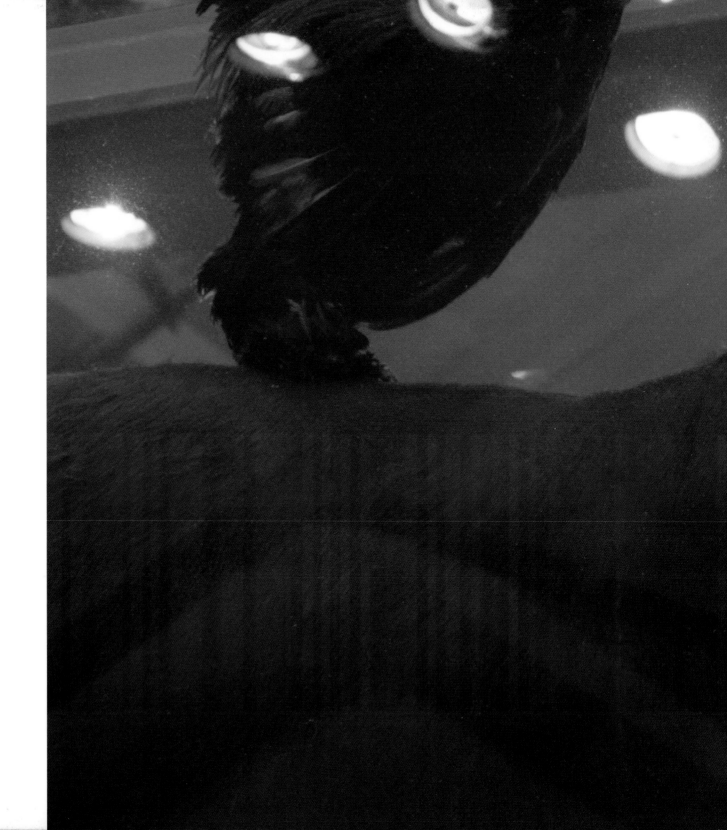

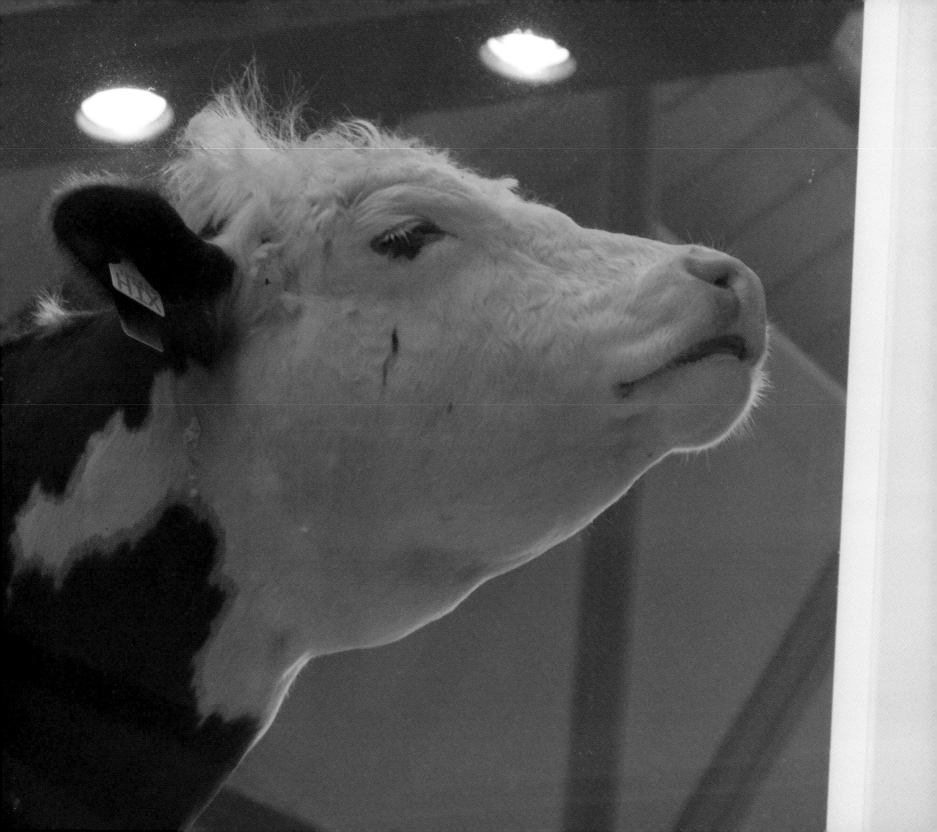

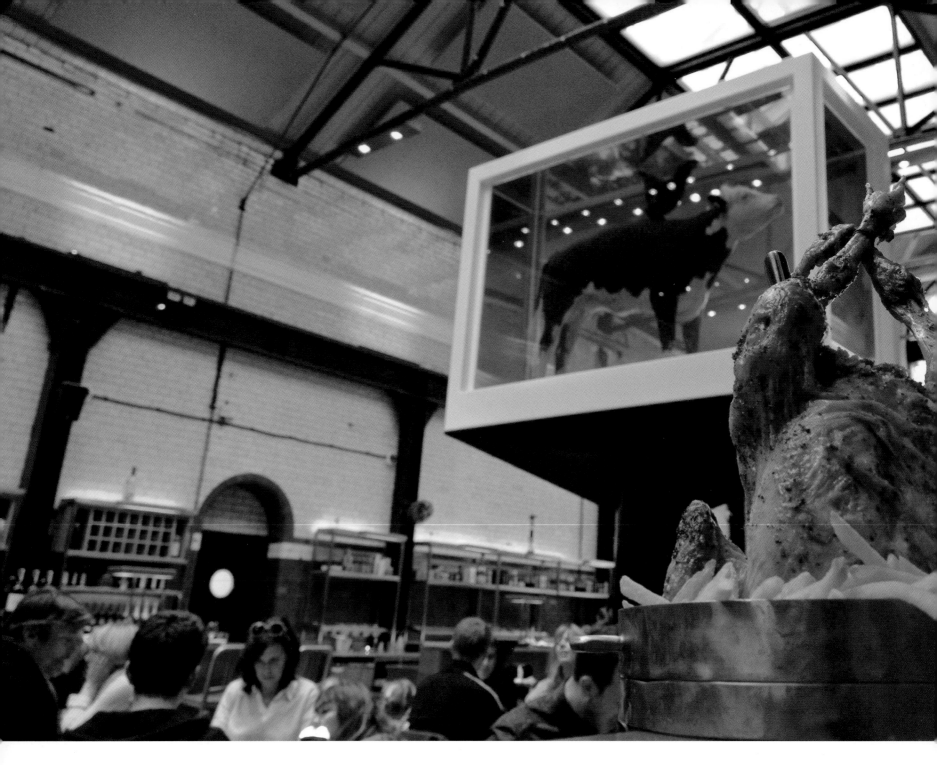

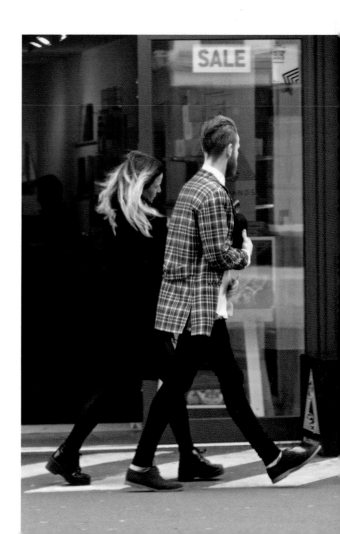

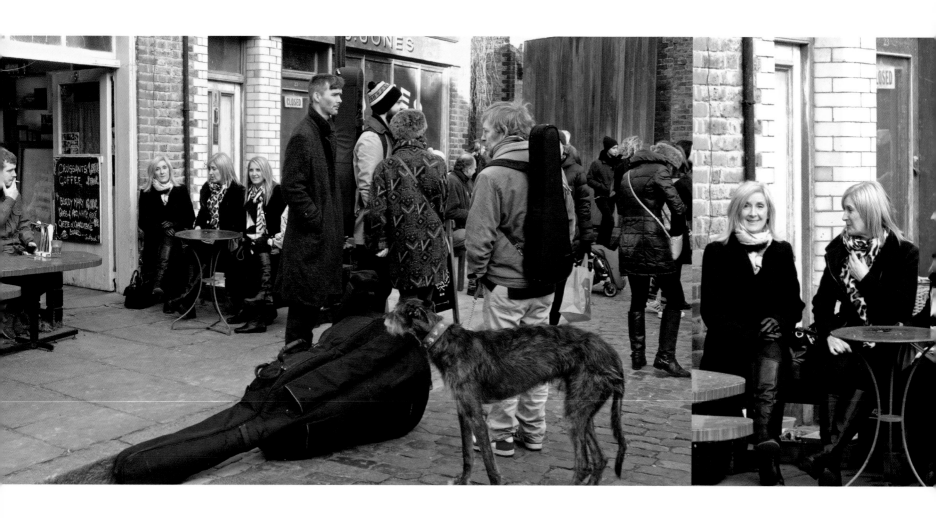

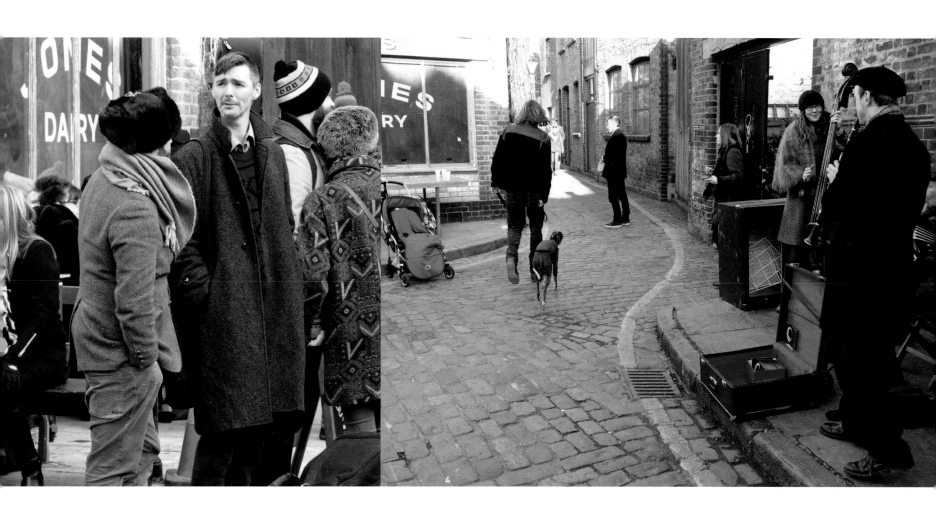

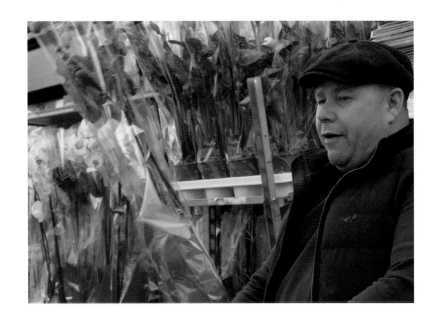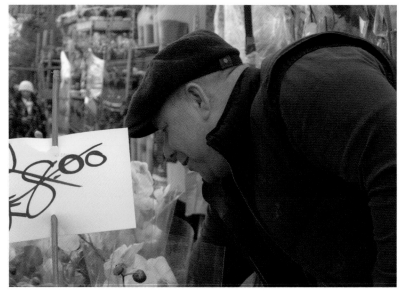

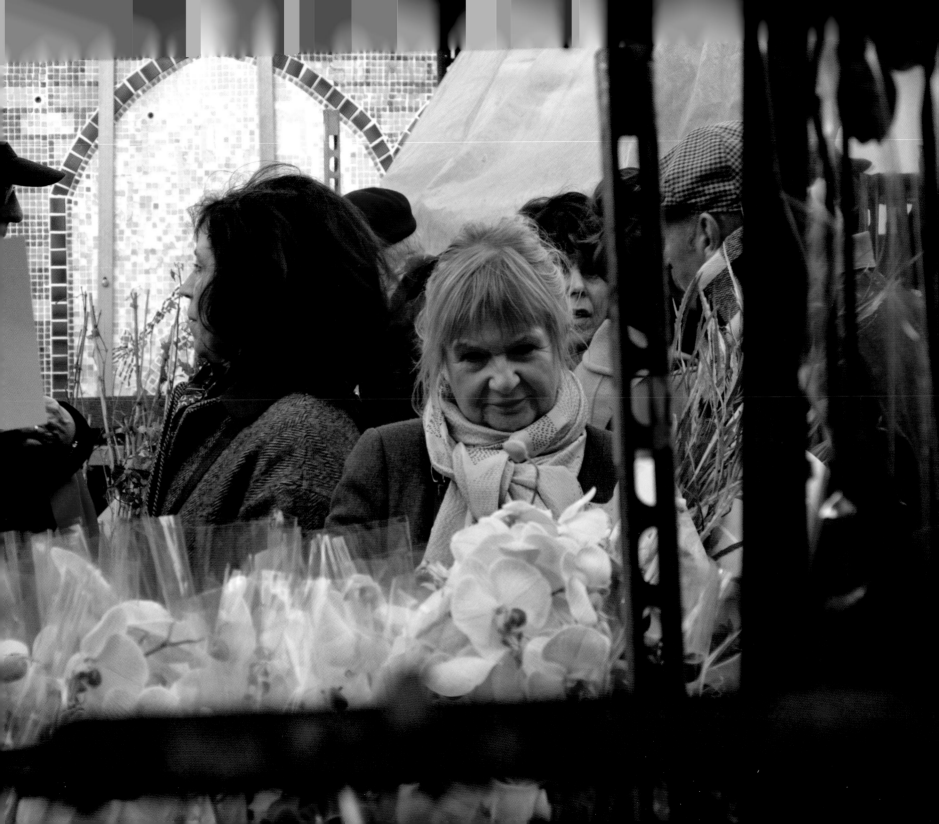

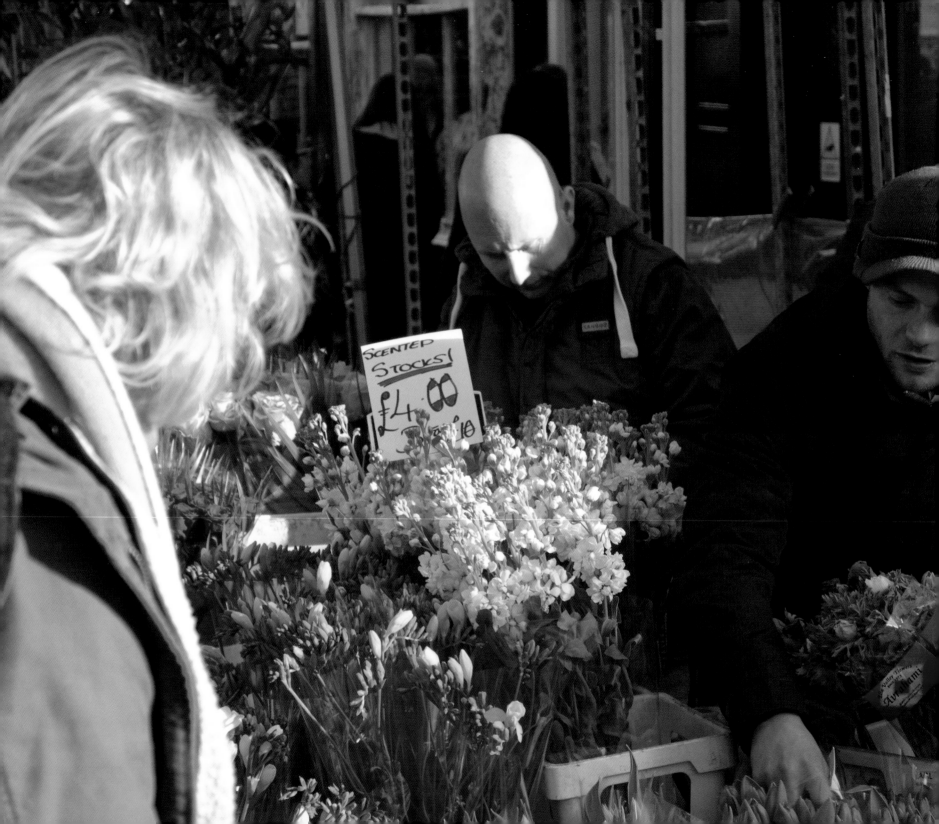

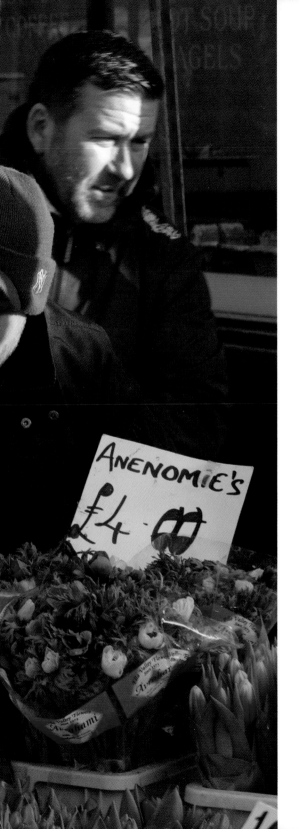

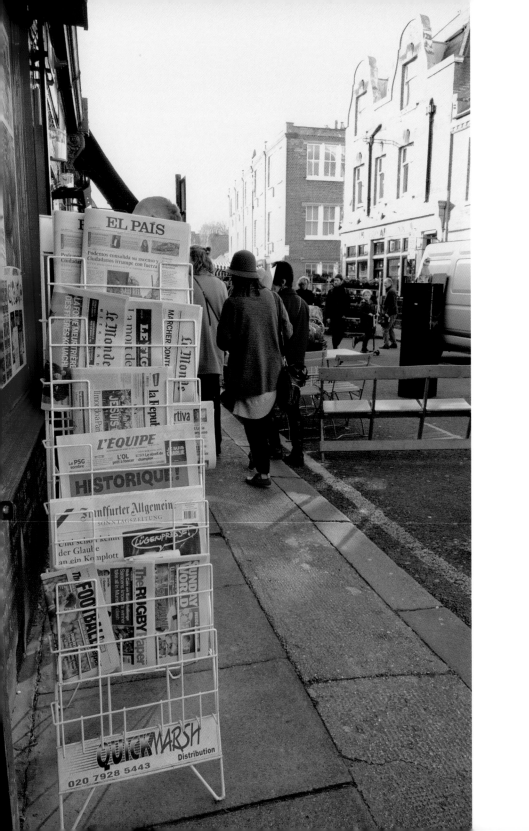

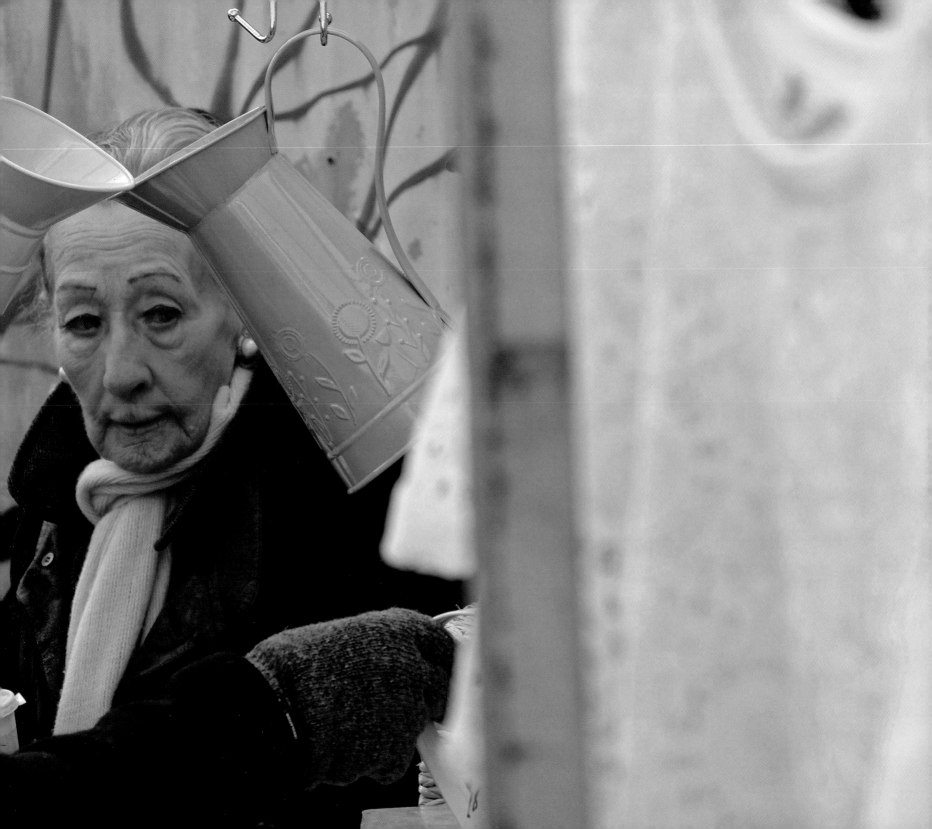

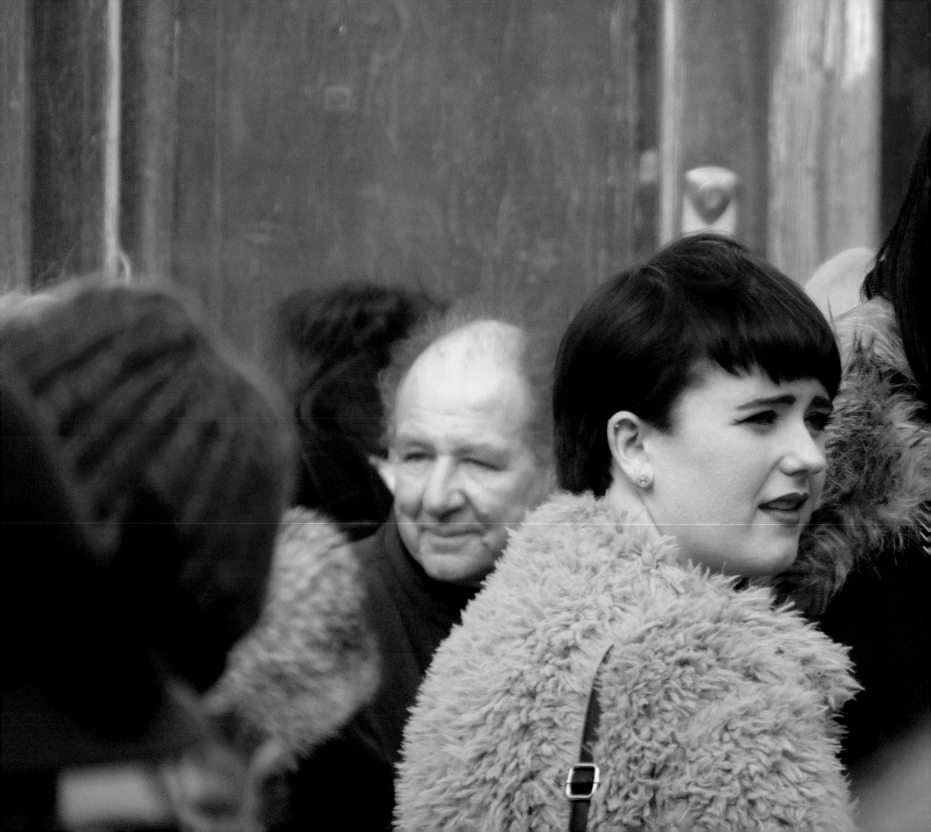

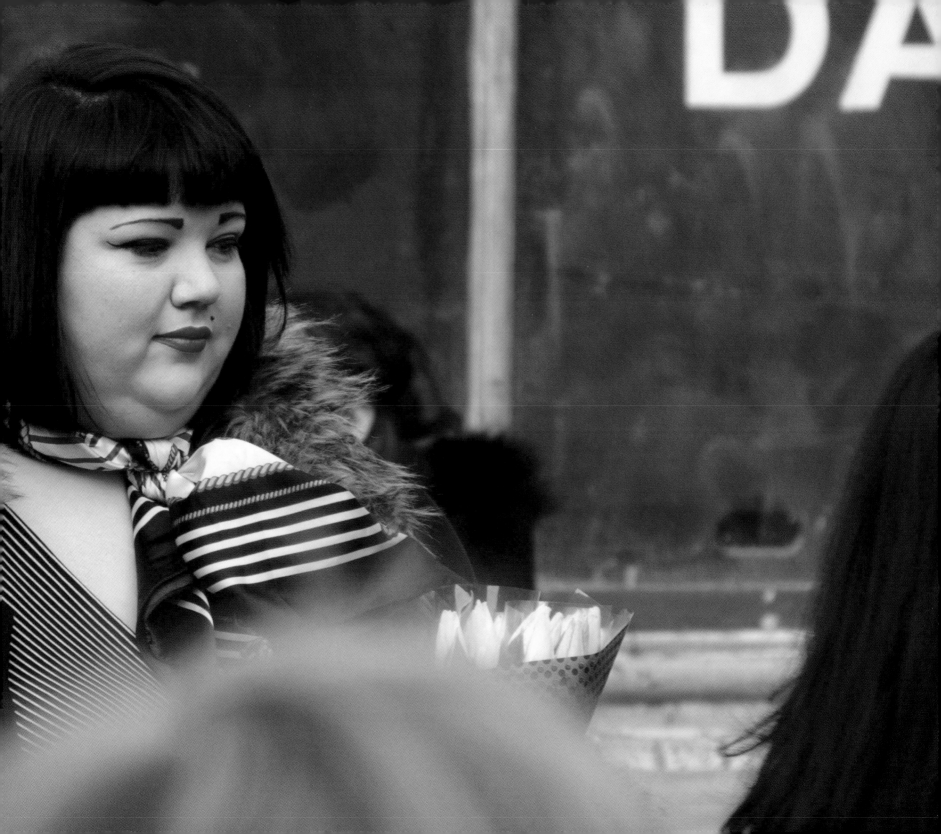

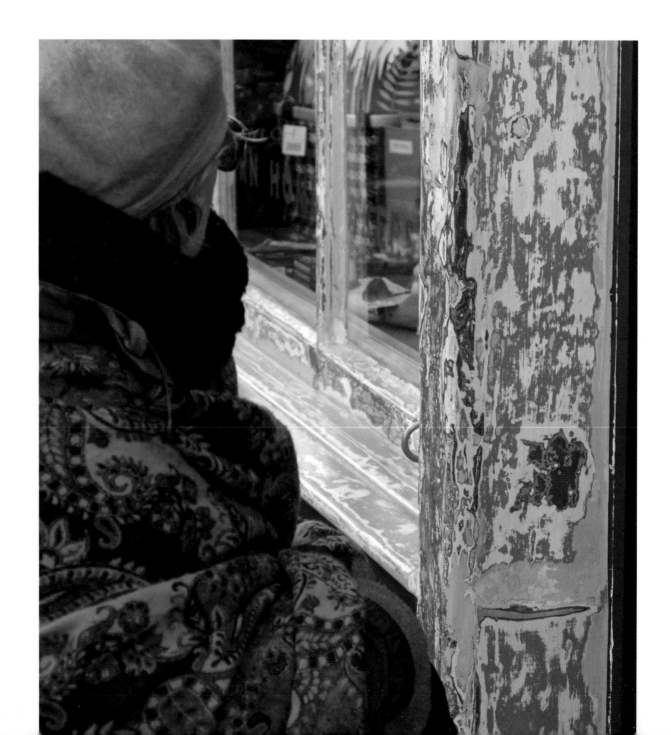

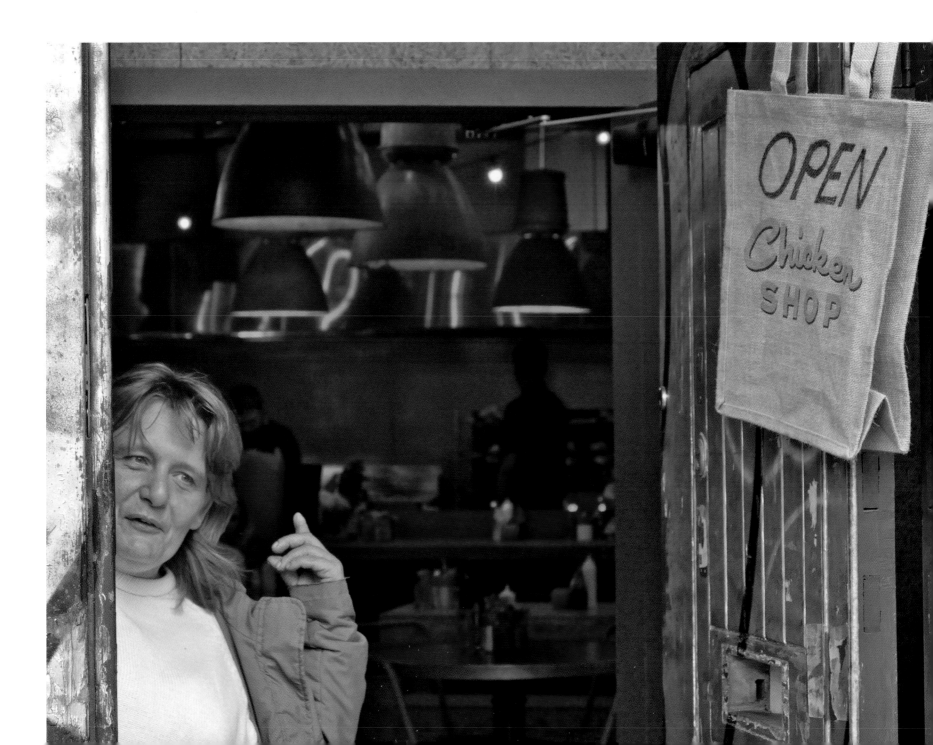

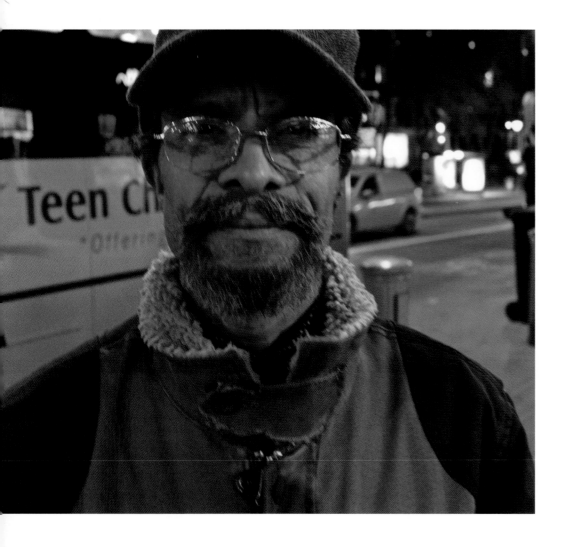

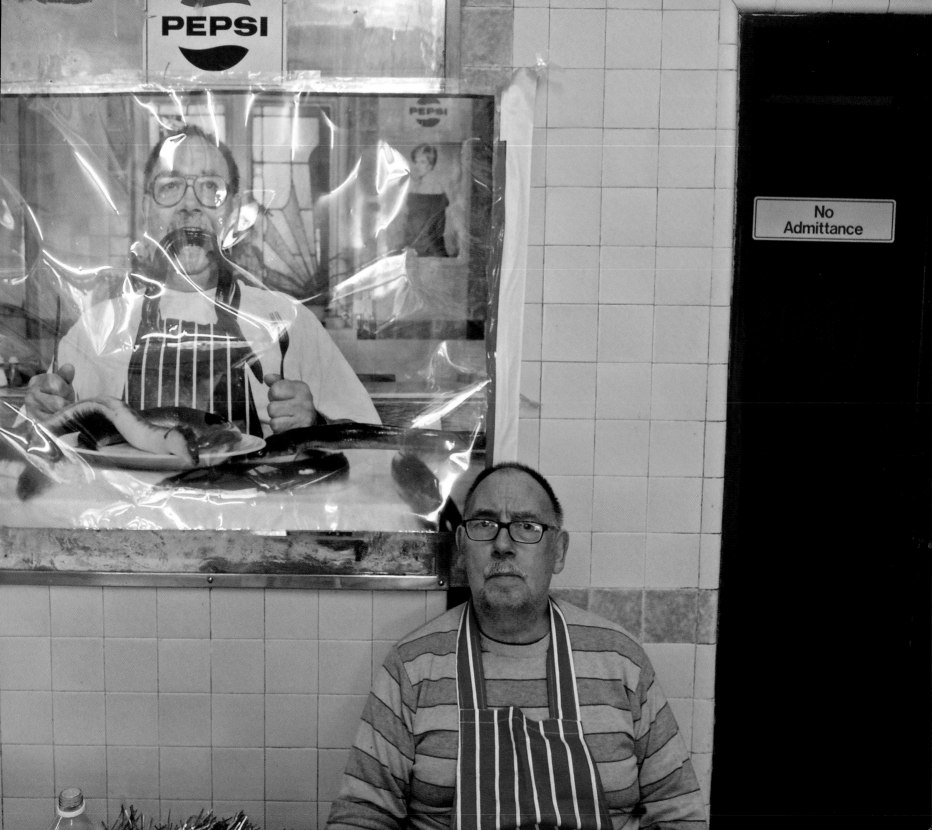

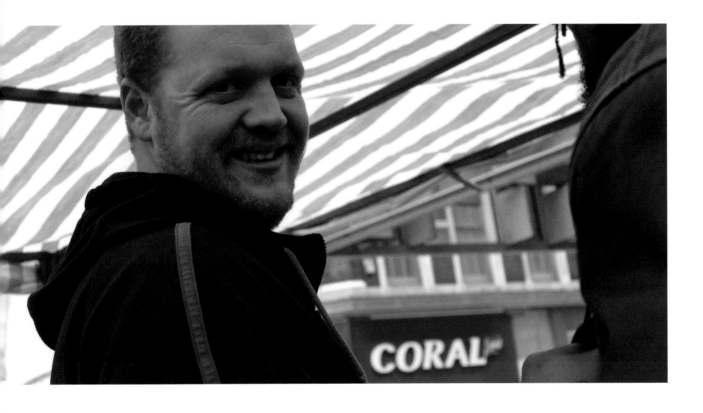

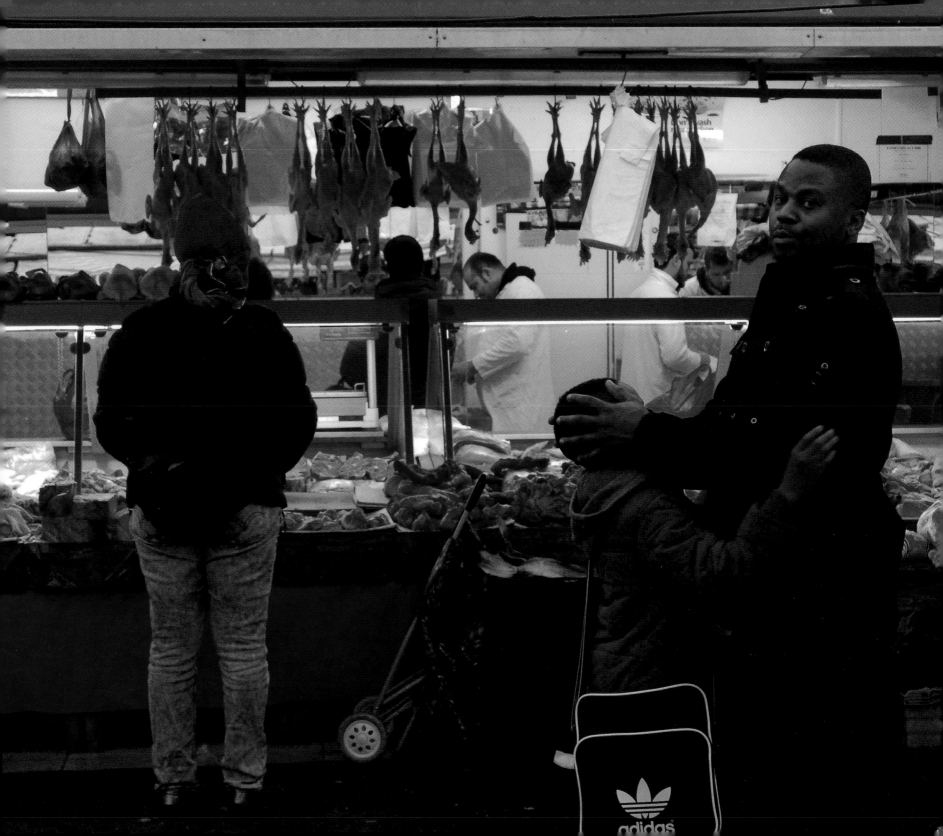

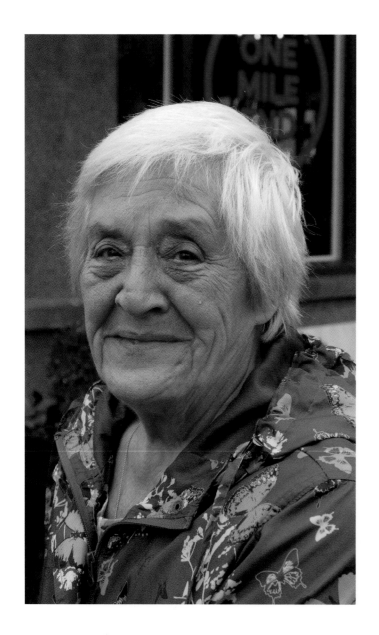 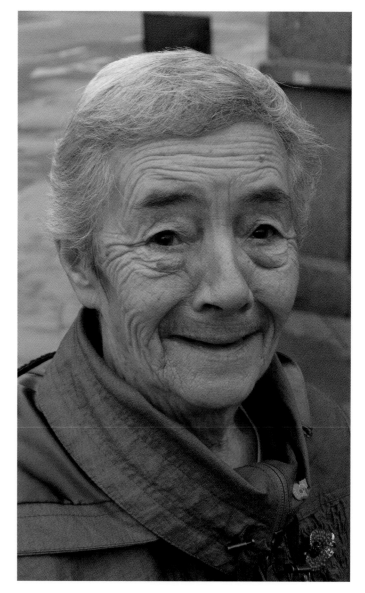

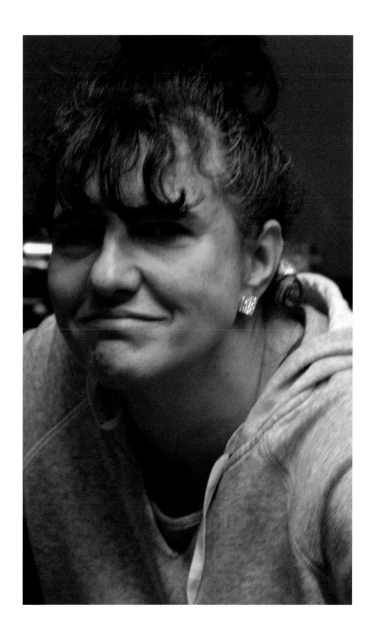

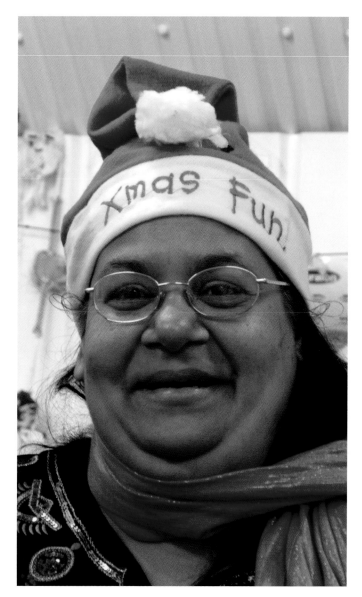

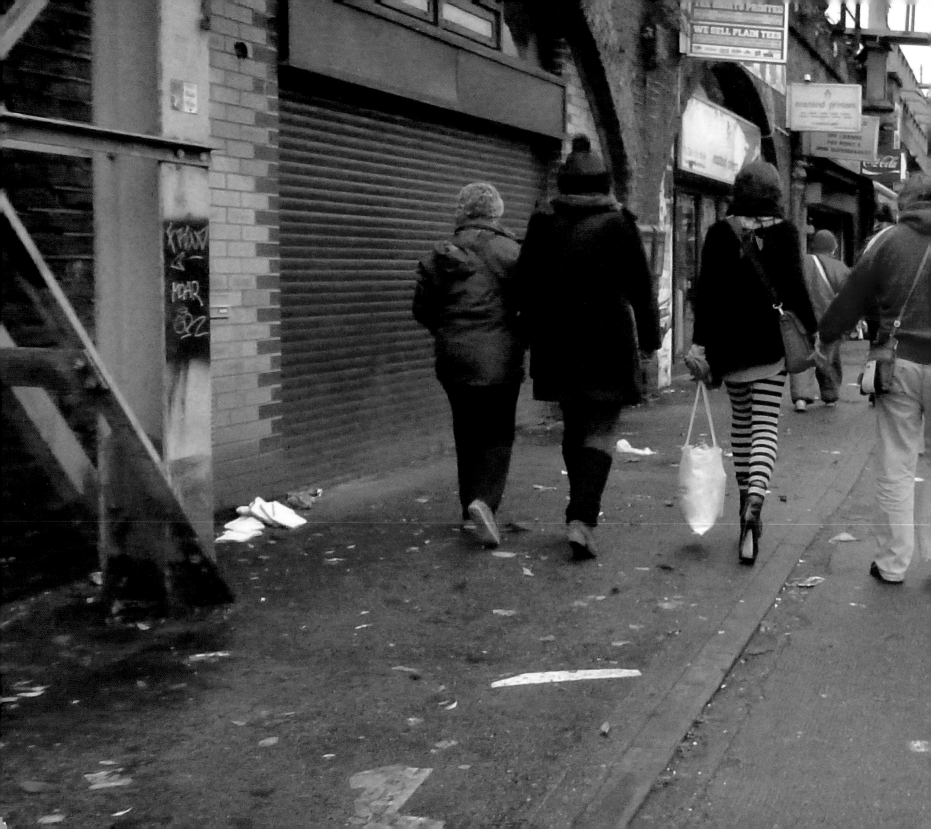

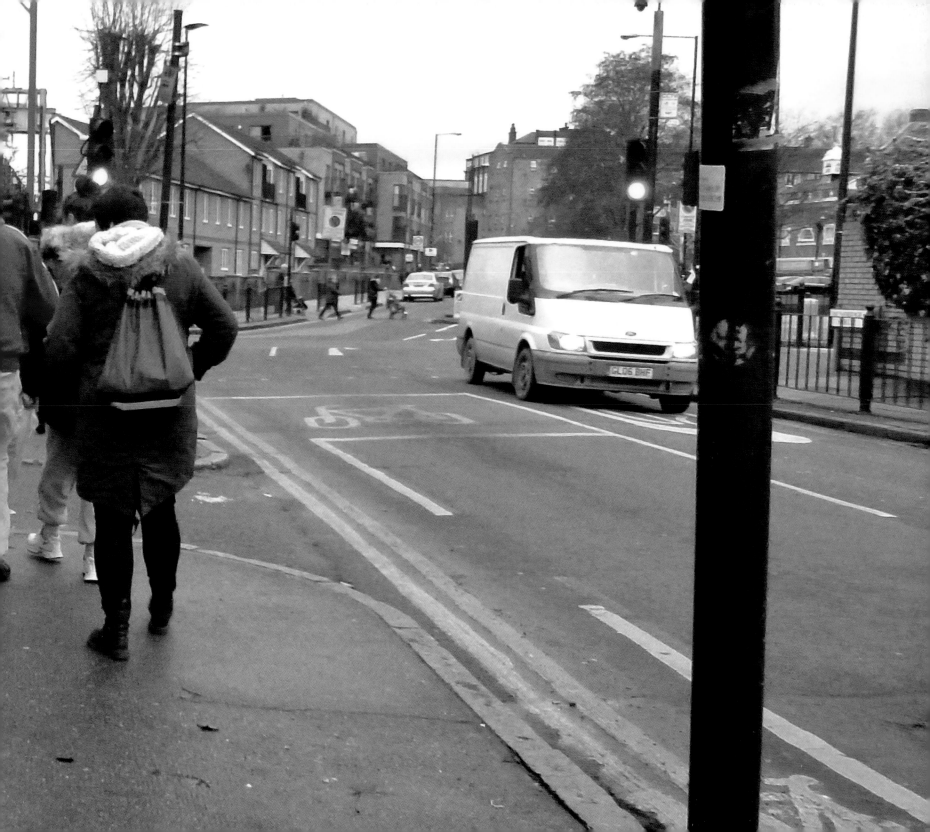

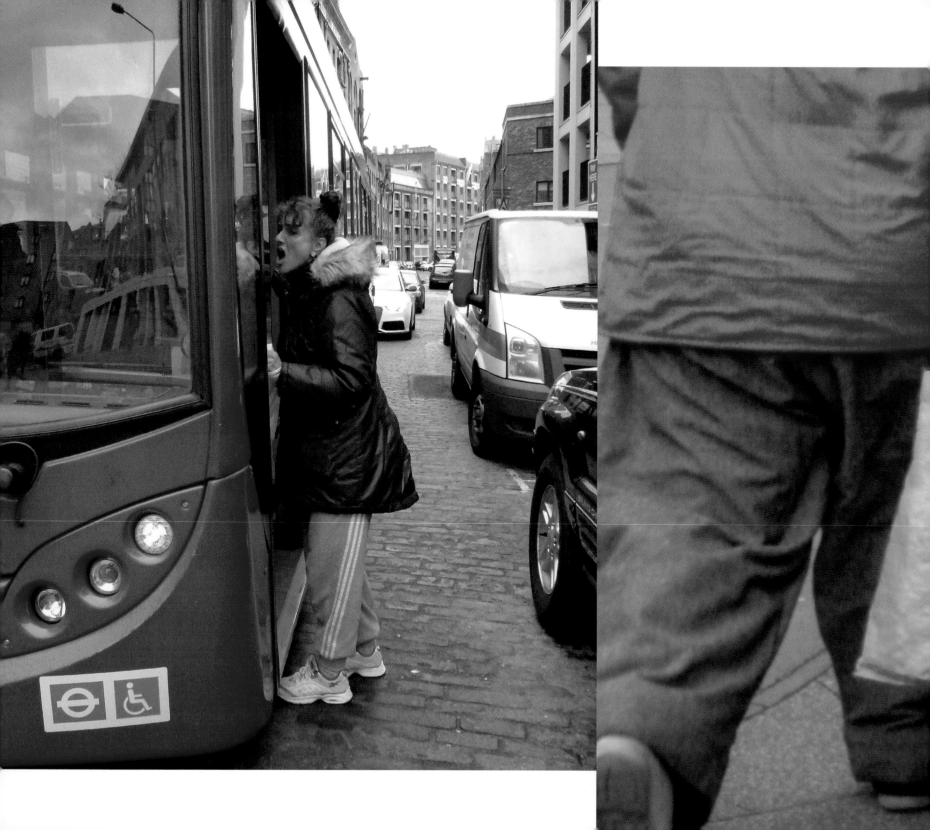

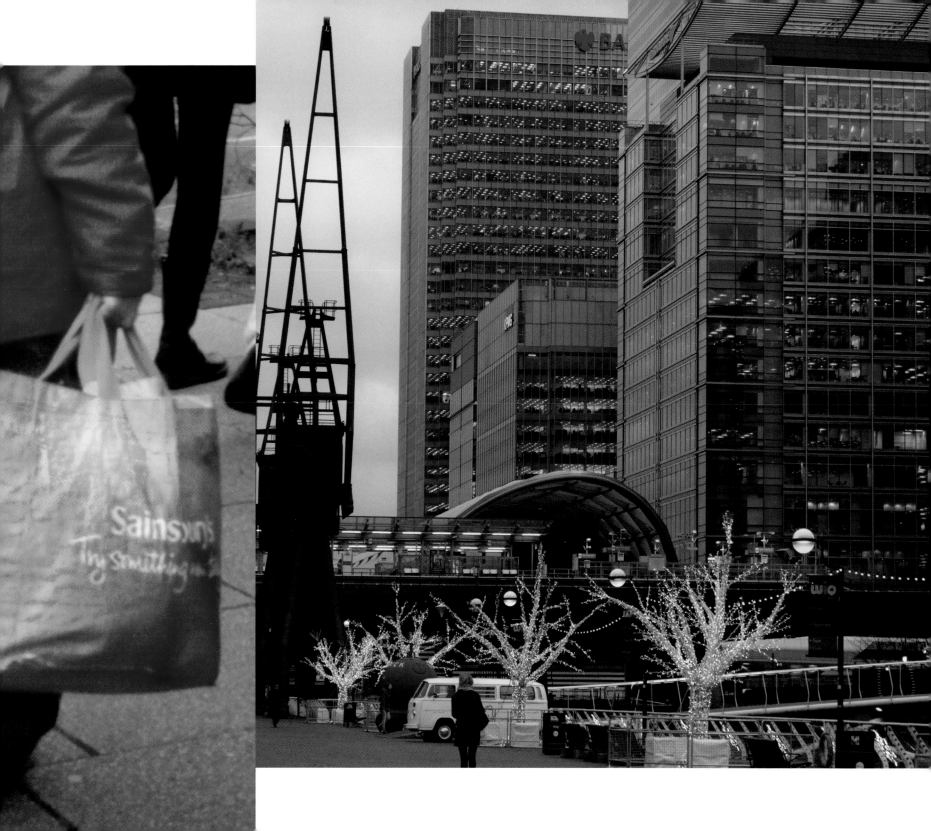

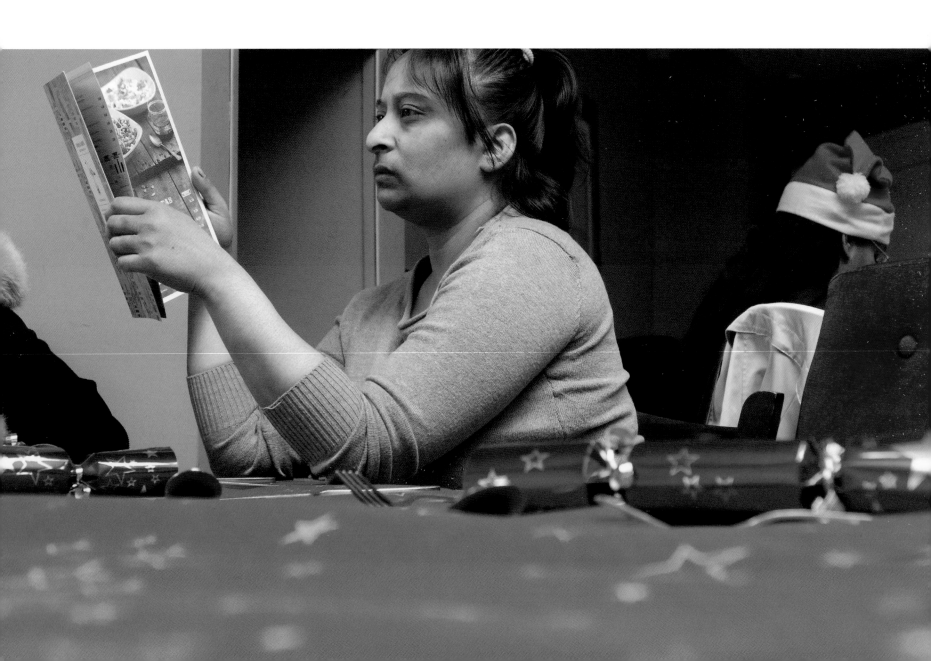

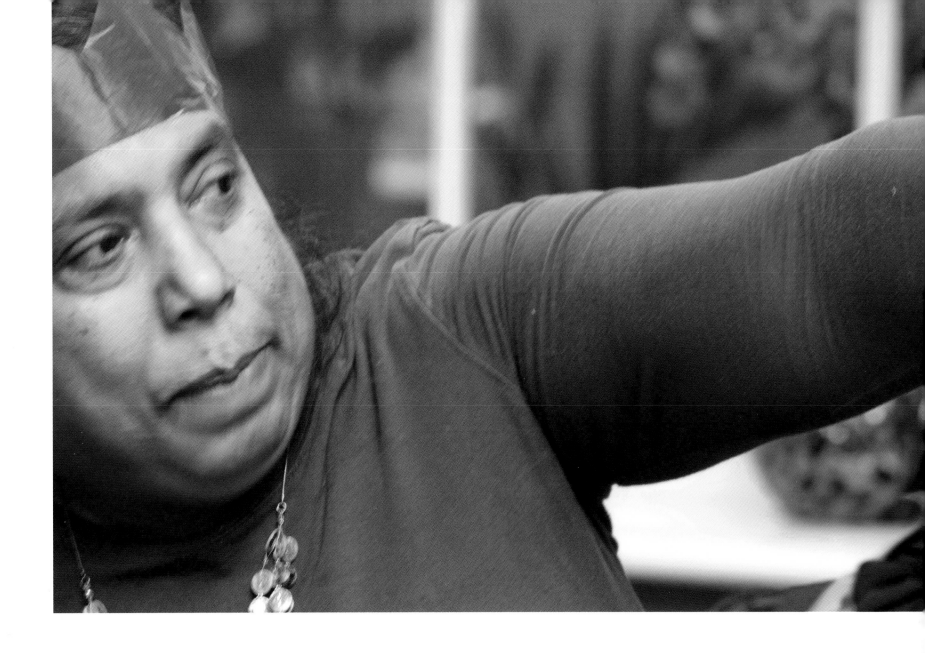

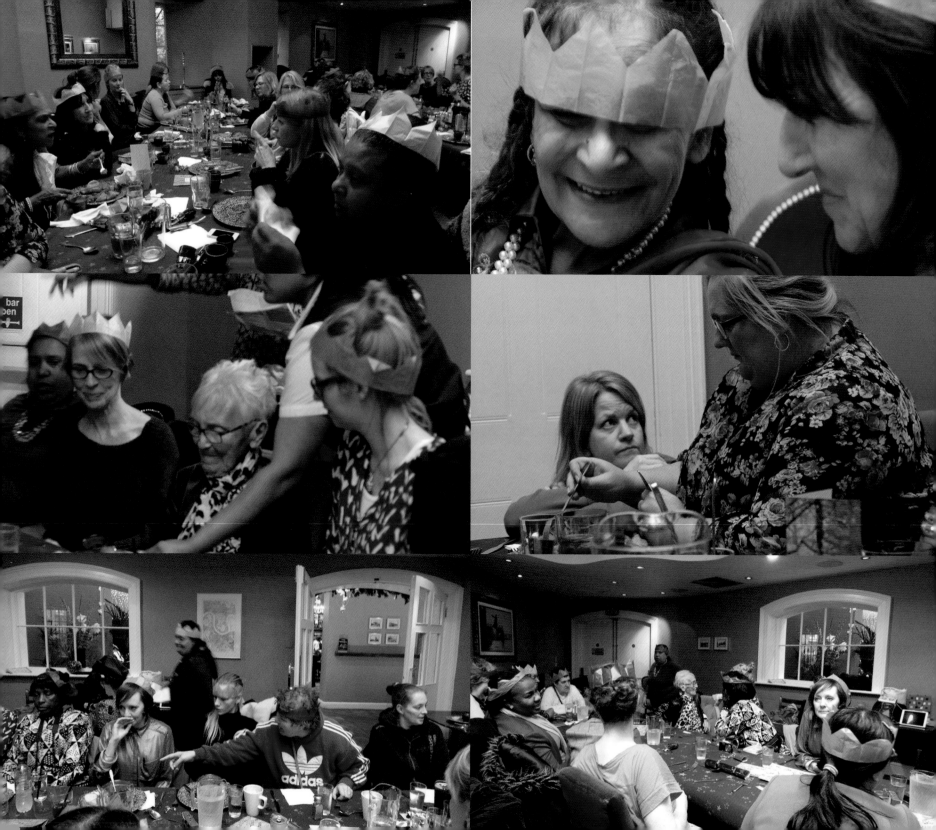

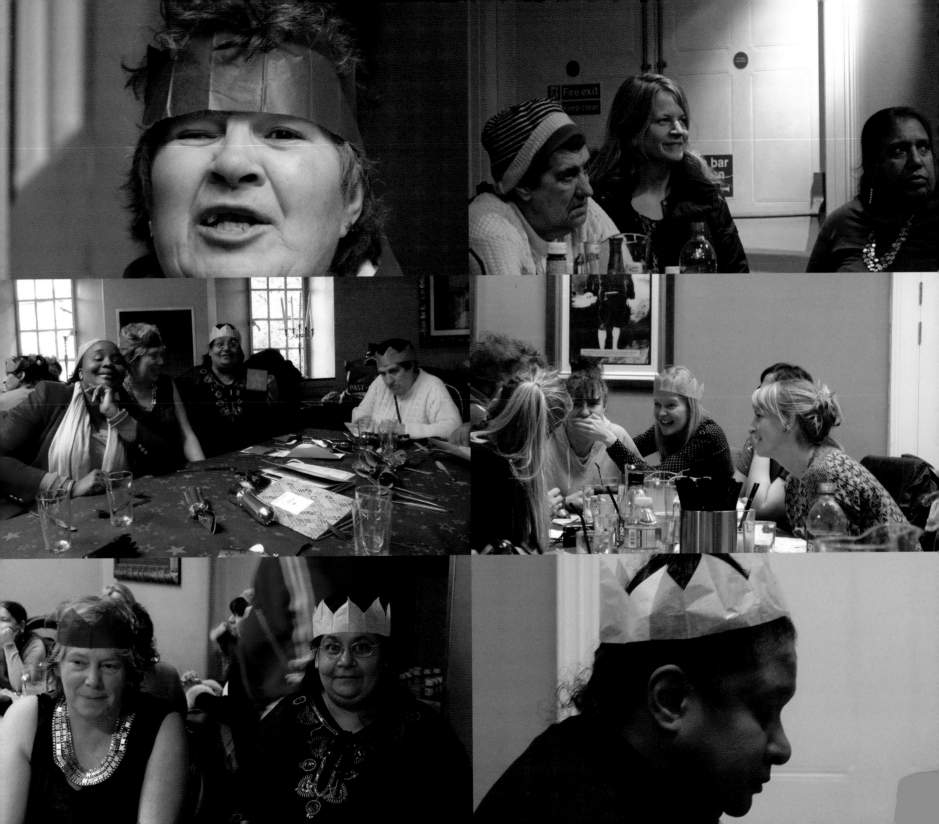

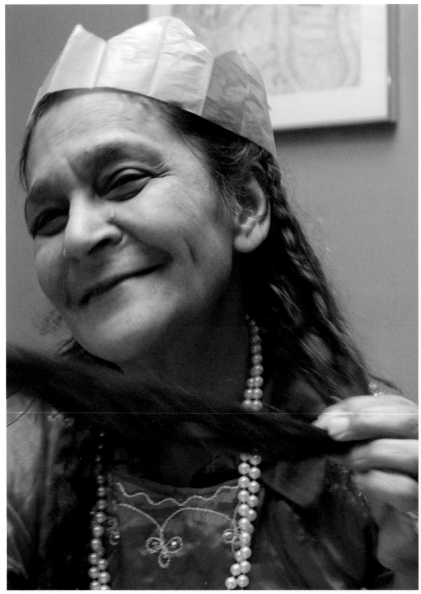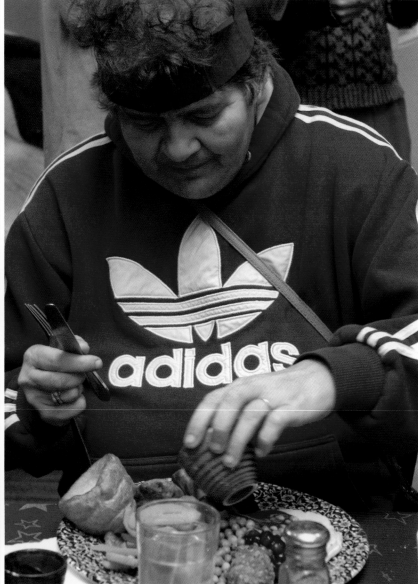

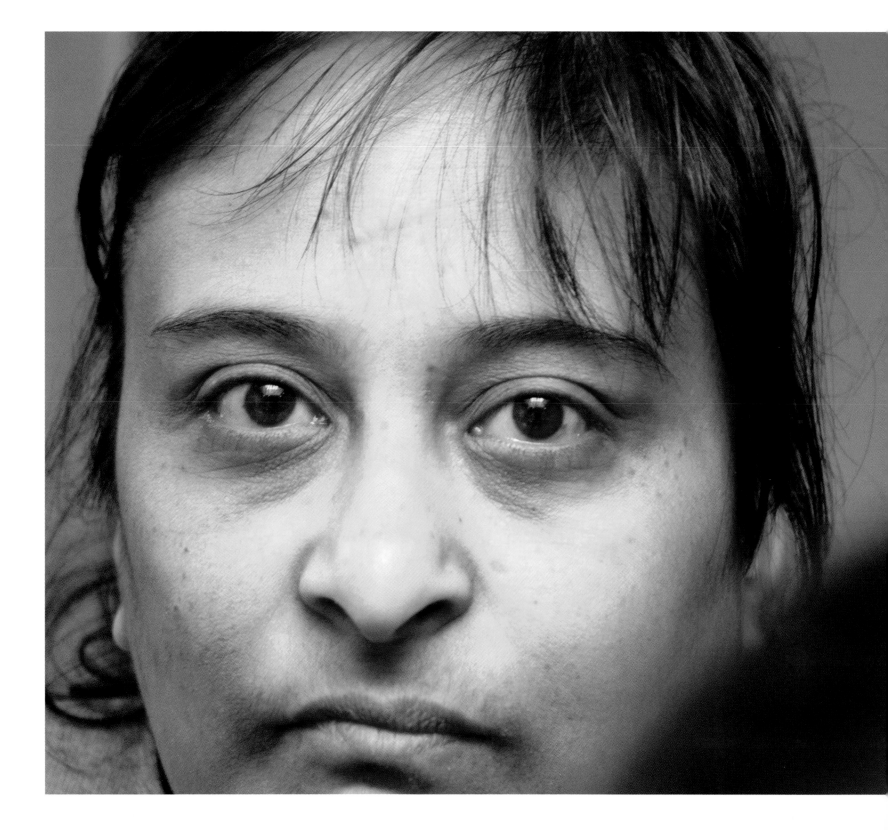

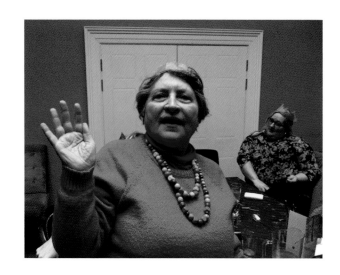

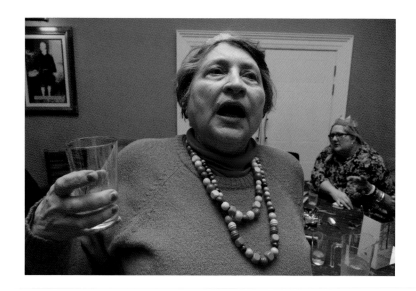

6 - 10 - 14

PARDON!

1. "I'M A BIT DEAF IN MY LEFT EAR",
 I SAY, WITH A SMILE, WHEN GREETING,
 BUT NO-ONE LOOKS INTO MY FACE,
 TO SHOW, THAT OUR MINDS ARE MEETING.

2. I TILT MY HEAD, AND SAY "PARDON?"
 BUT THEY DON'T SEEM TO UNDERSTAND,
 STILL THEY MUTTER, AND MURMUR, FACE TURNED ASIDE ,
 AND SHOW IRRITATION WHEN I ASK "WHAT'S PLANNED?"

3. AND SO, I OFTEN MISS THE MEANING,
 THE NUANCES, AND THE UNSPOKEN ,
 AGAIN, I NOD, SMILE, OR SAY "MMM",
 MY PARTICIPATION IS BUT A TOKEN.

4. IN GROUPS, THEY SPEAK – AT EACH OTHER ,
 NOT WAITING FOR AGREEMENT, NOR SHUSHES,
 NO FACE-SIGNALS TO SAY IF THEY AGREE – OR NOT,
 LIKE 'POOH-STICKS' IN A STREAM, TALK RUSHES.

5. IN AN URBAN POPULATION – NO NEED TO SHOUT,
 THERE'S A GOOD REASON FOR NOISE SUPPRESSION,
 BUT MEANING IS CONVEYED BY VOICE – FACE AND BODY,
 SO OVERCOME THE TABOO ON EMOTING, OR EXPRESSION.

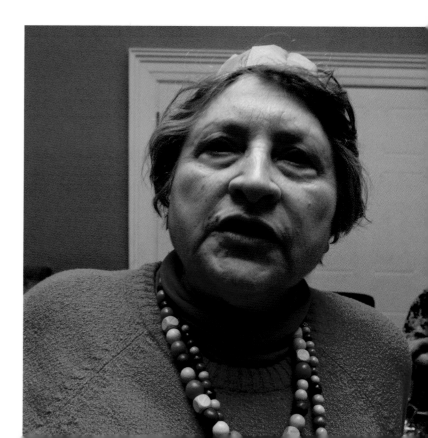

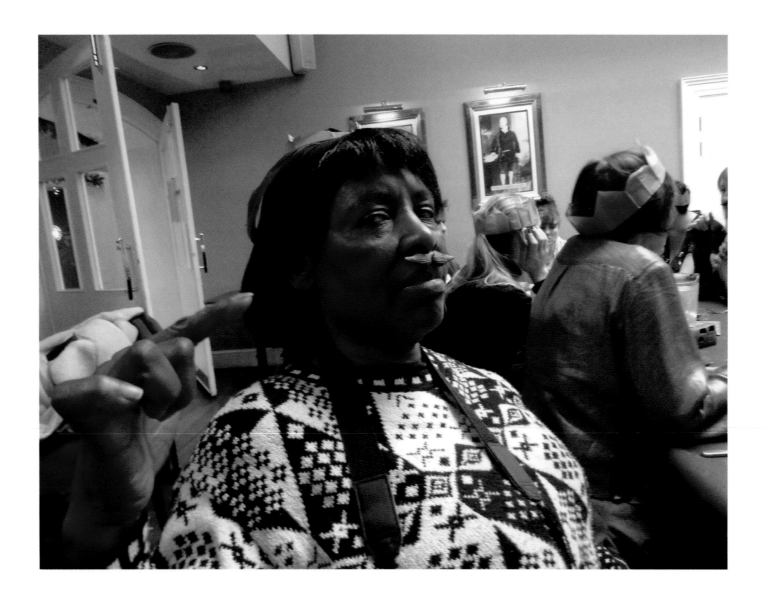

44

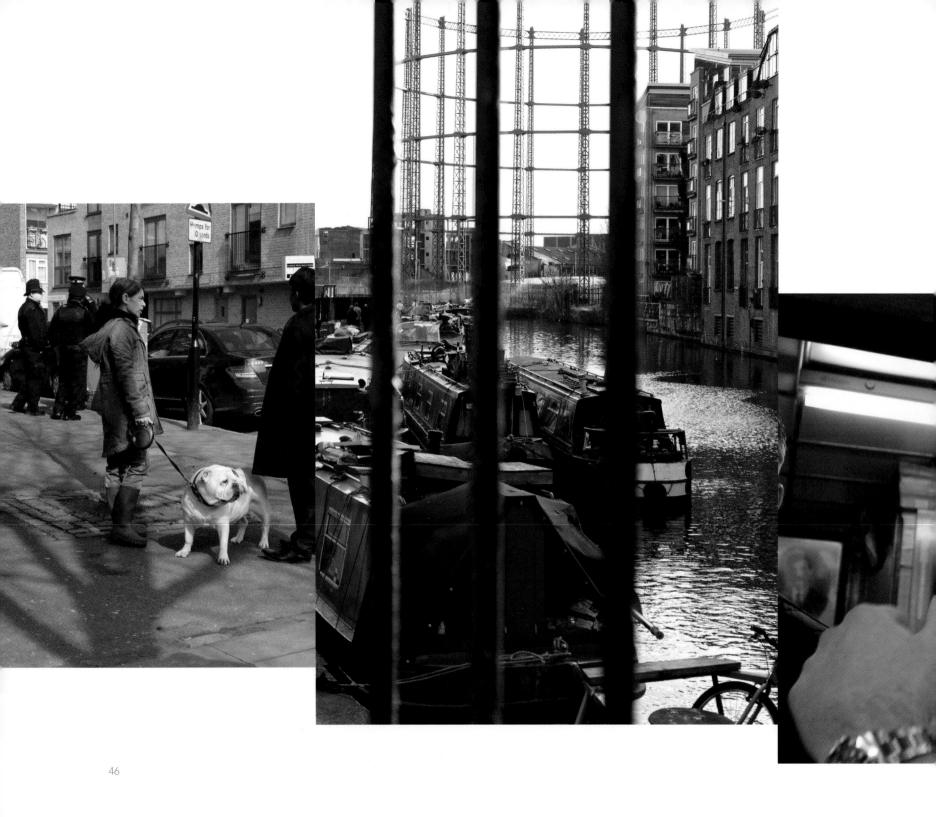

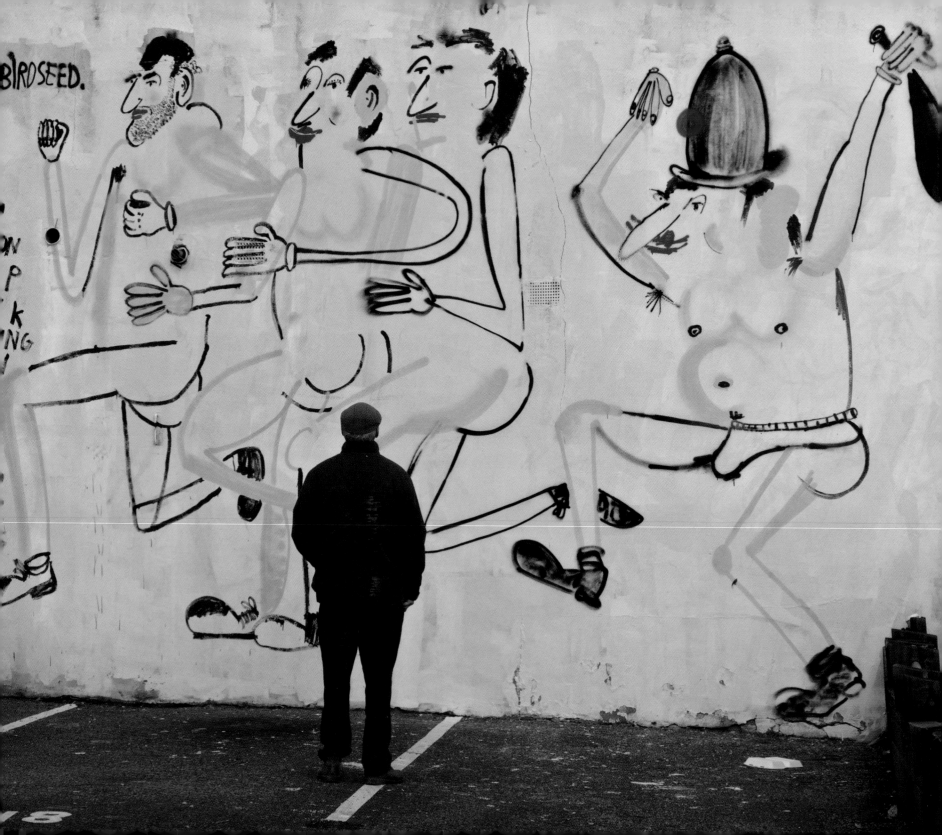

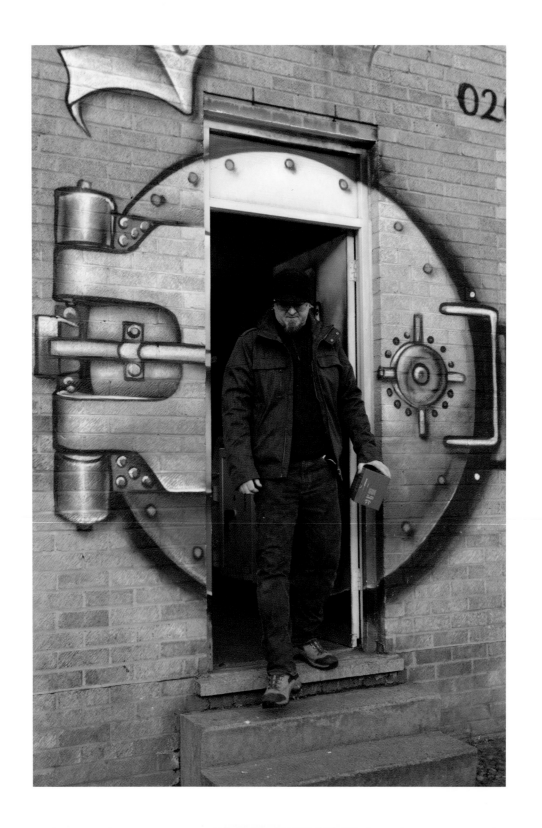

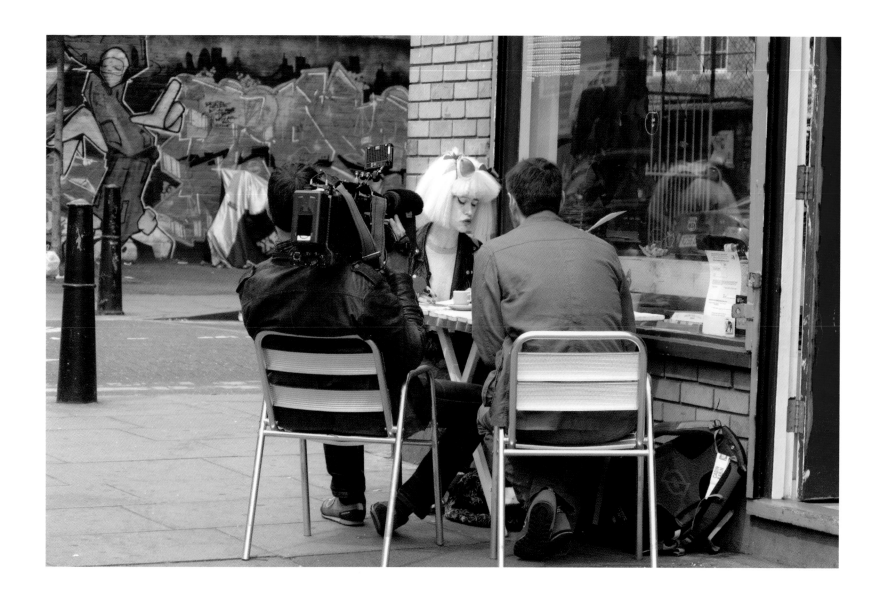

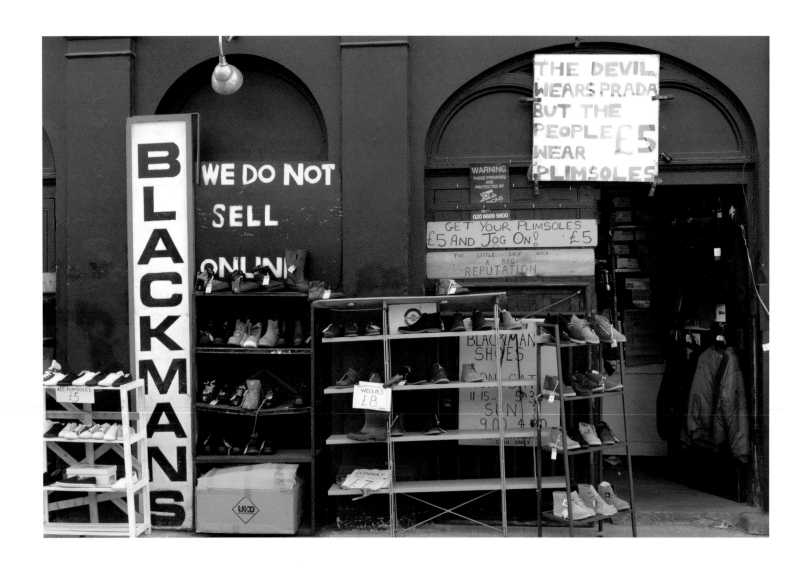

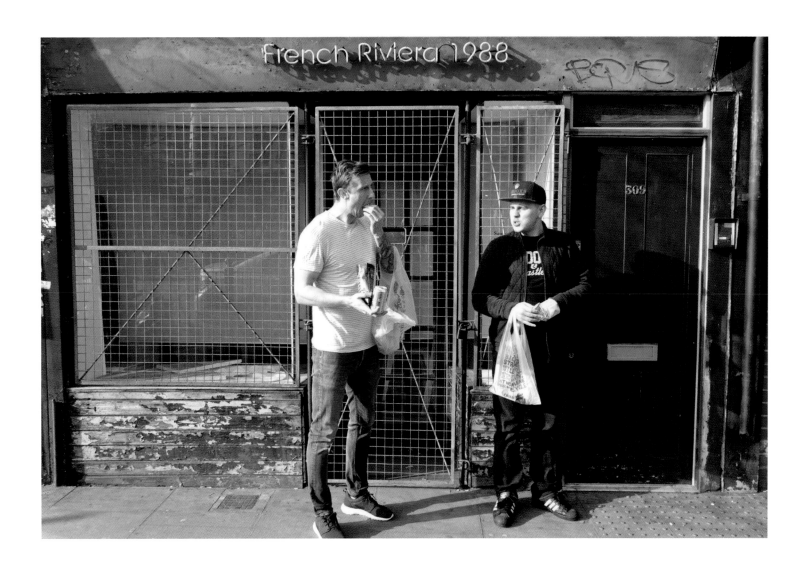

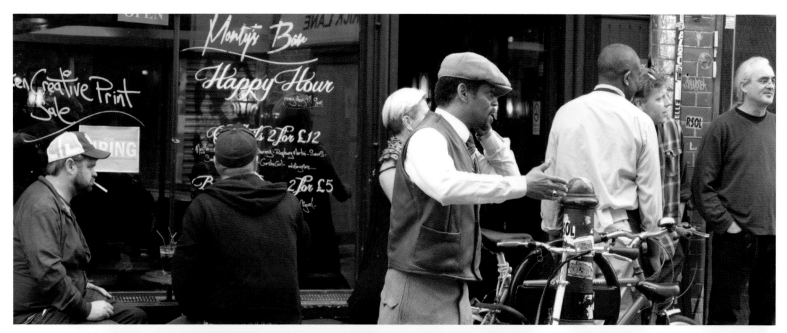

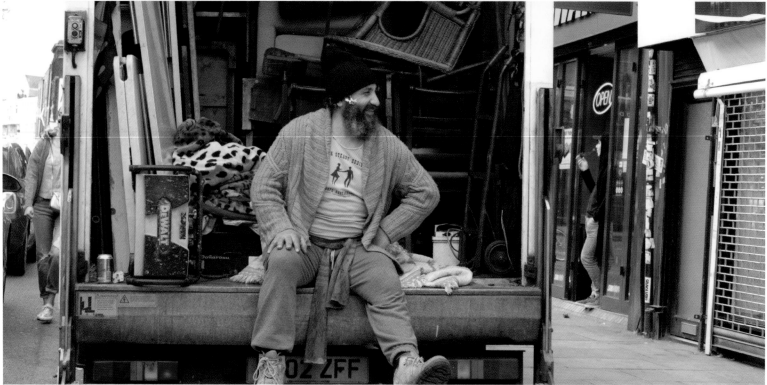

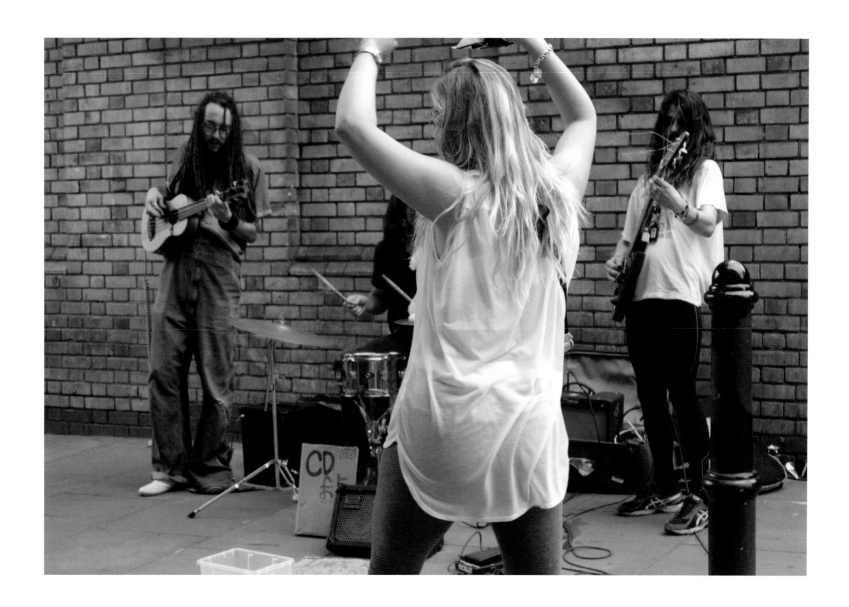

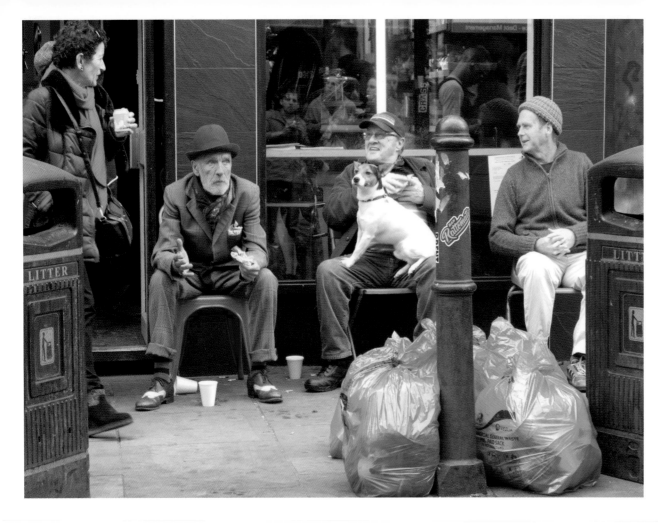

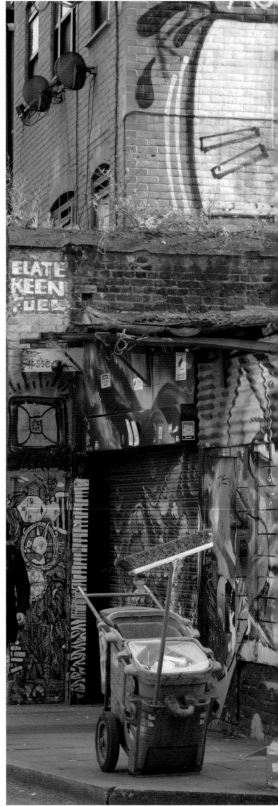

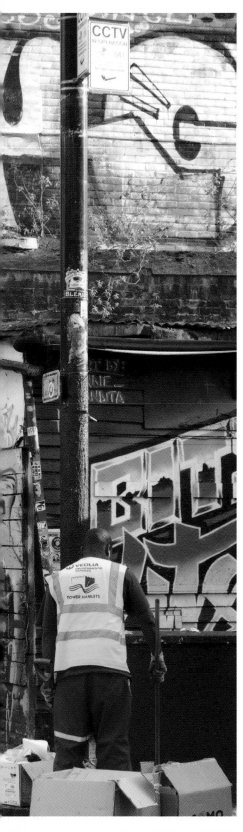
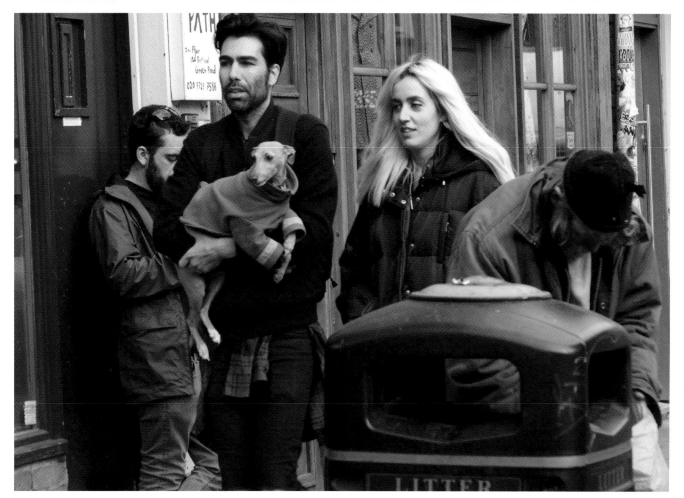

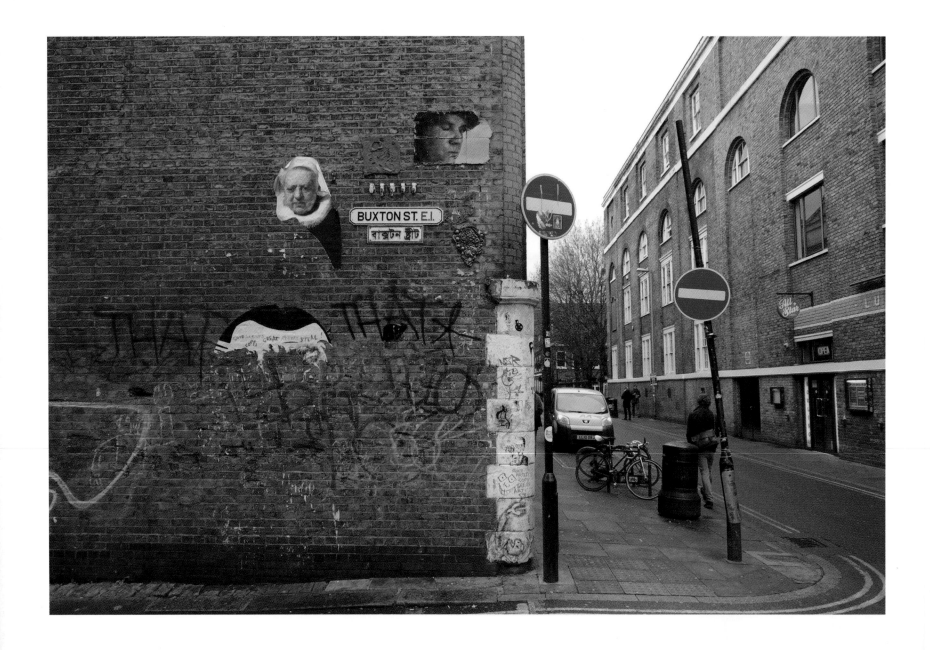

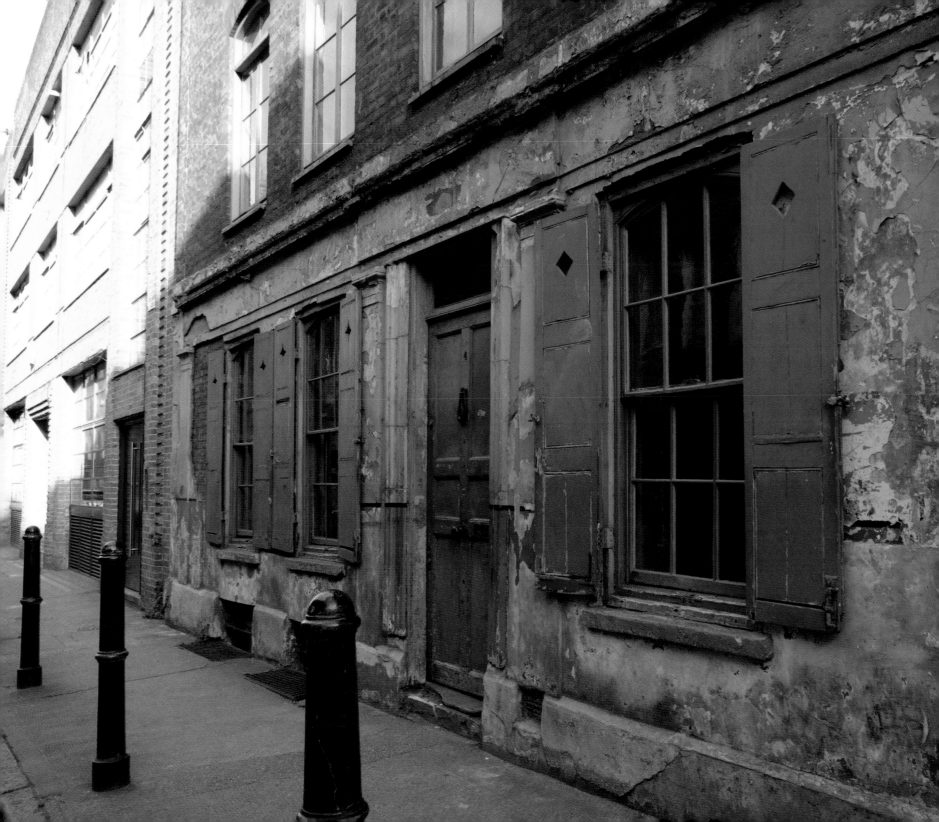

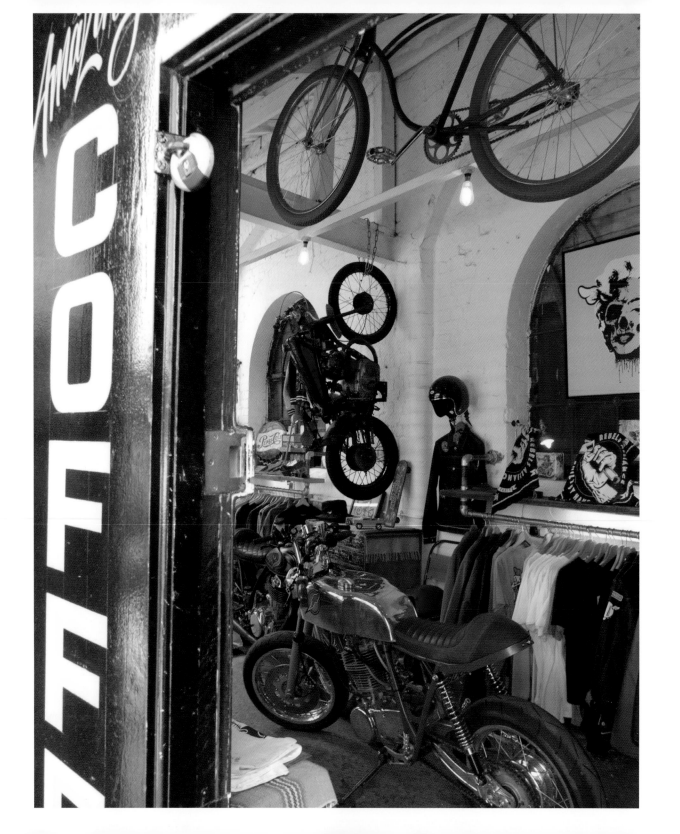

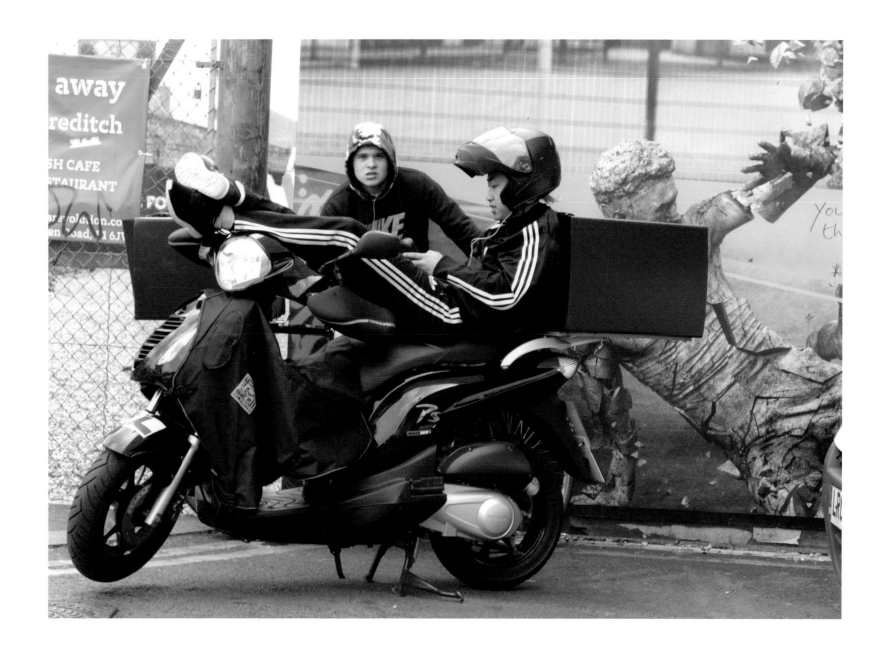

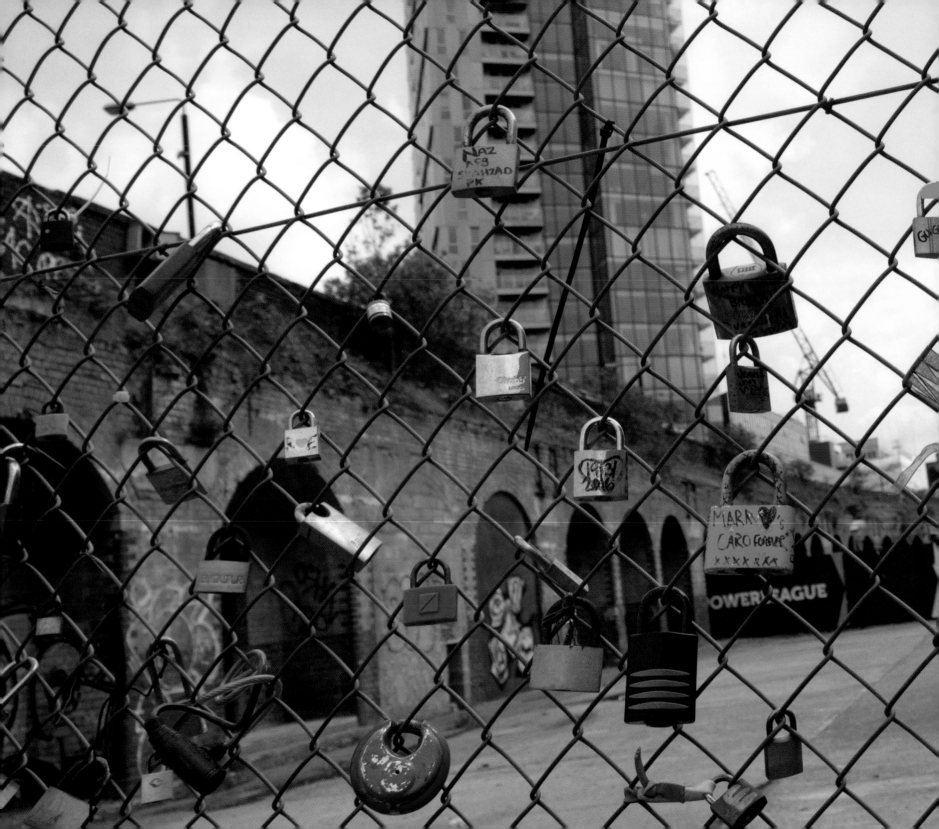

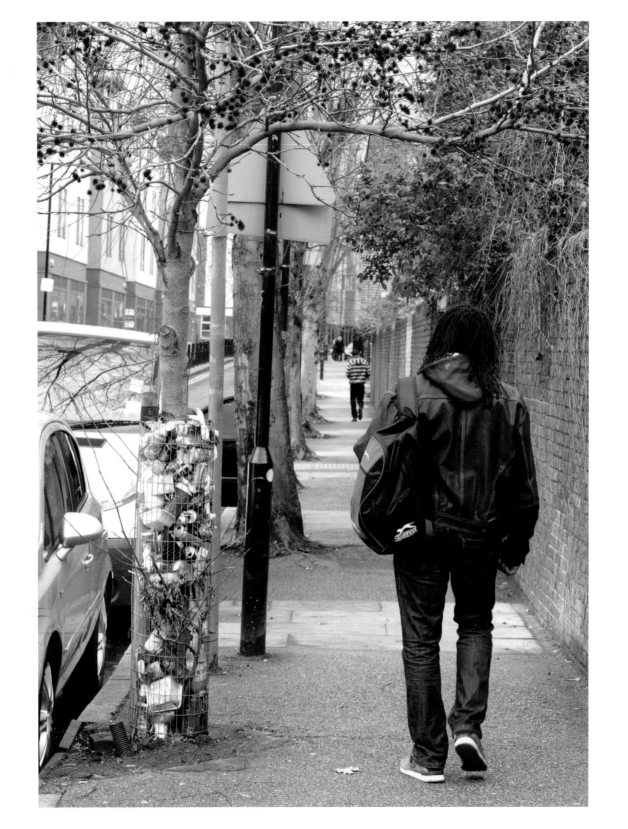

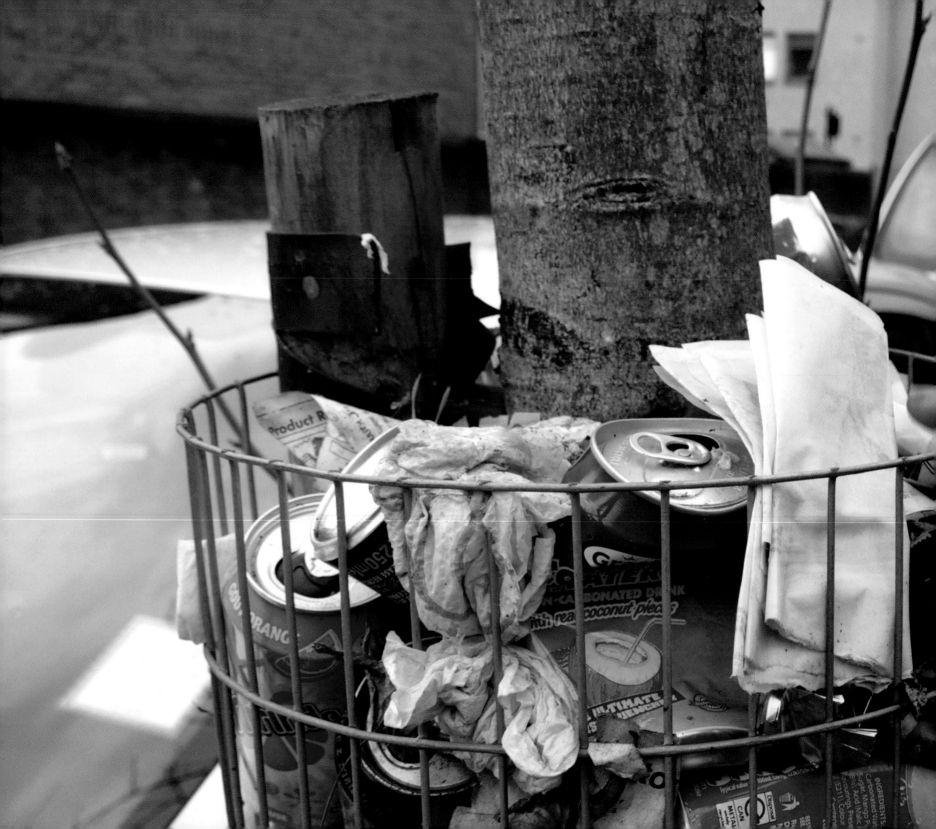

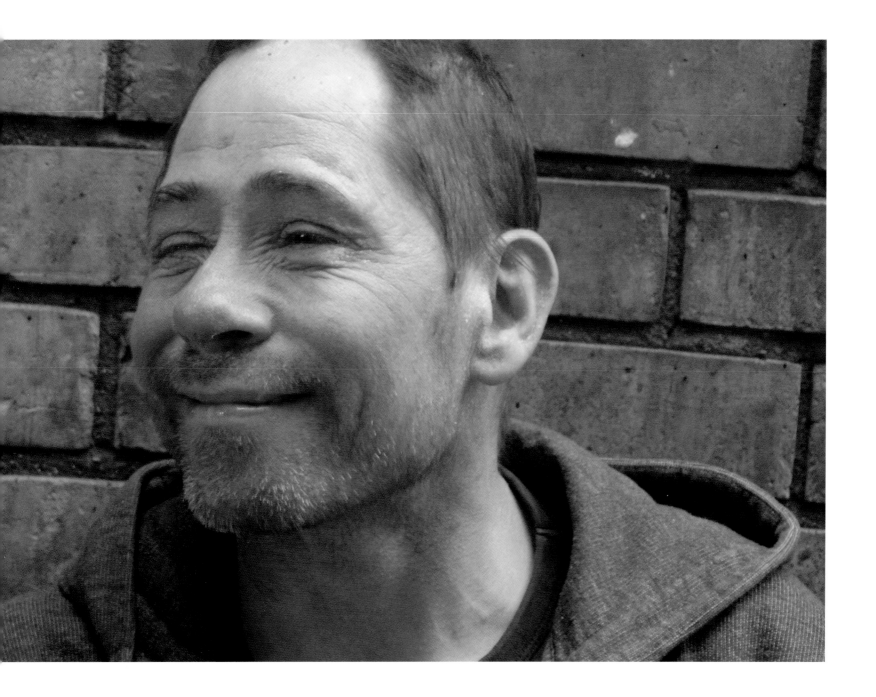

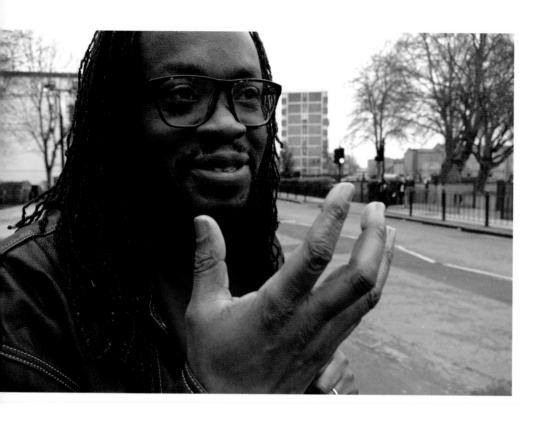

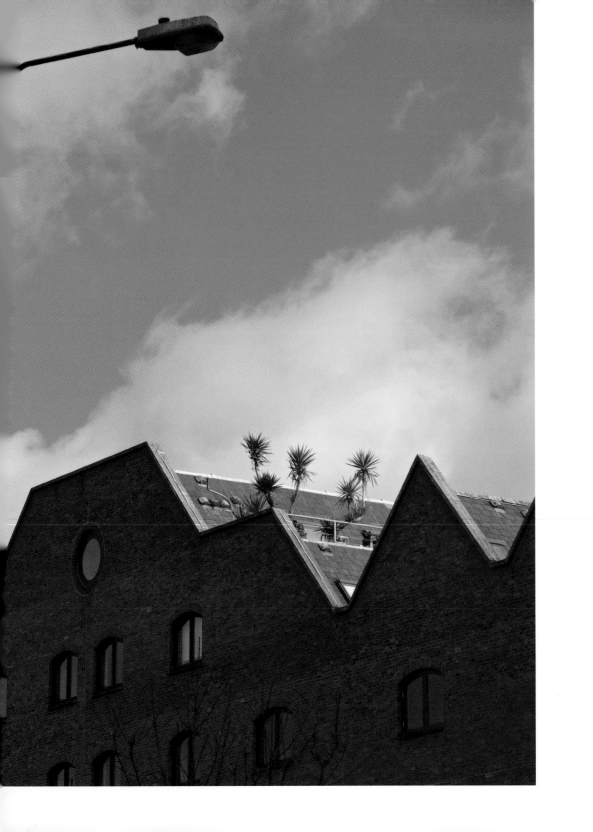

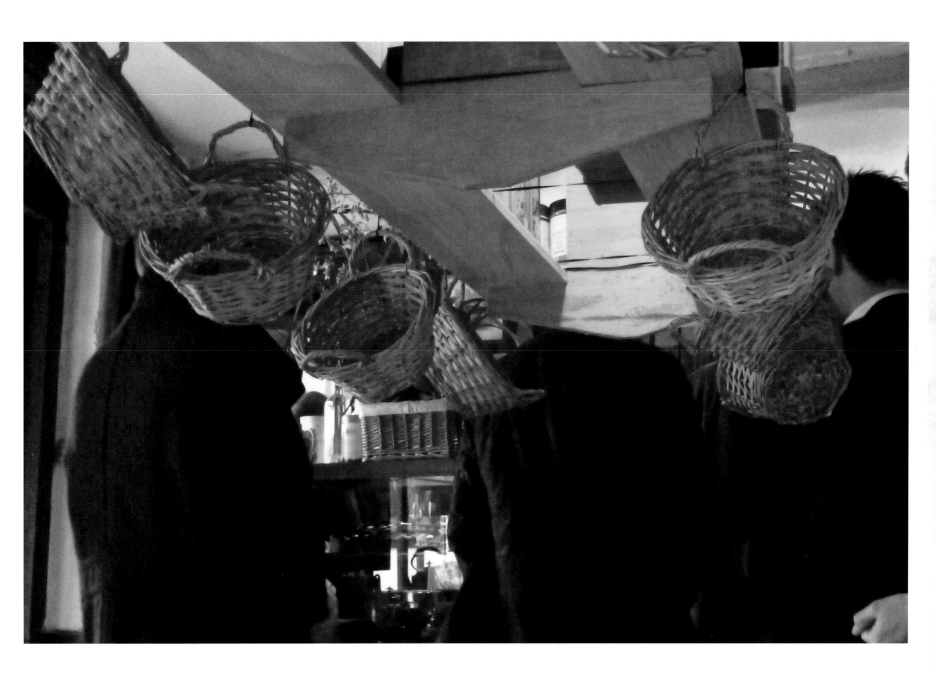

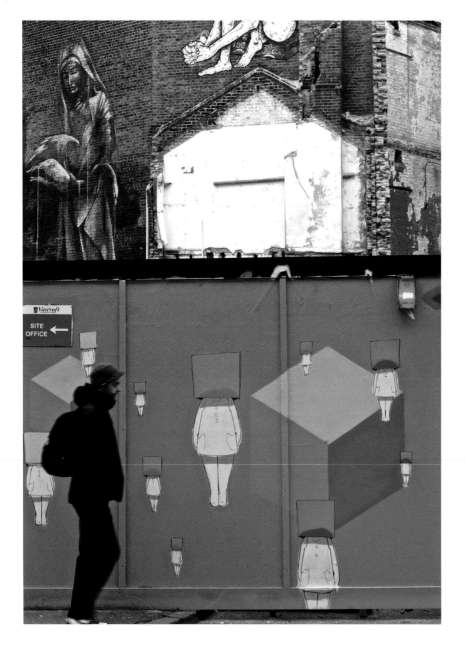

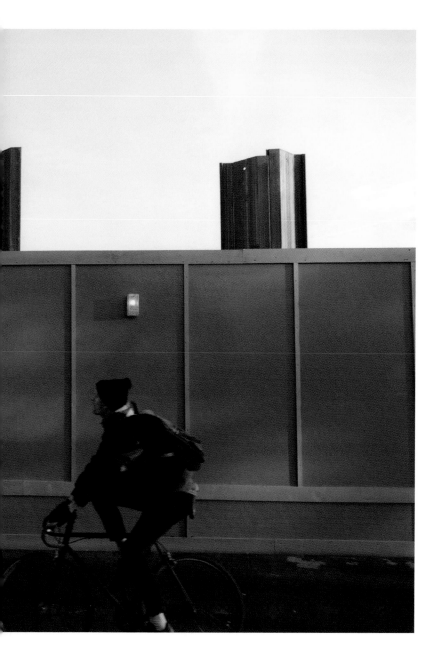

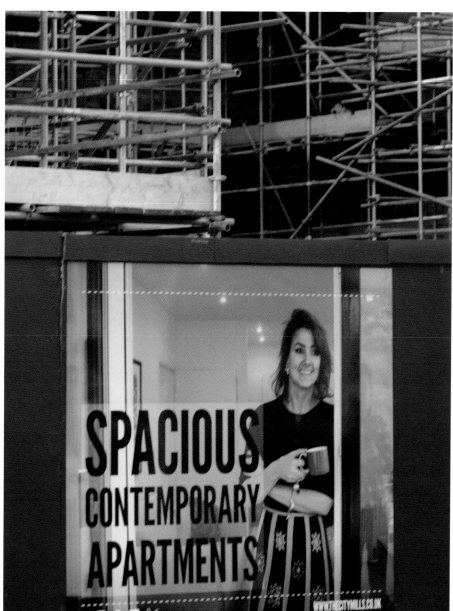

SPACIOUS CONTEMPORARY APARTMENTS

WWW.THECITYMILLS.CO.UK

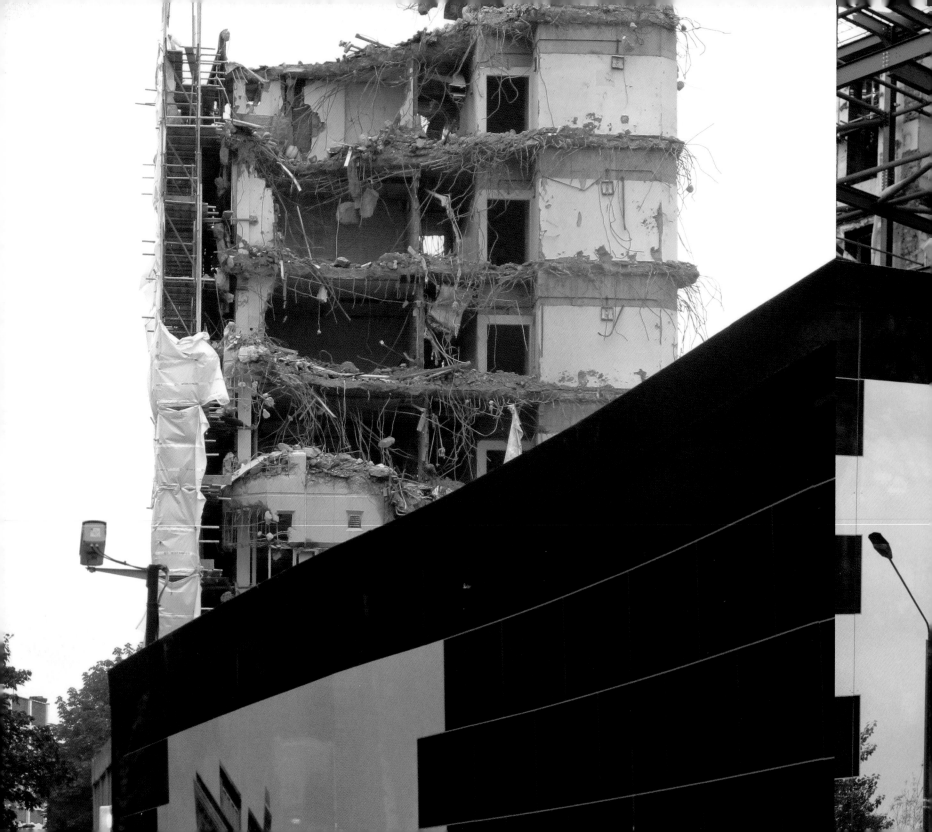

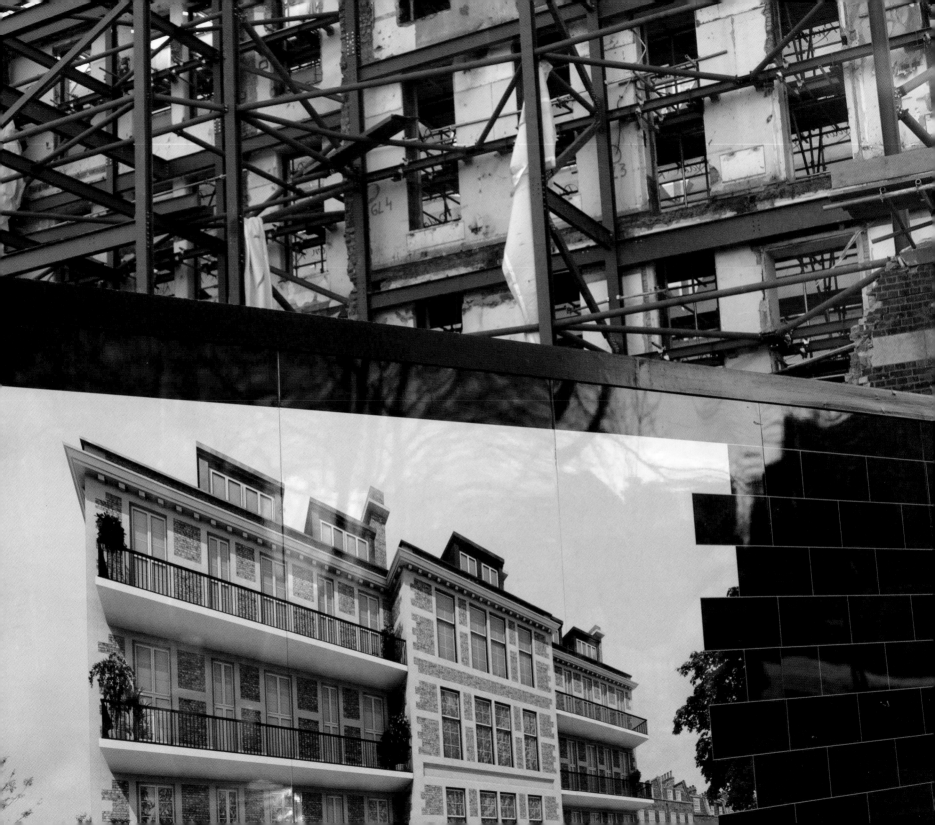

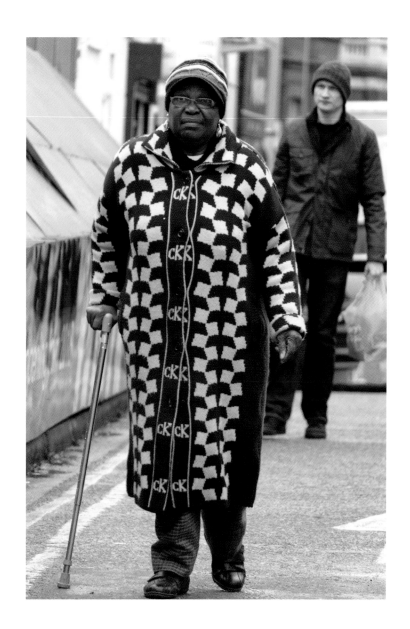

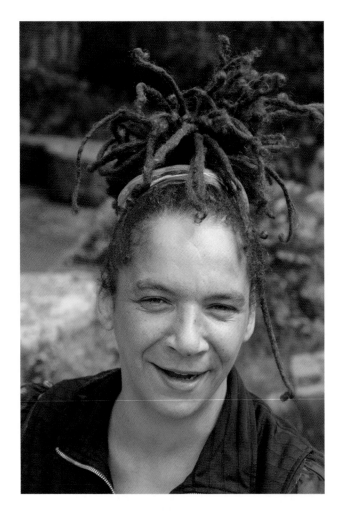
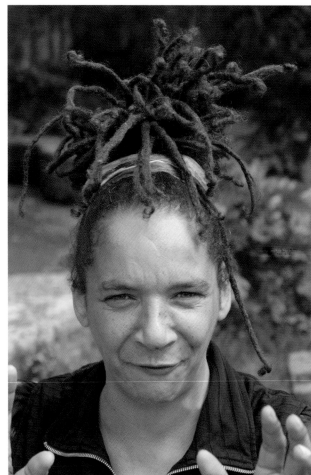

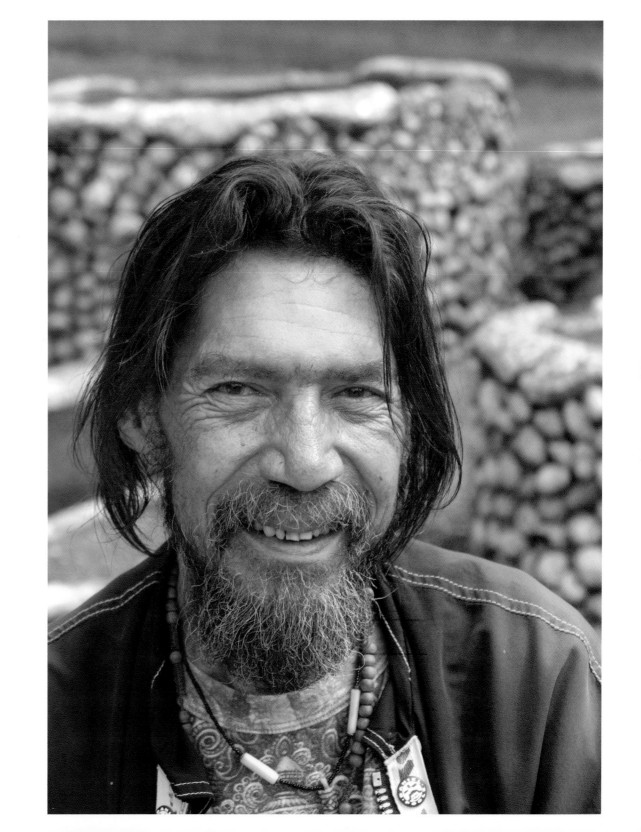

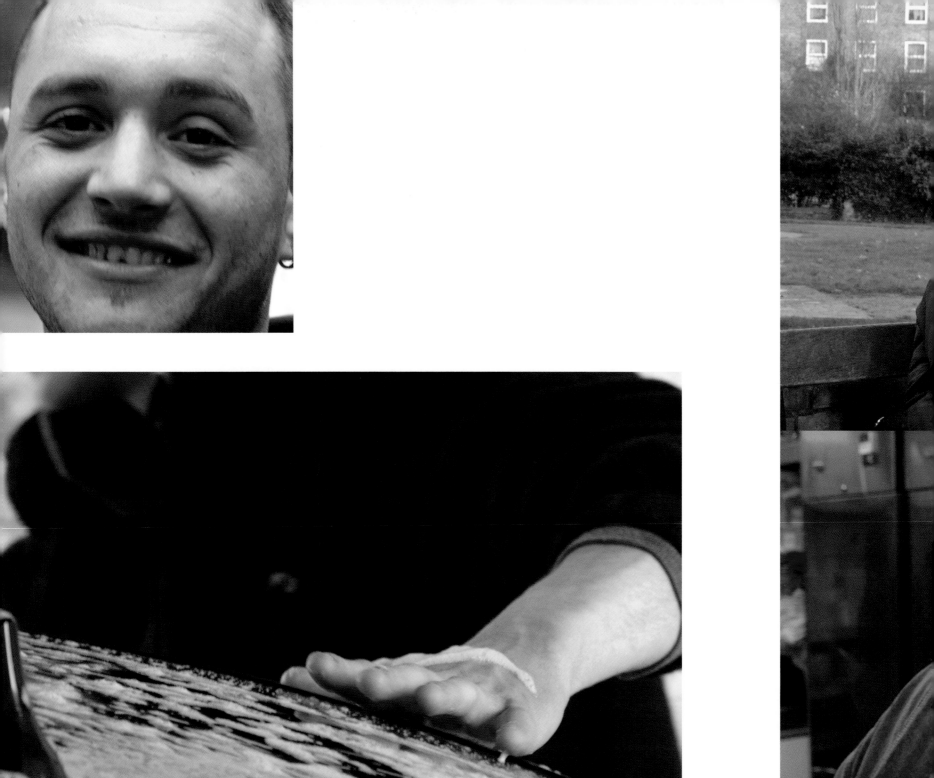

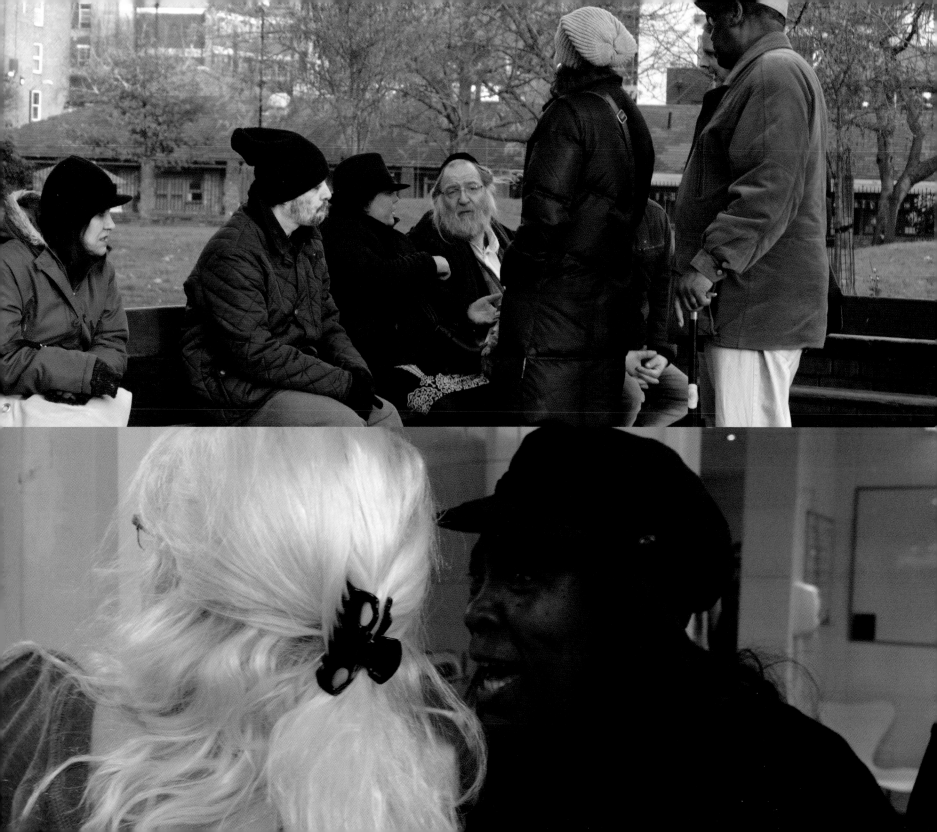

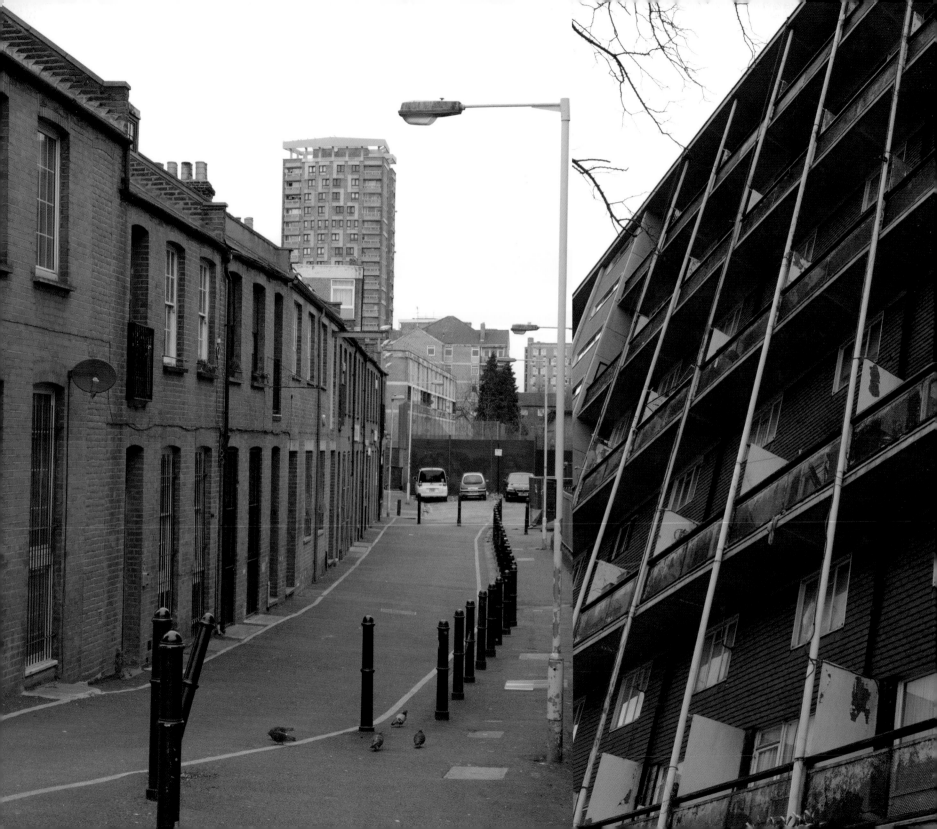

OF LONDON

FOR ALL ENQUIRIES
020 7488 9146

TOWER VIEW

FIVE
APARTMENTS
AND ONE
PENTHOUSE

OPEN
WEDNESDAY
TO SUNDAY

PRICES FROM
£1,650,000 TO
£5,950,000

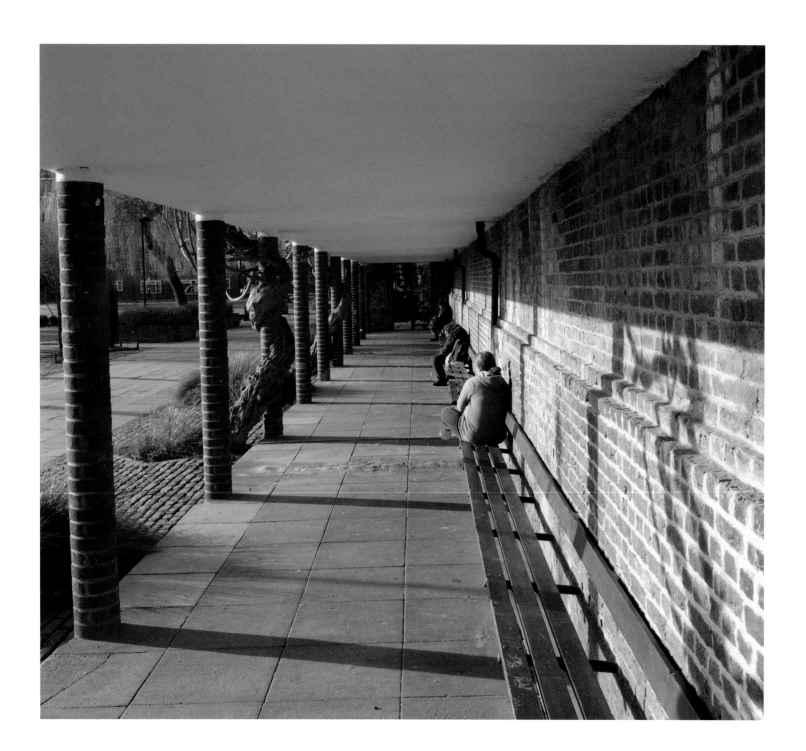

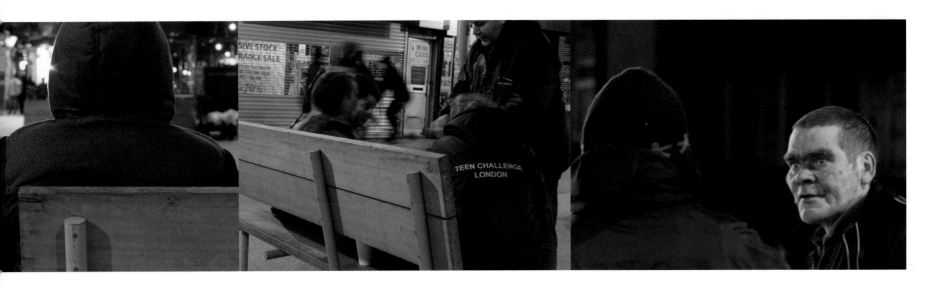

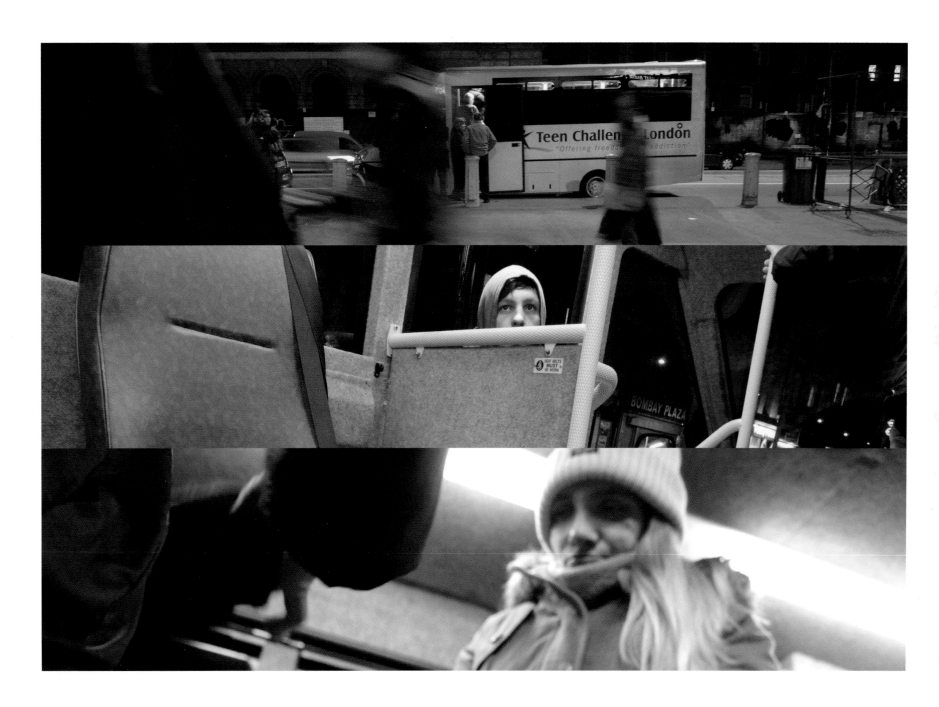

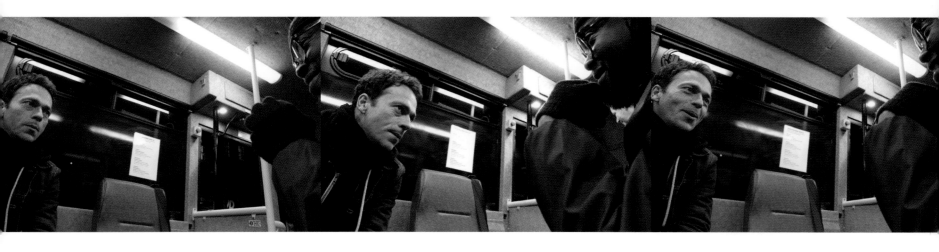

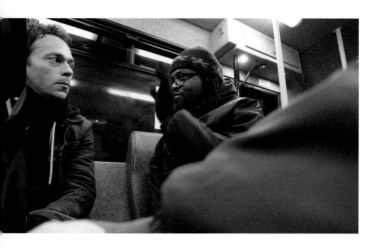

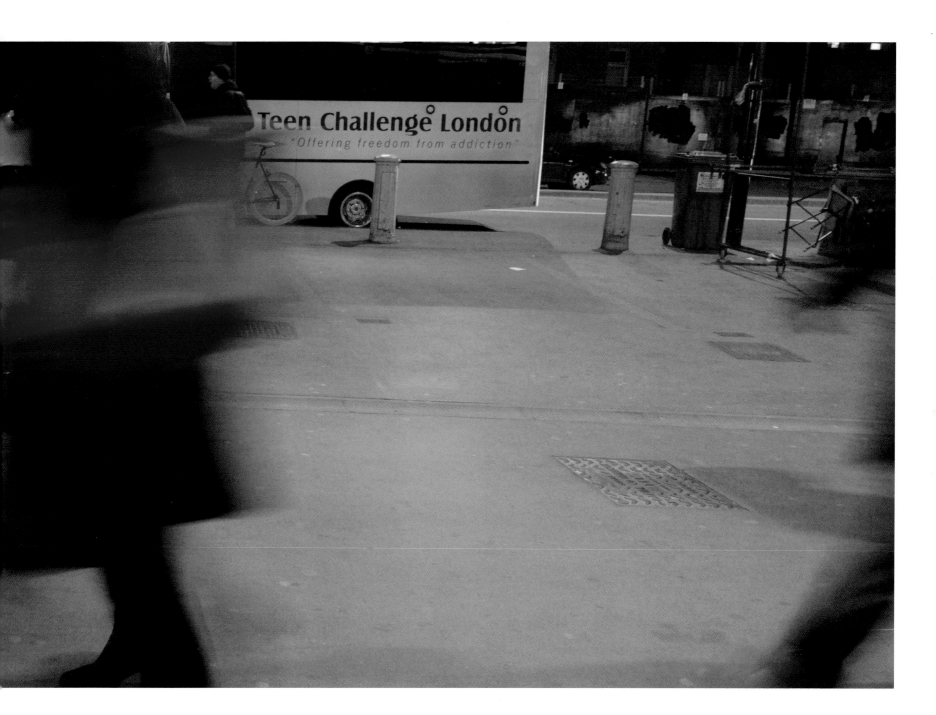

wishes for

Cloths of Heaven

eats

Yeats 2015

Had I the heavens' embroidered cloths,
Enwrought with golden and silver light,
The blue and the dim and the dark cloths
Of night and light and the half-light,
I would spread the cloths under your feet:
But I, being poor, have only my dreams;
I have spread my dreams under your feet;
Tread softly because you tread on my dreams.

ems on the Underground

Visit tfl.gov.uk/poems

YOR OF LONDON

 ARTS COUNCIL ENGLAND BRITISH COUNCIL THE POETRY SOCIETY

 TRANSPORT FOR LONDON
EVERY JOURNEY MATTERS

94

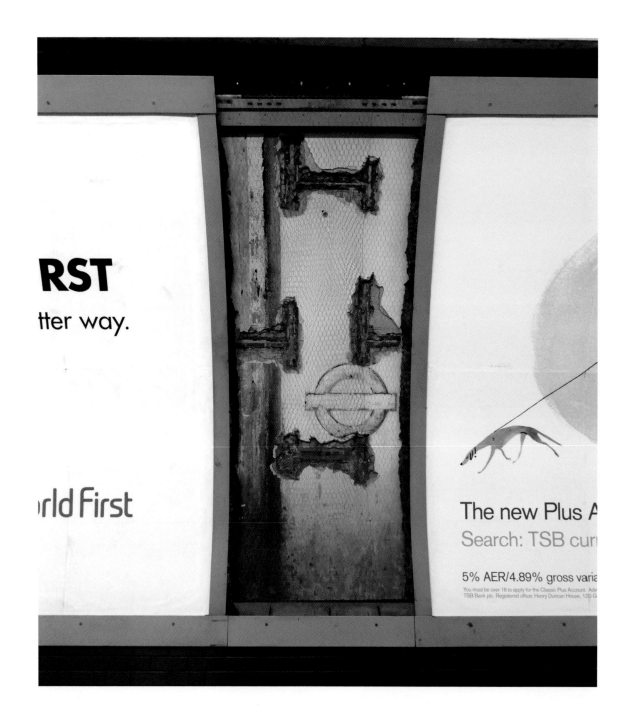

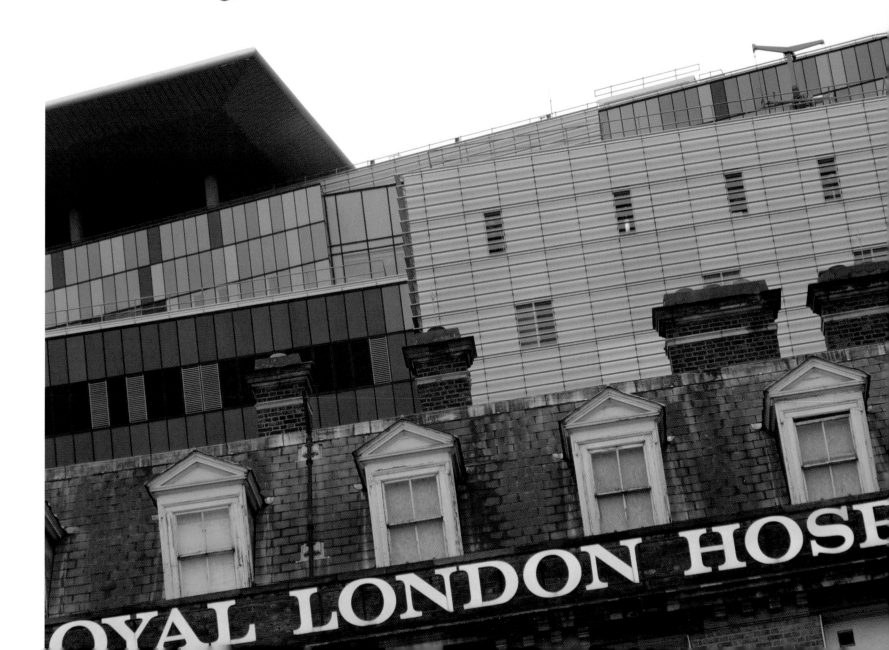

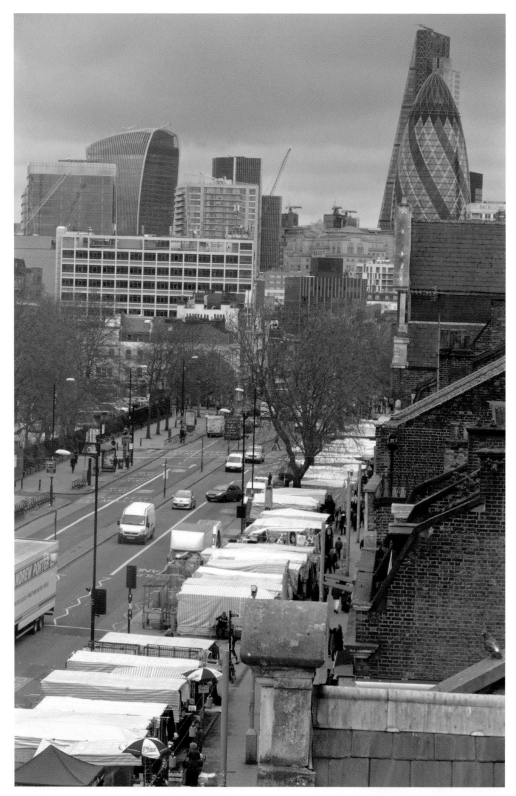

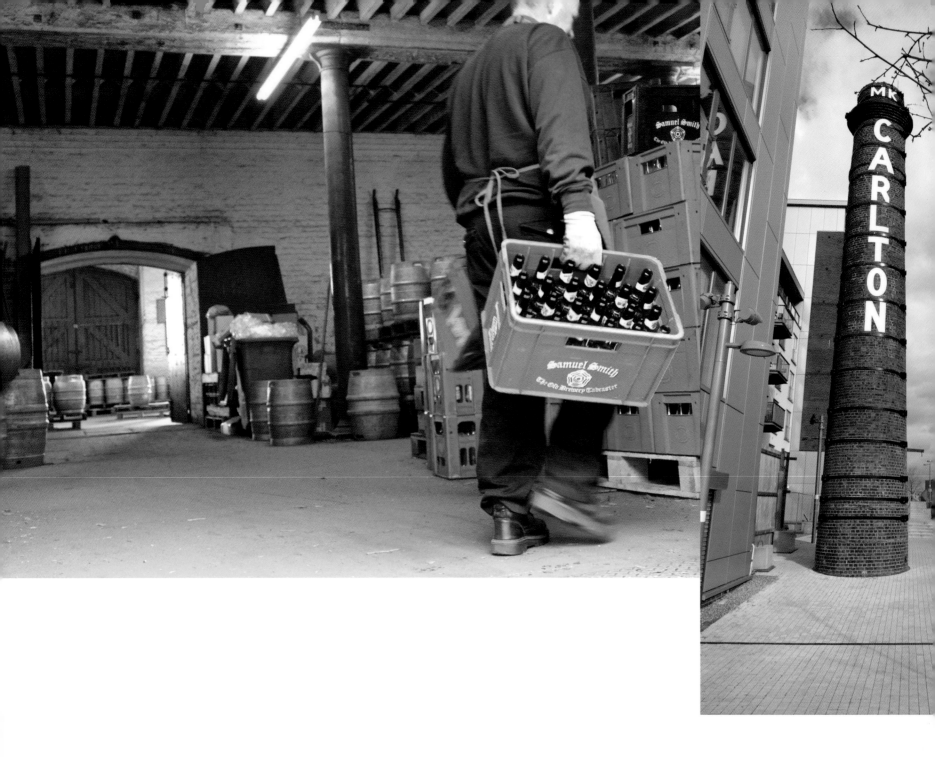

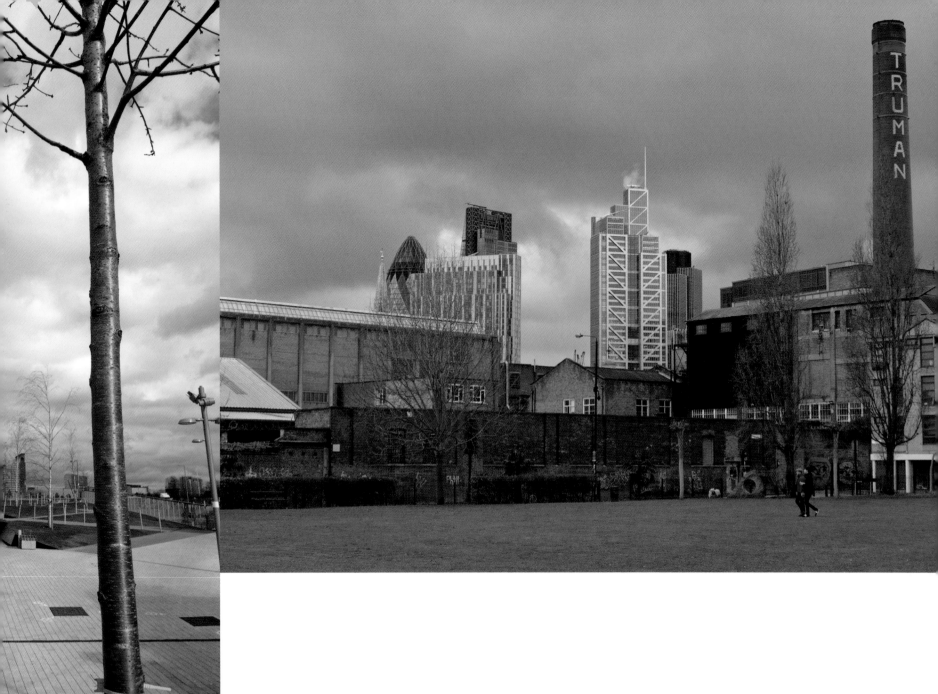

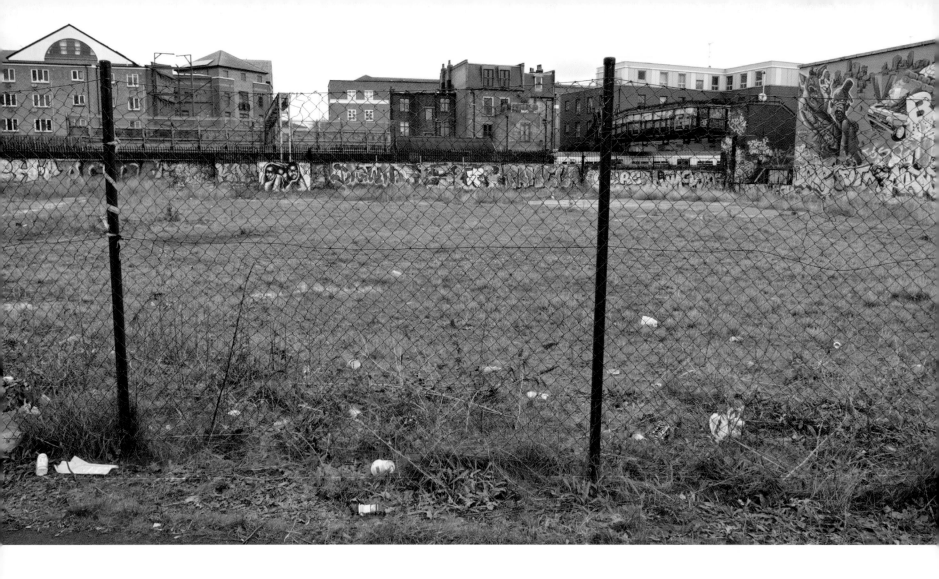

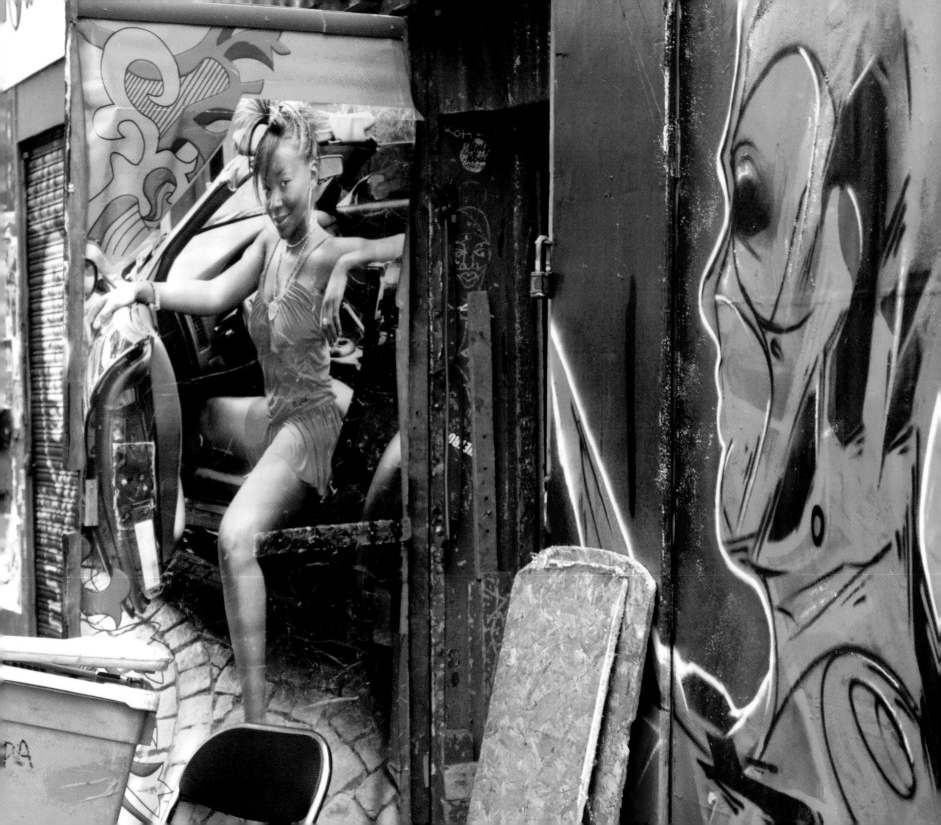

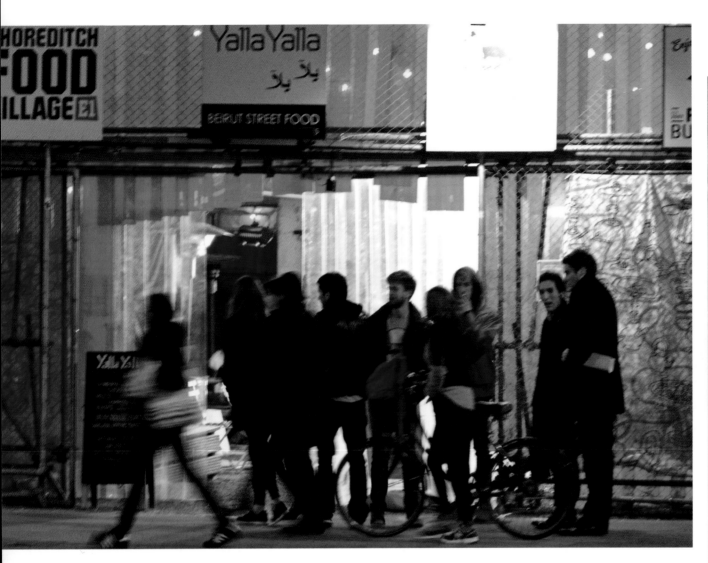

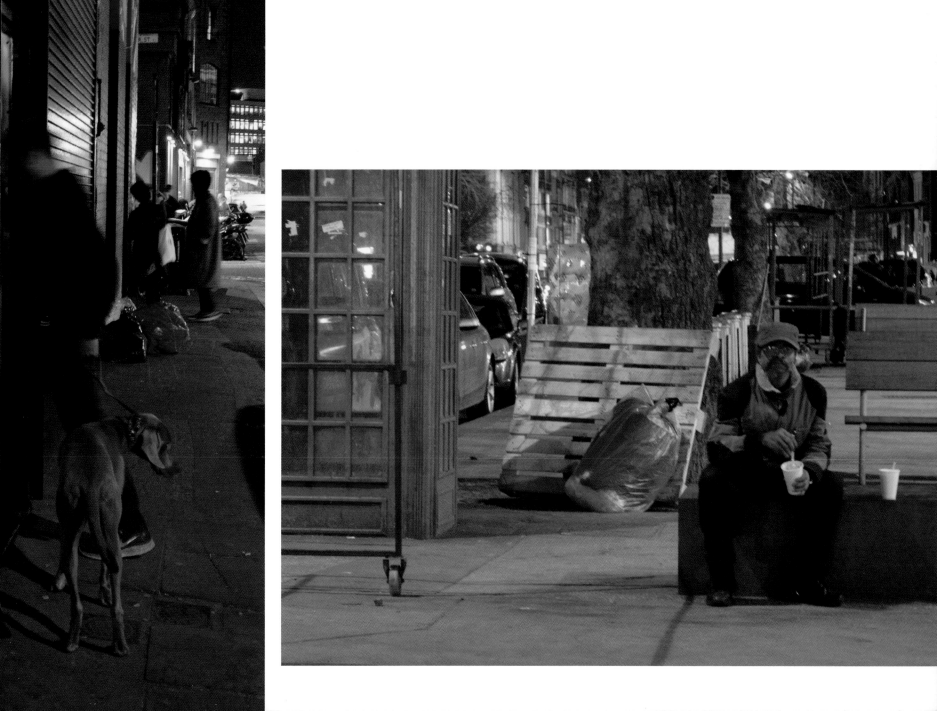

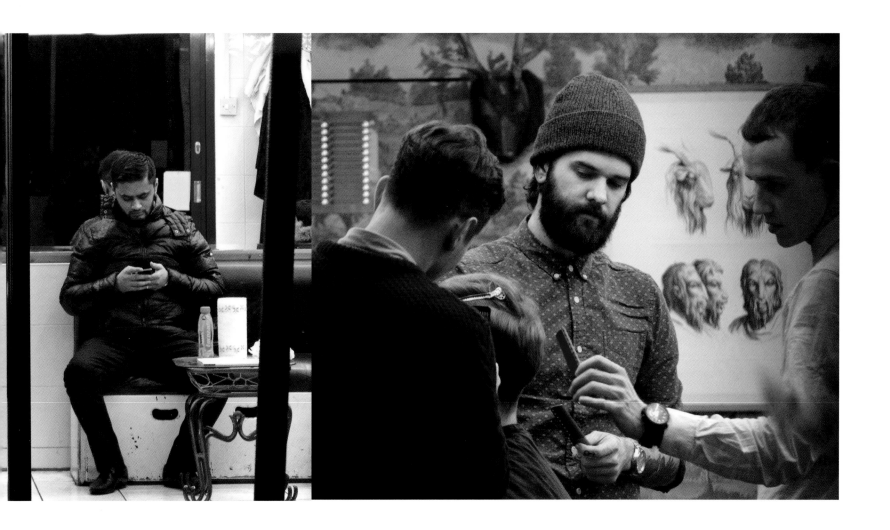

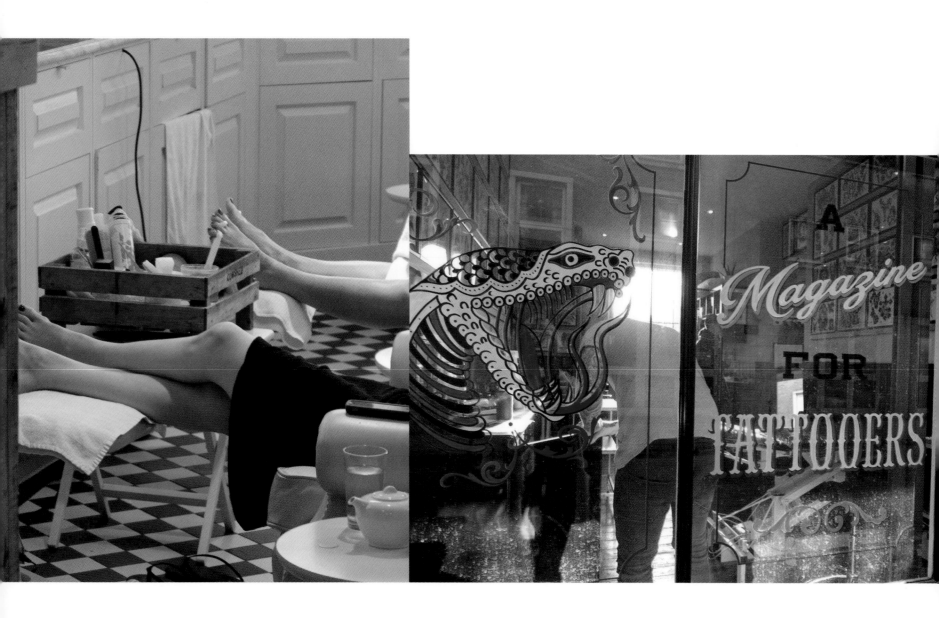

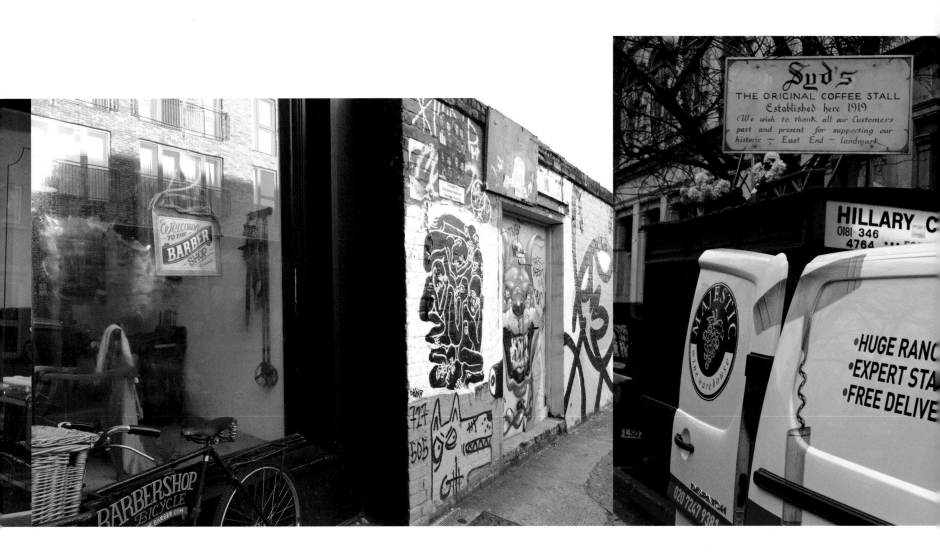

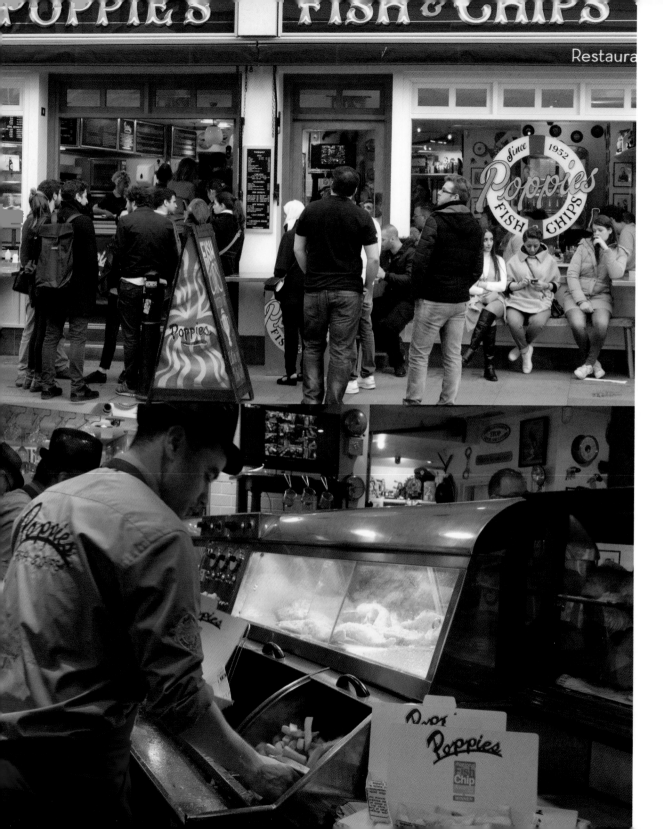

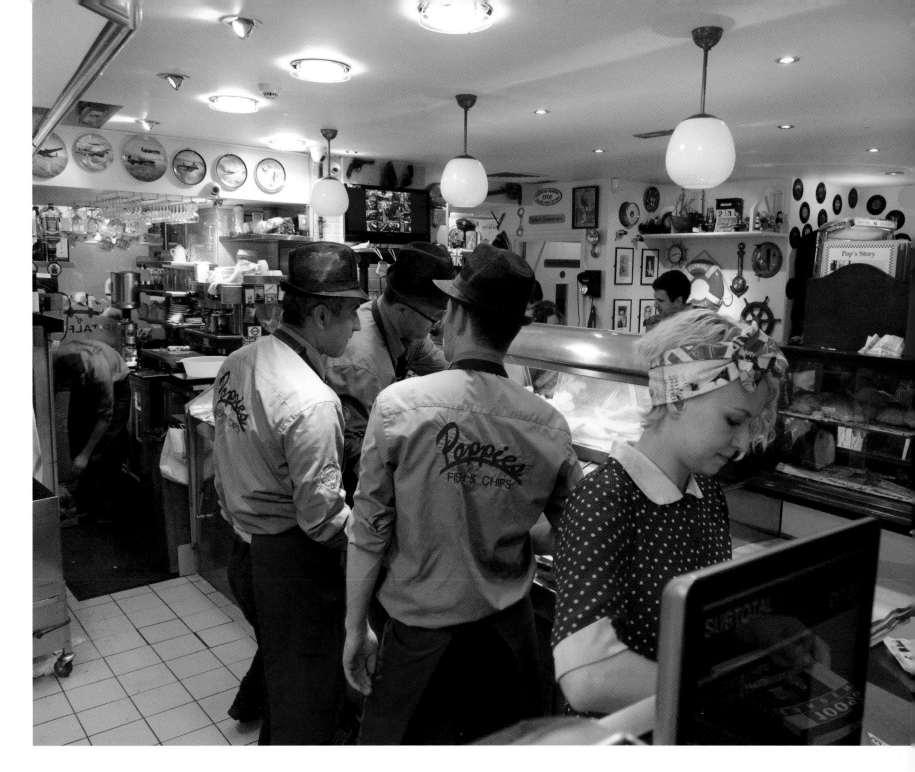

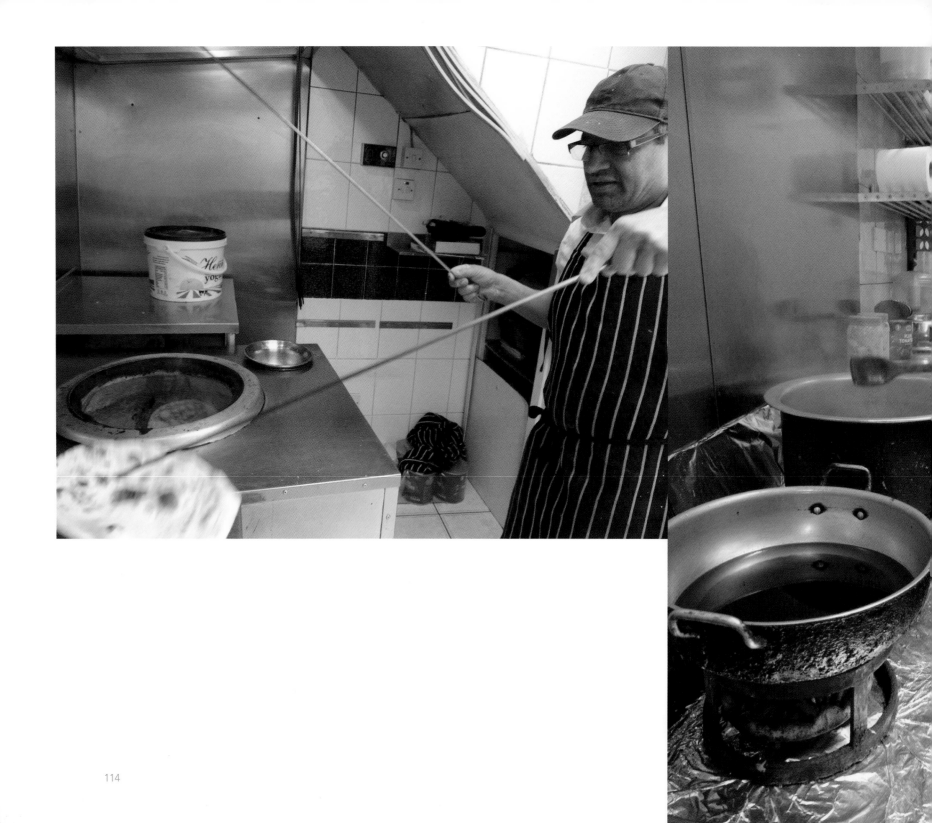

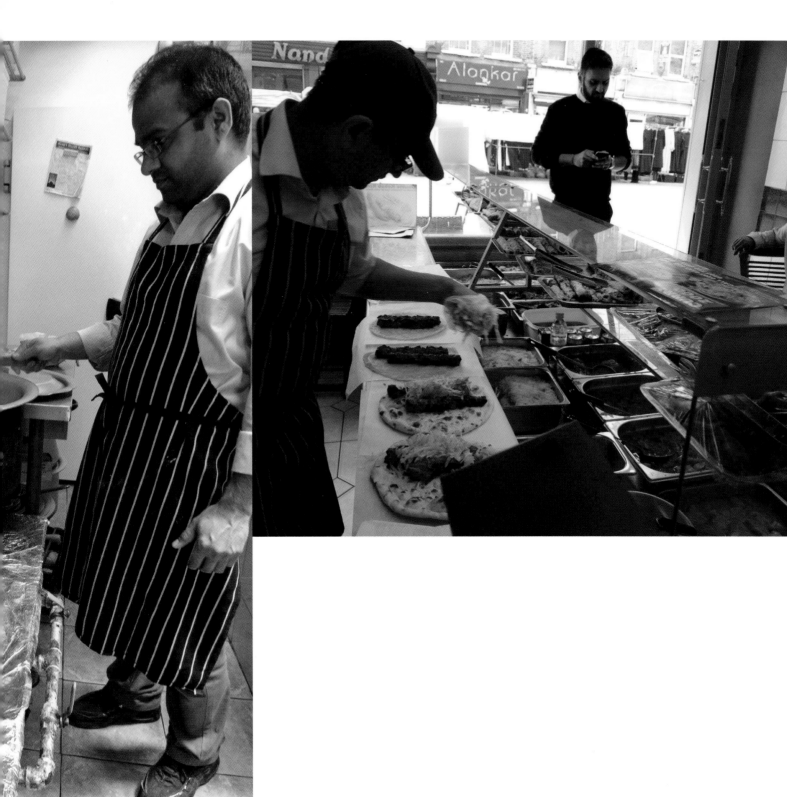

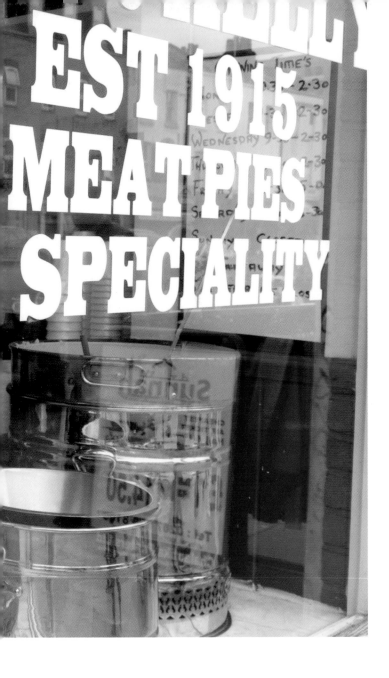

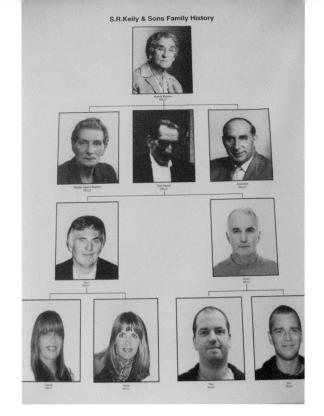

S.R.Kelly & Sons Family History

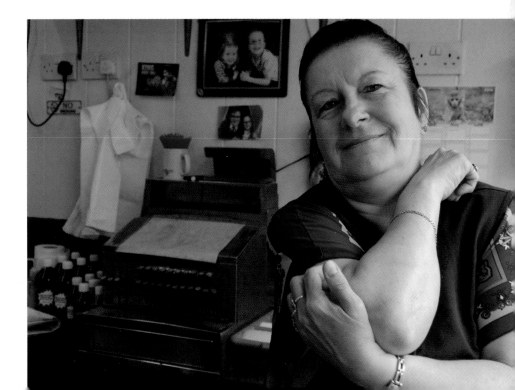

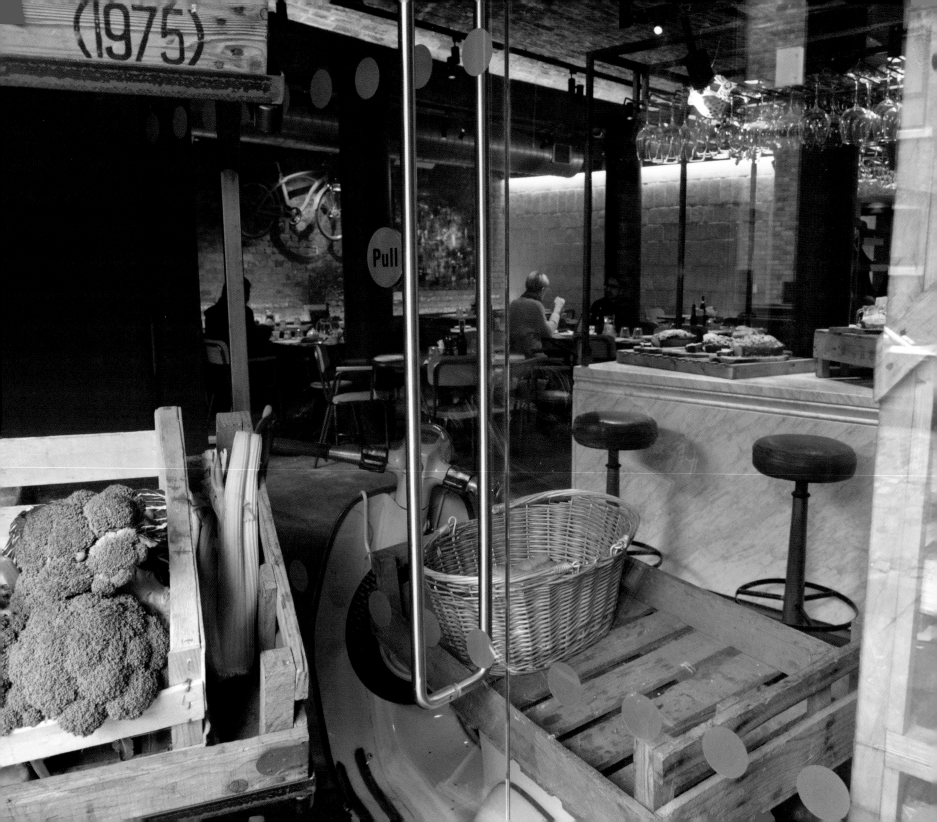

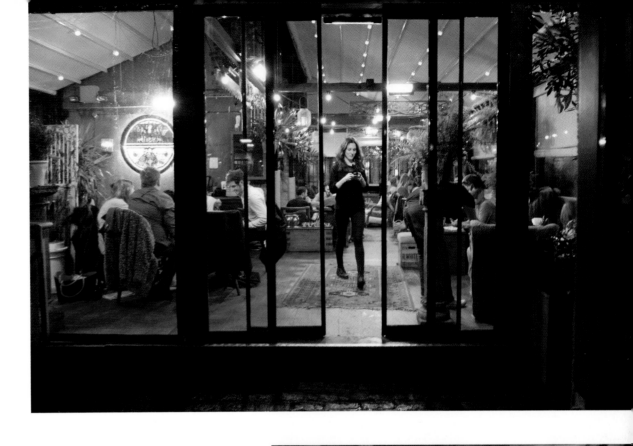

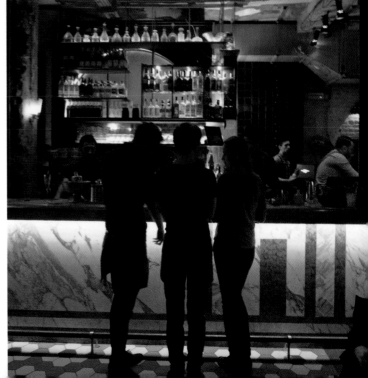

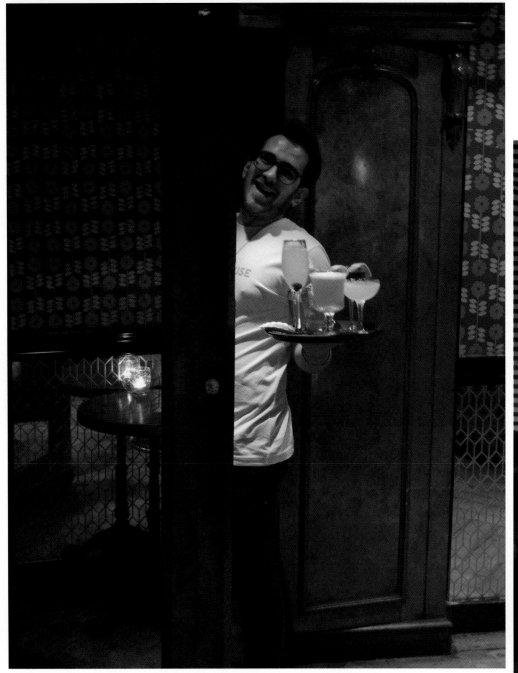
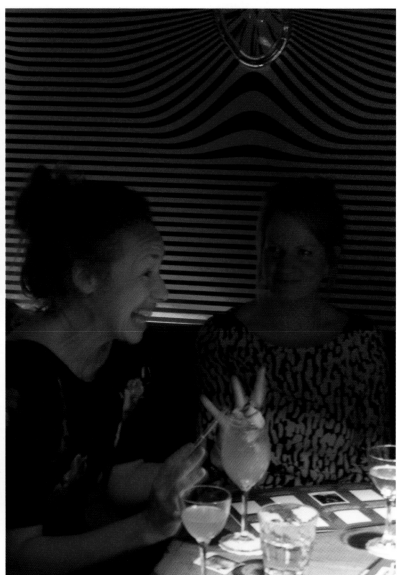

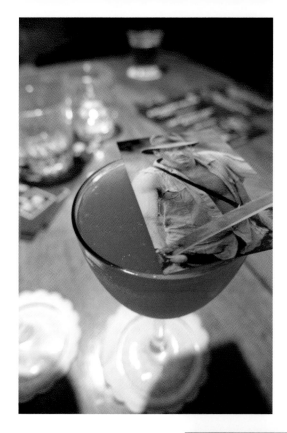

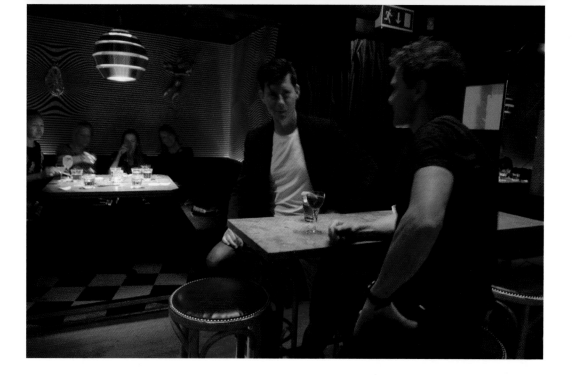

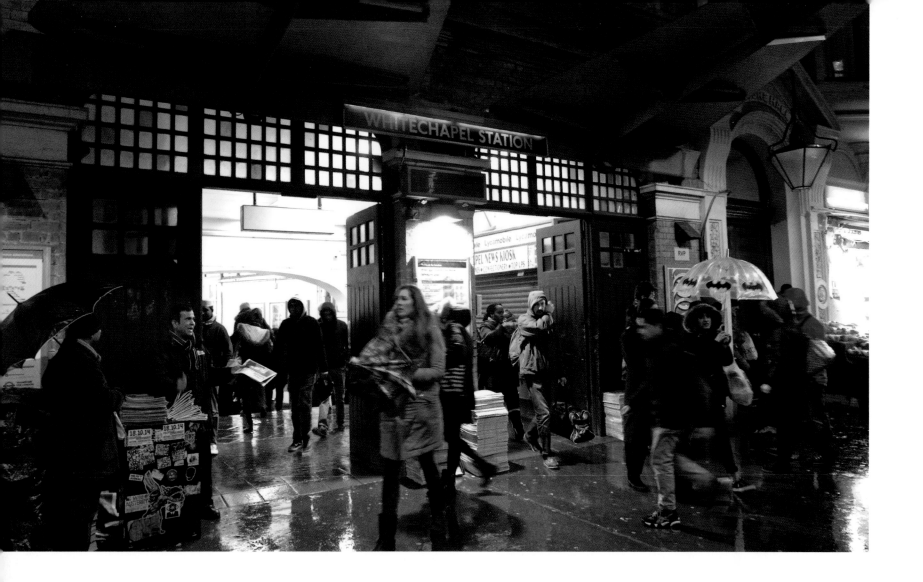

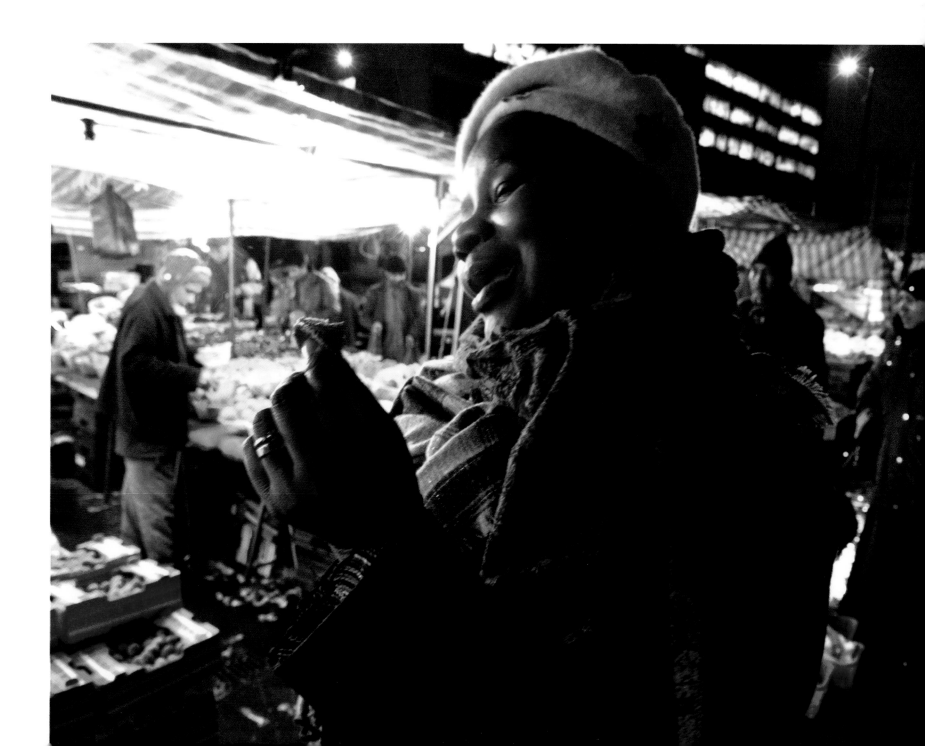

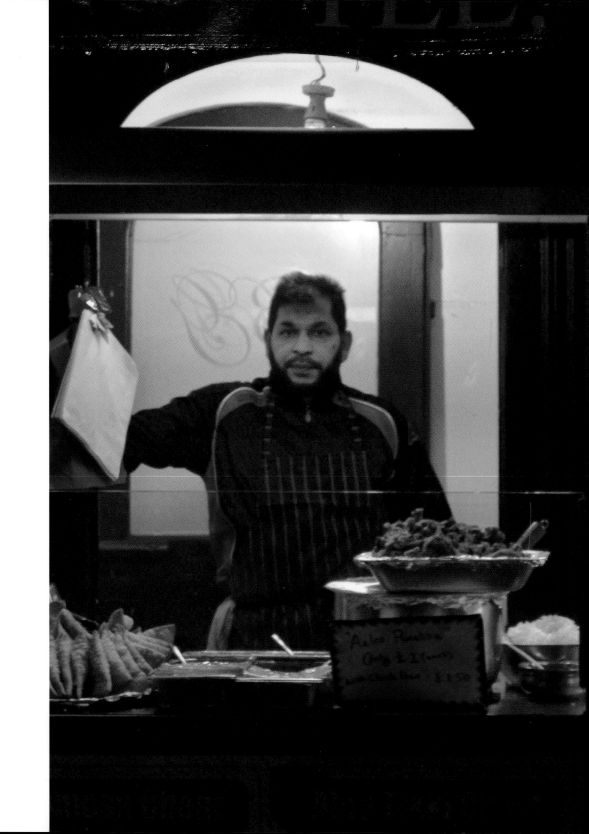

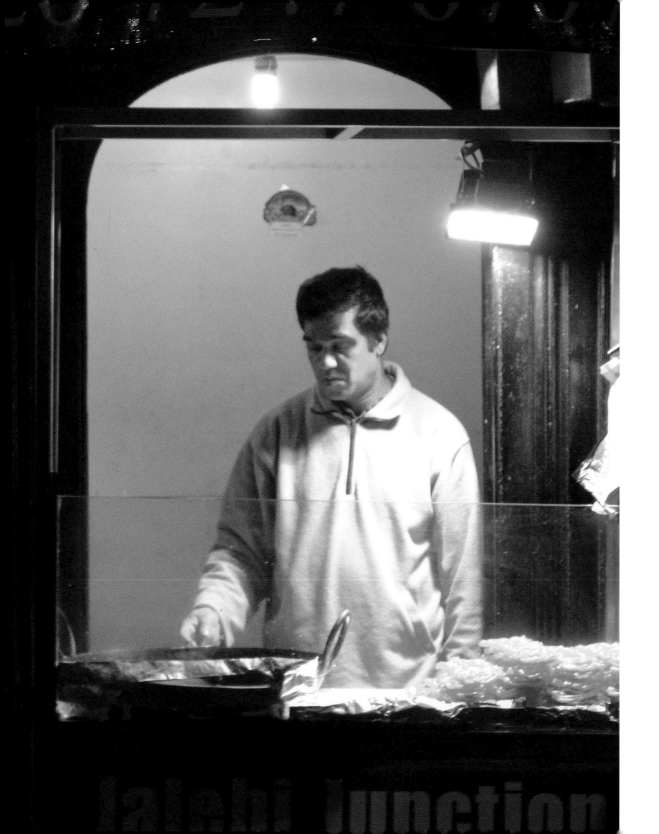

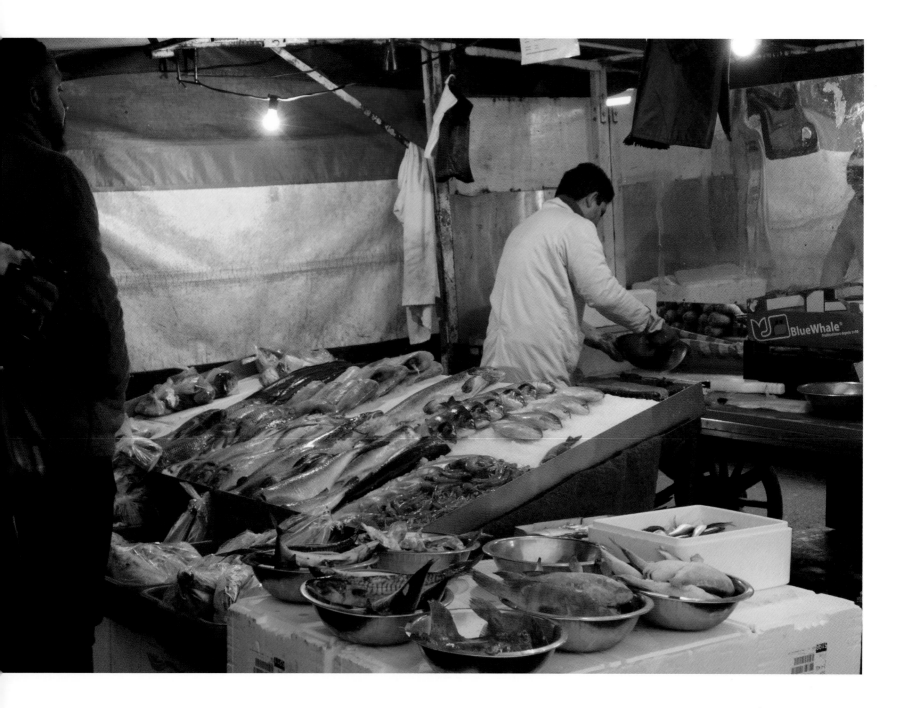

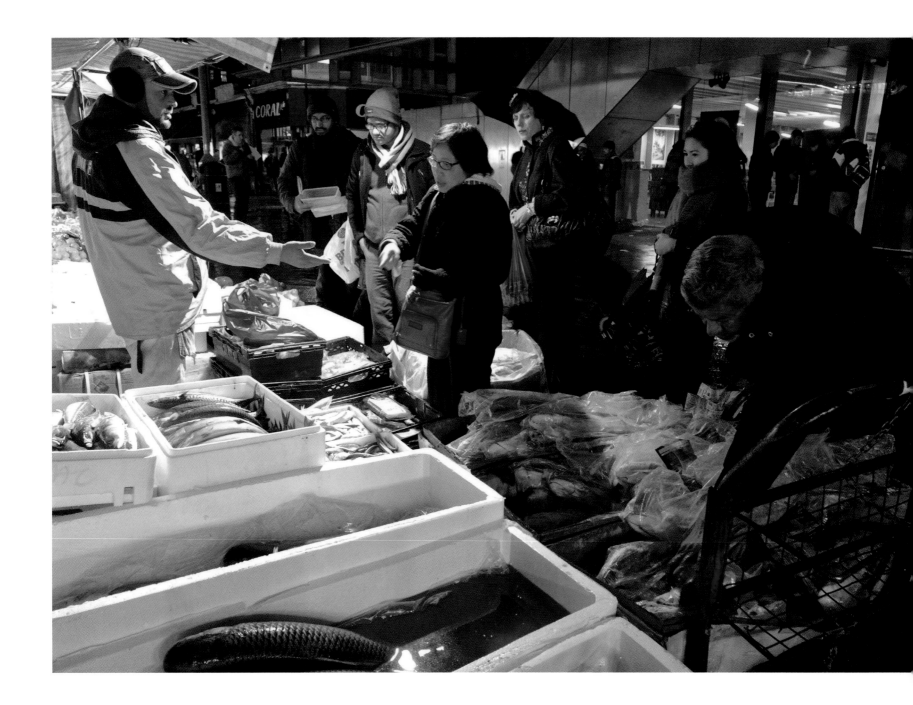

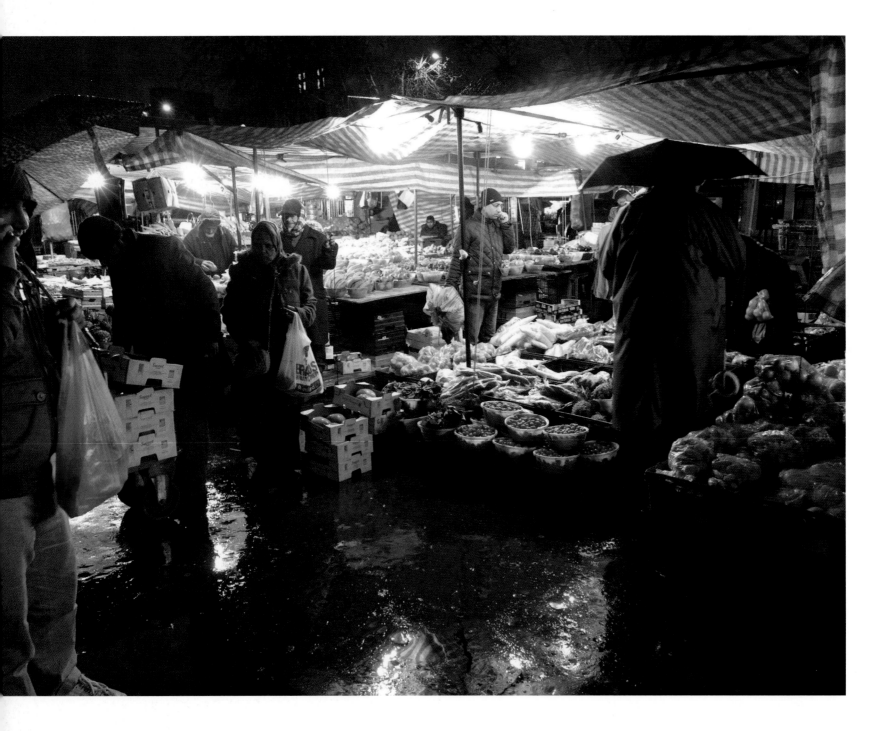

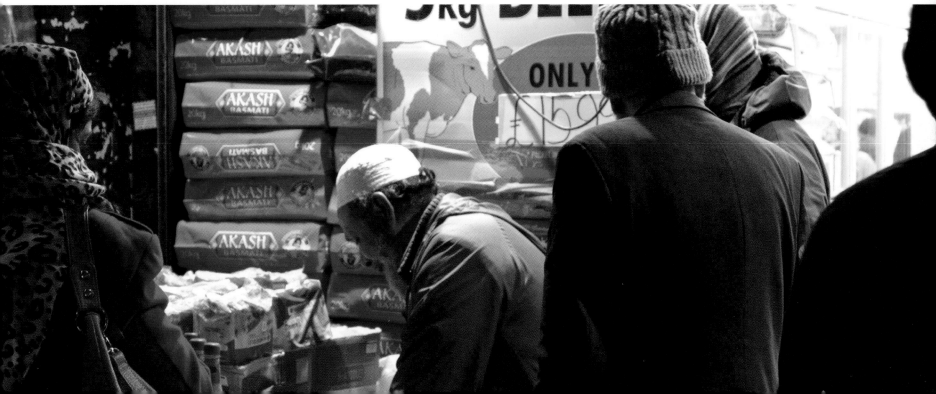

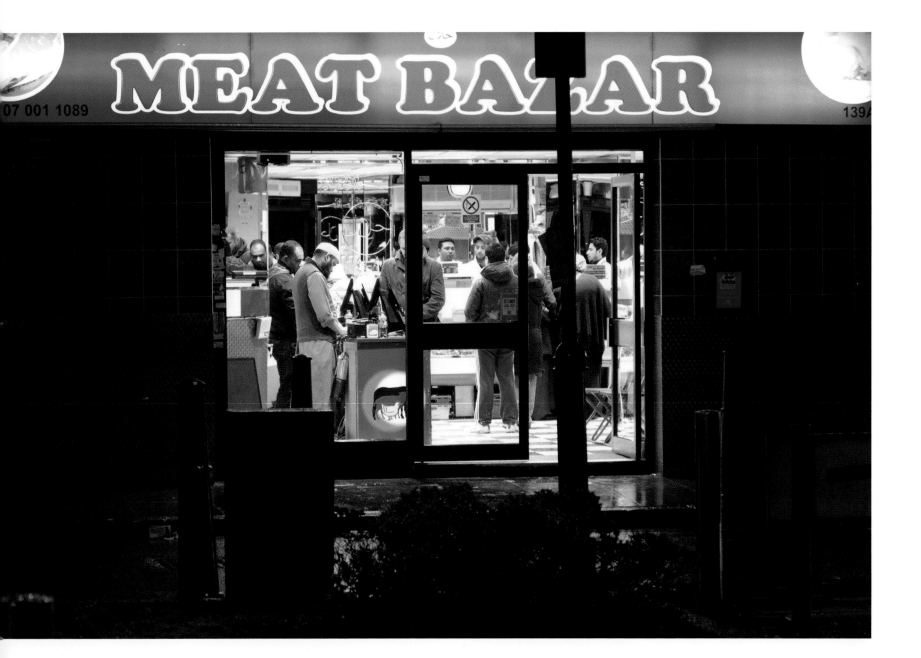

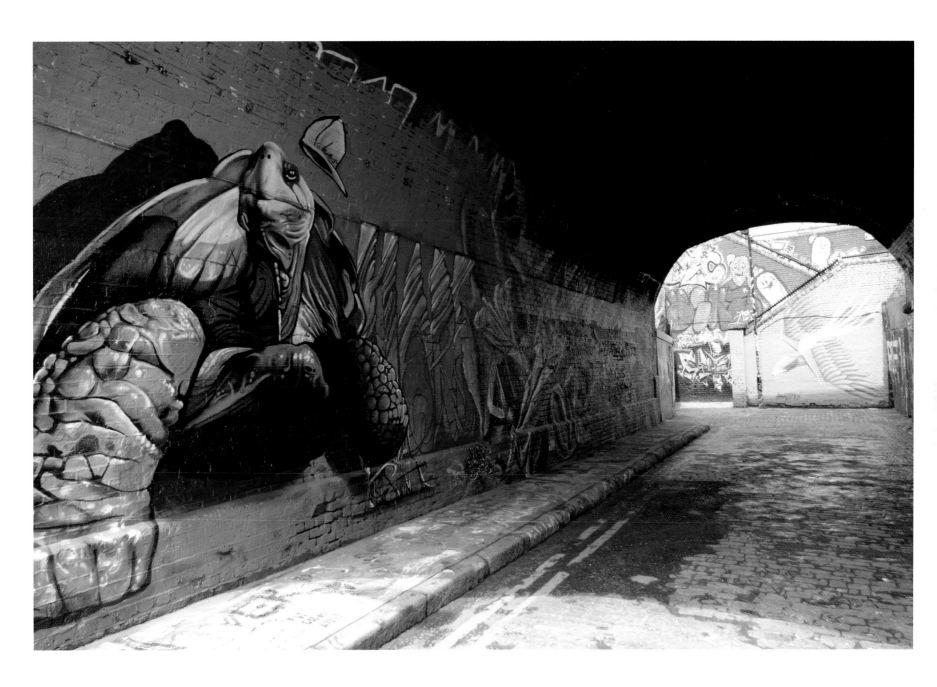

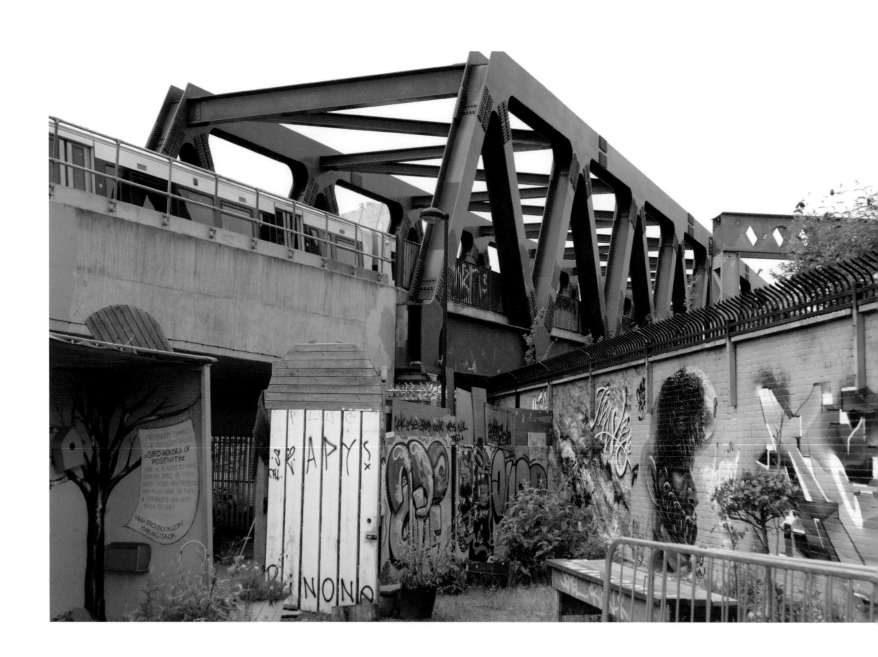

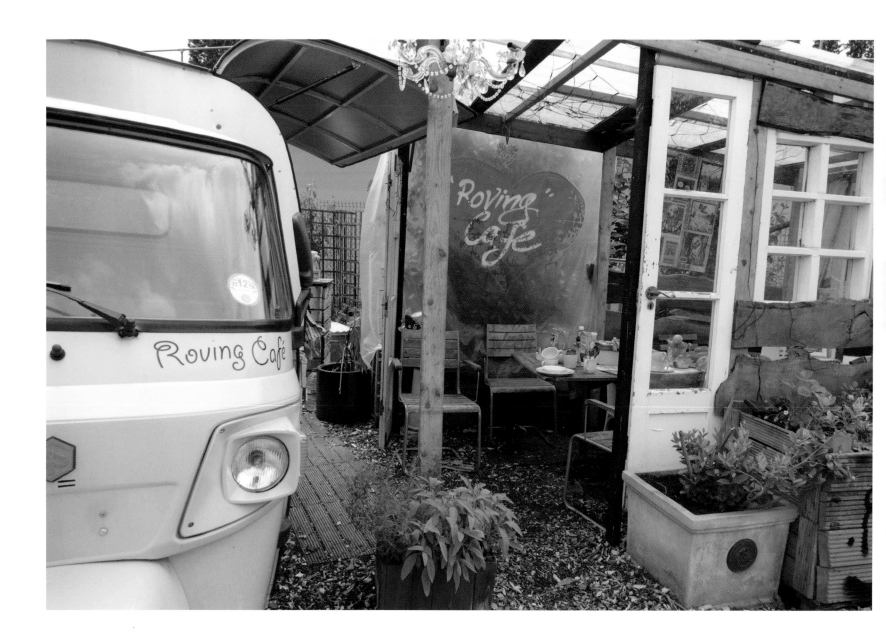

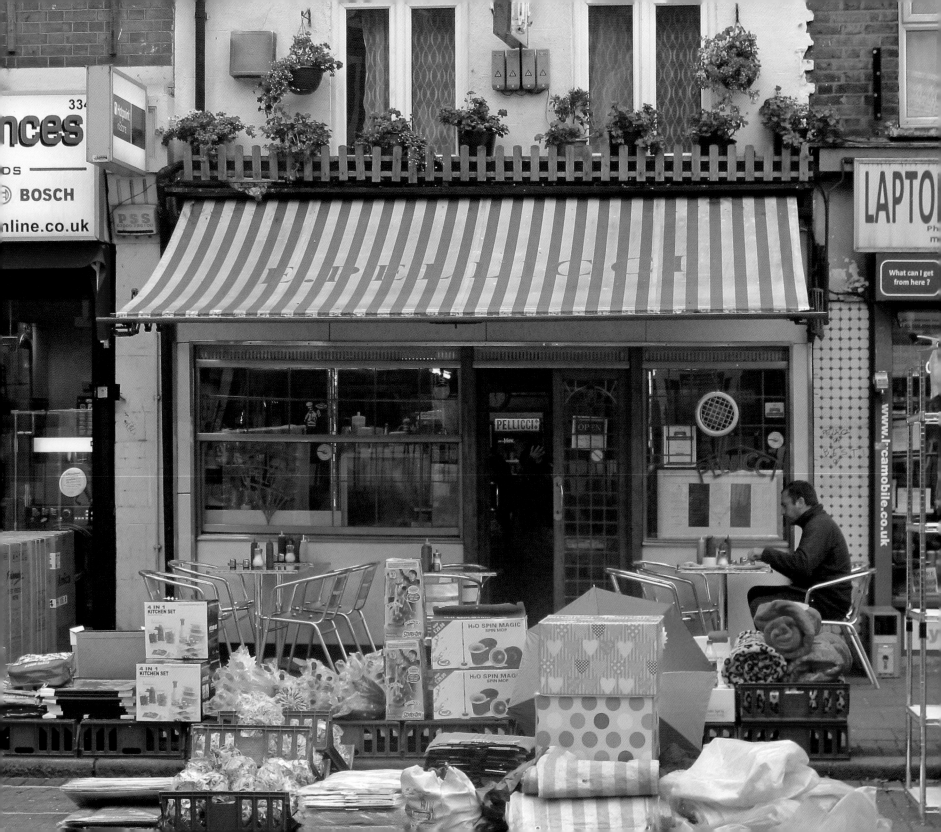

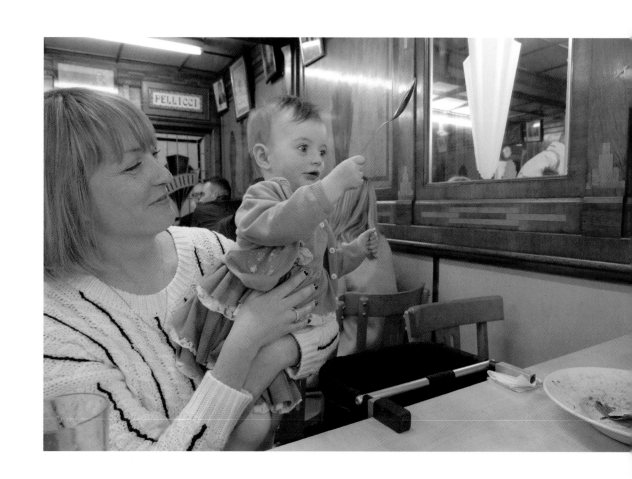

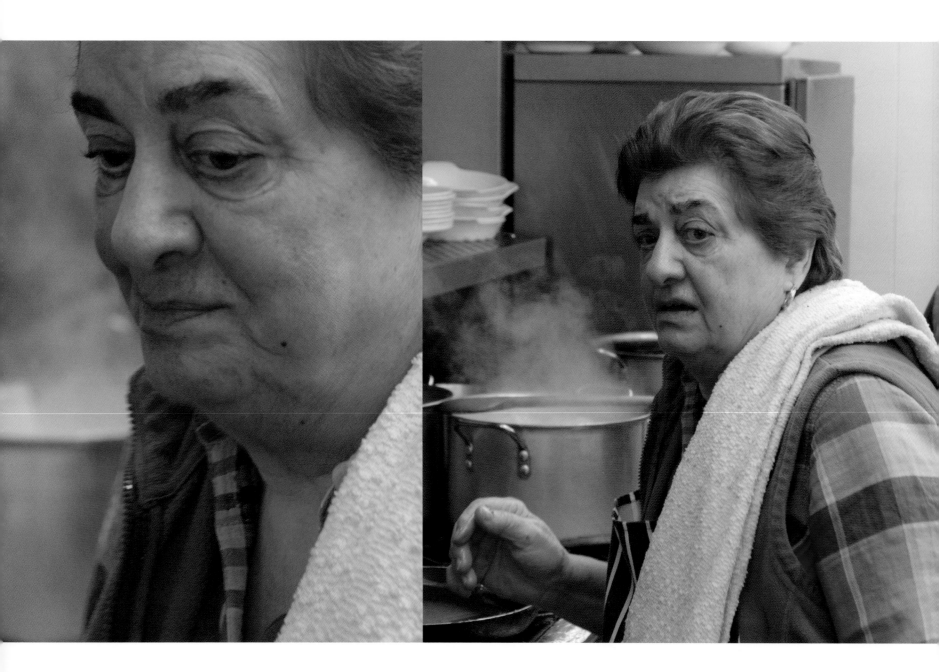

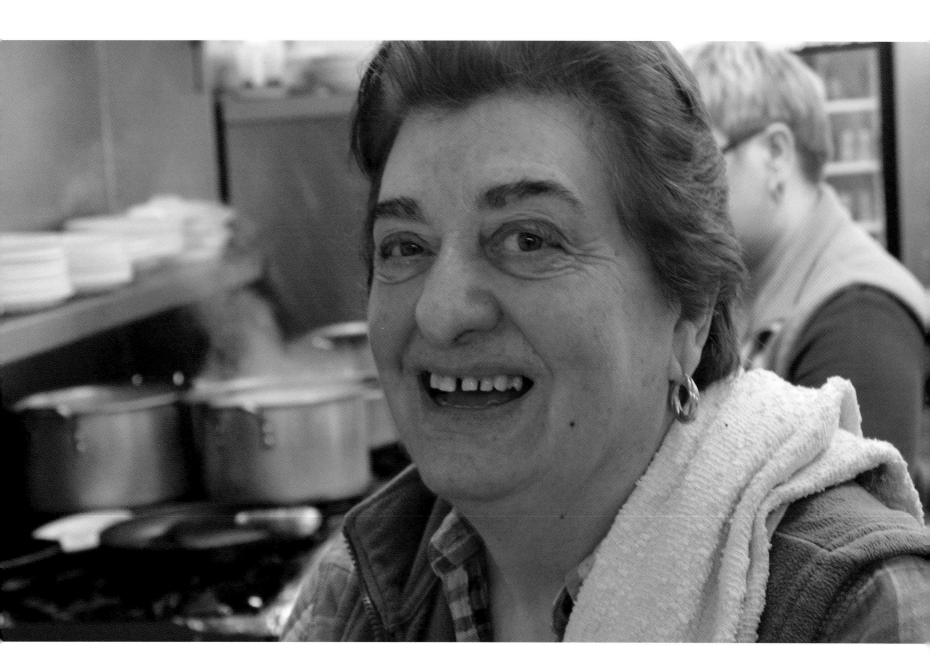

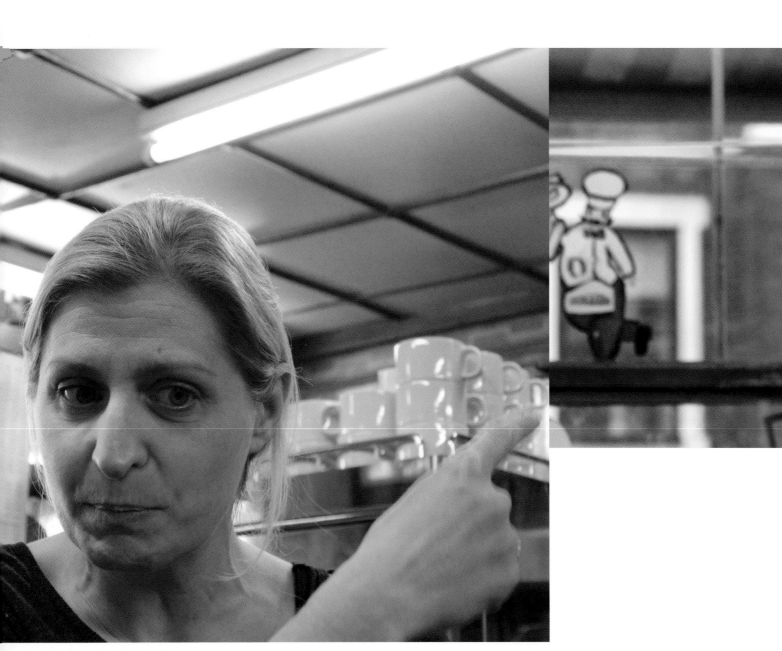

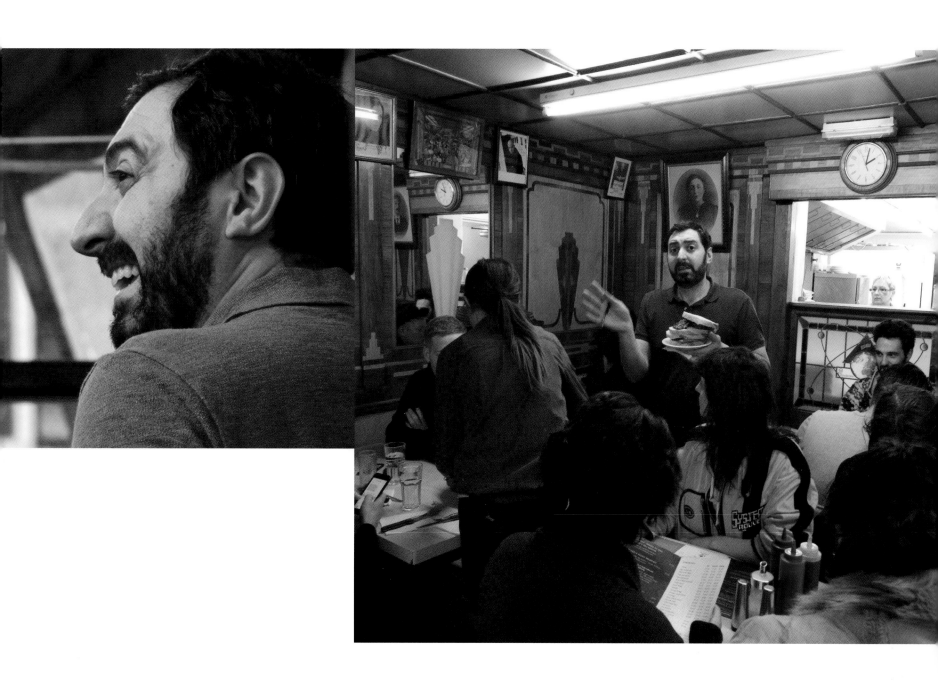

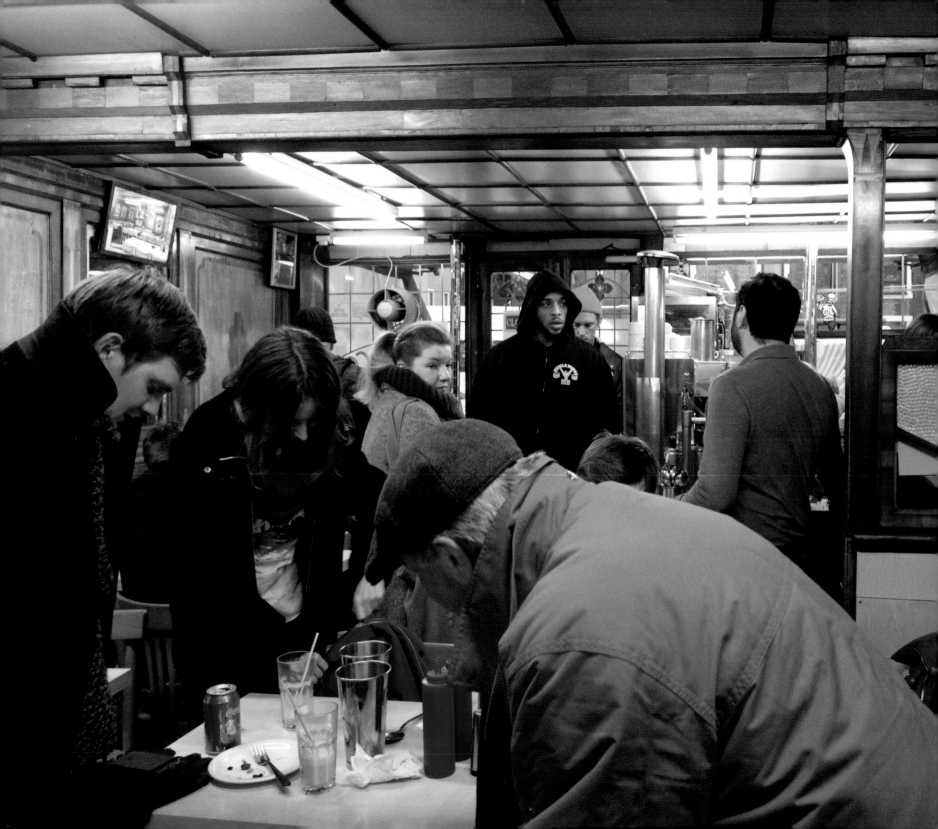

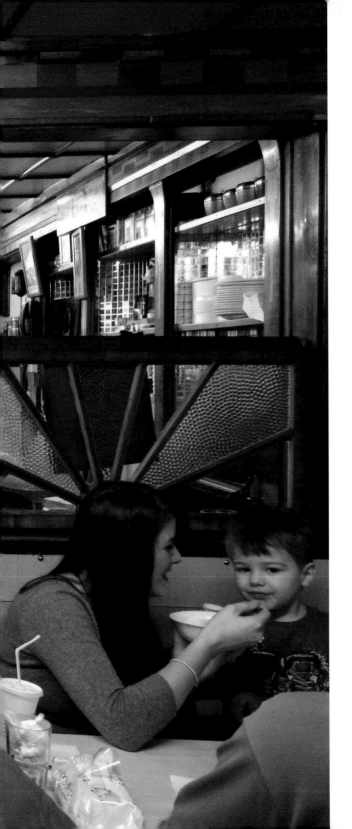

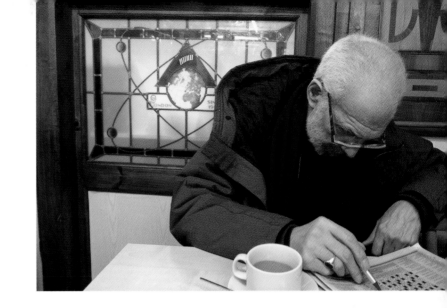

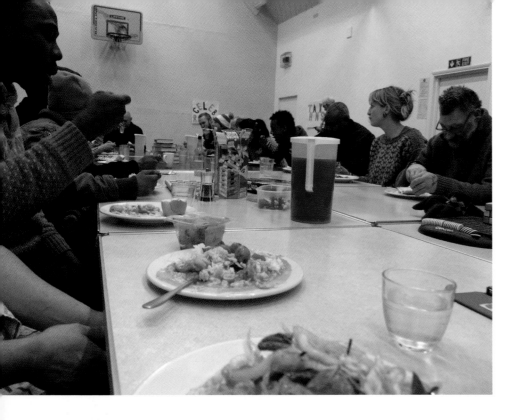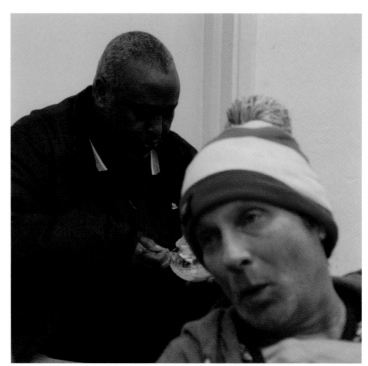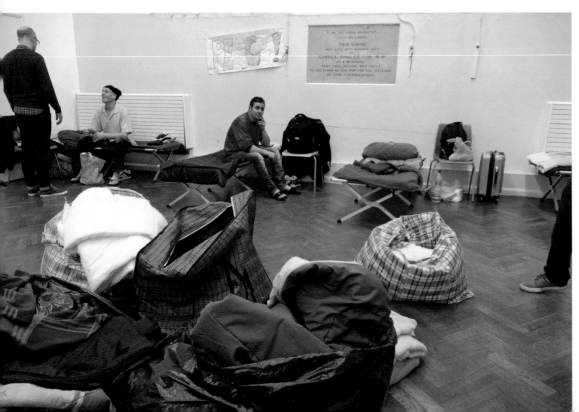

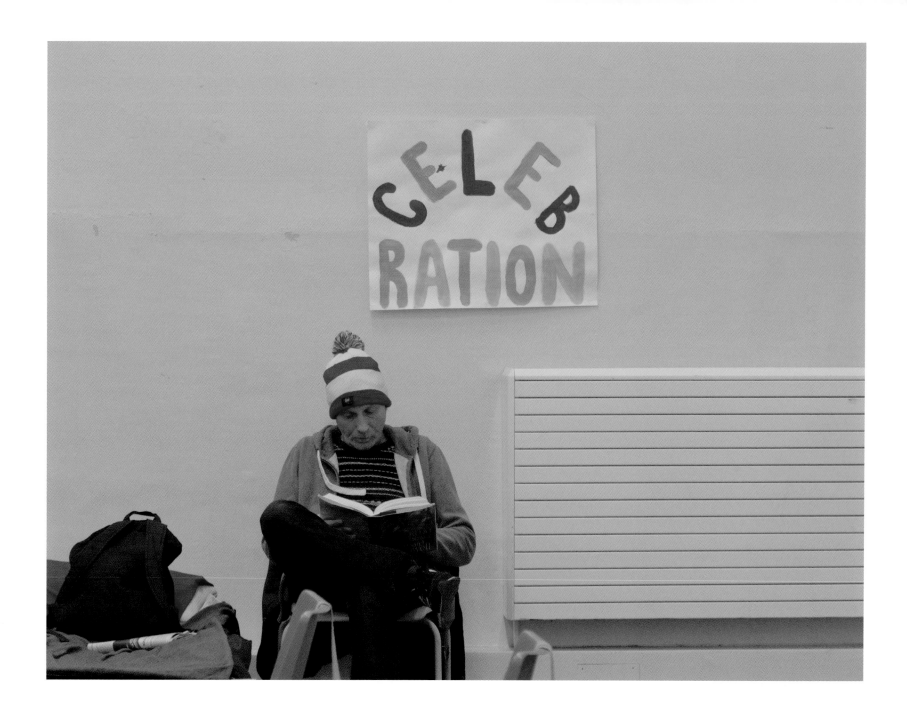

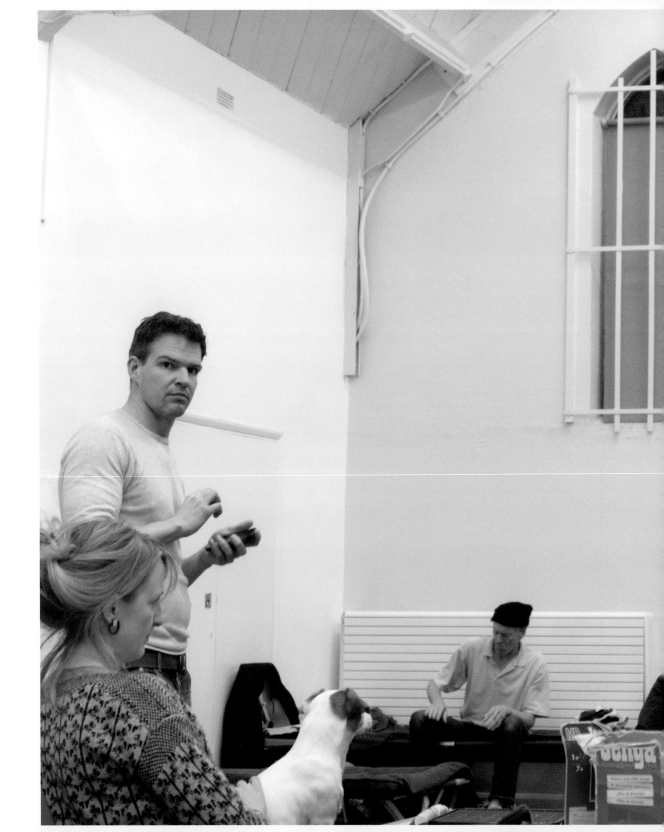

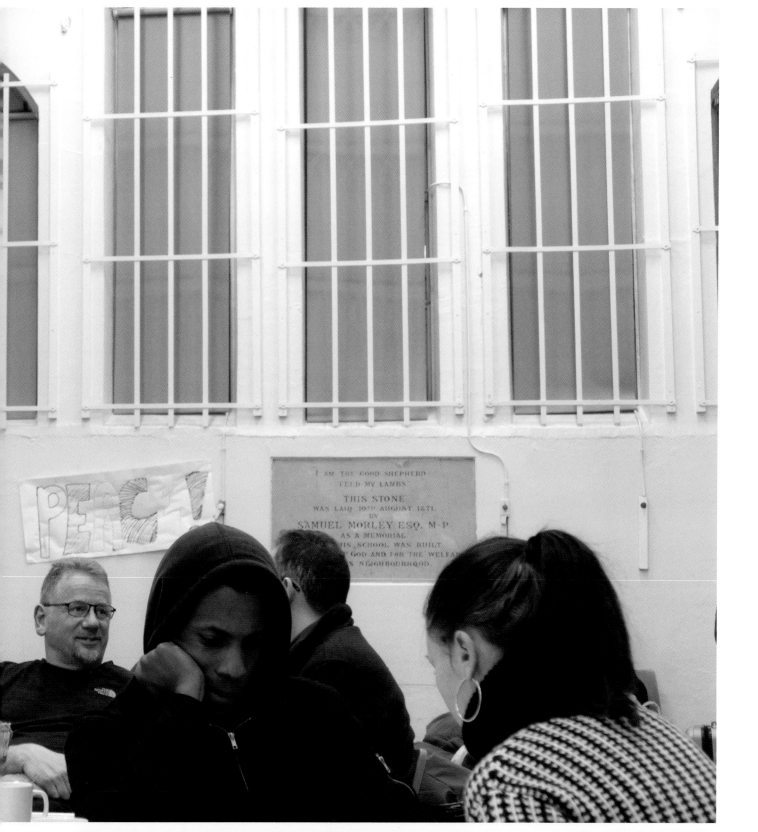

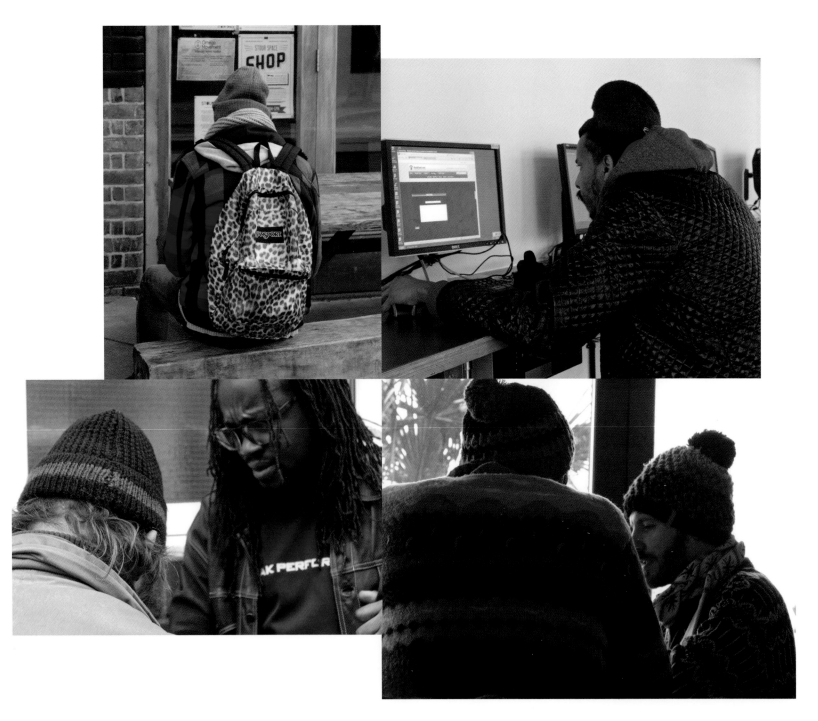

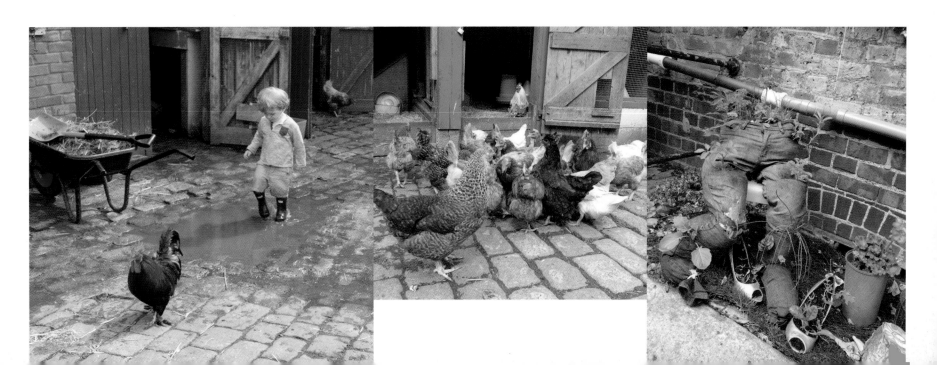

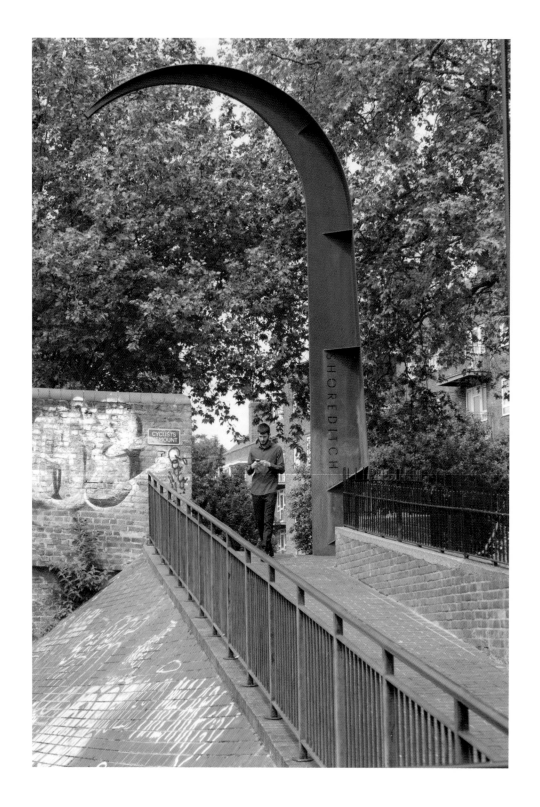

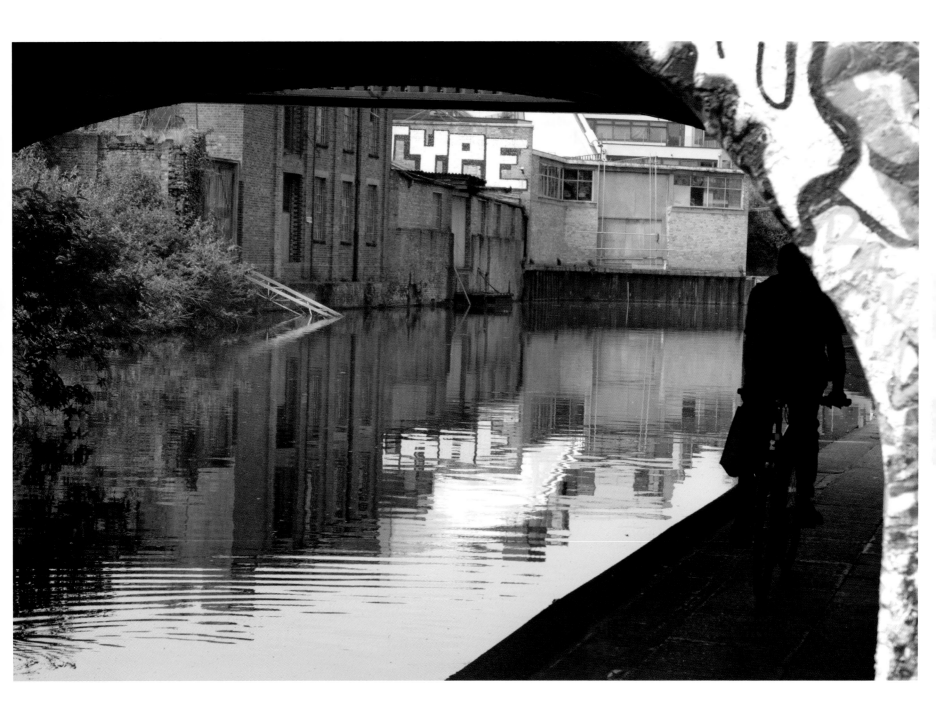

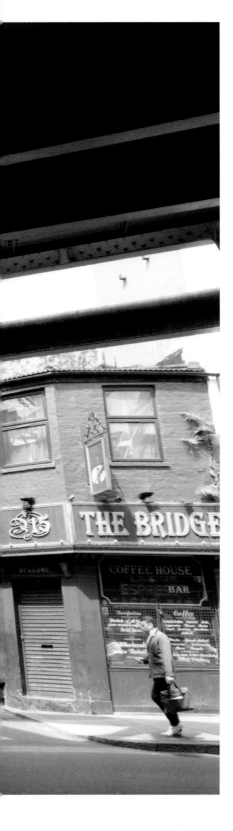

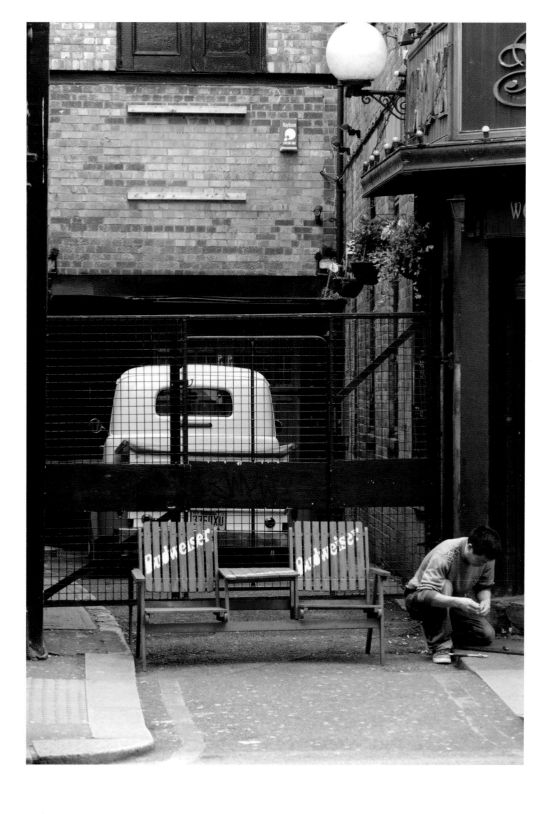

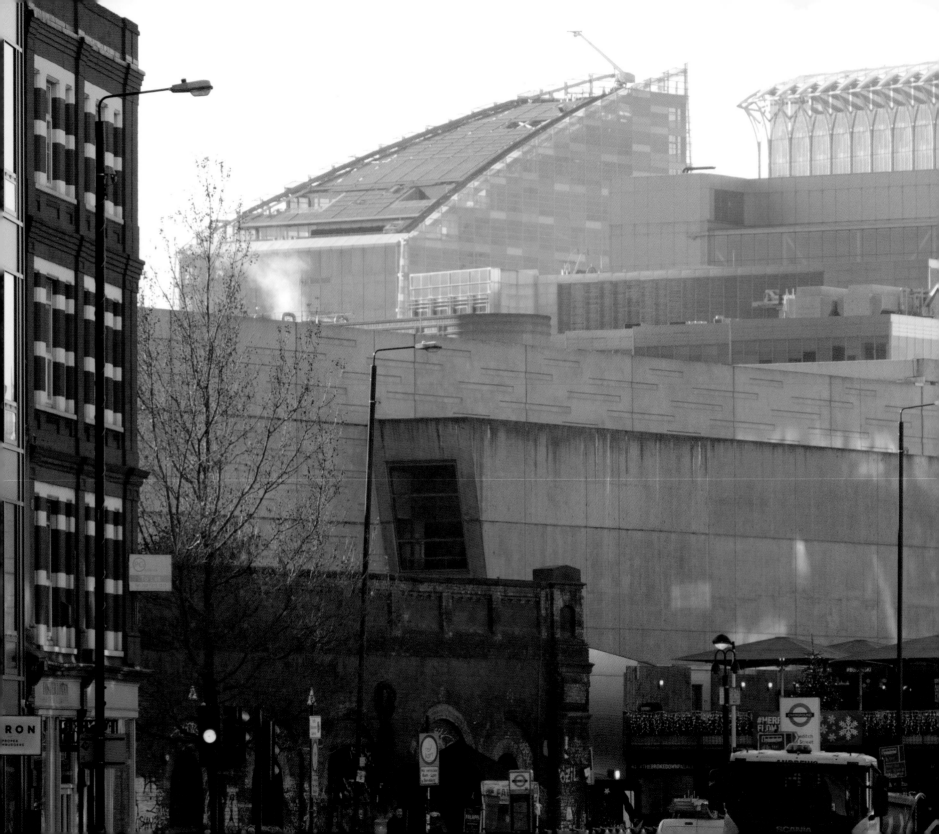

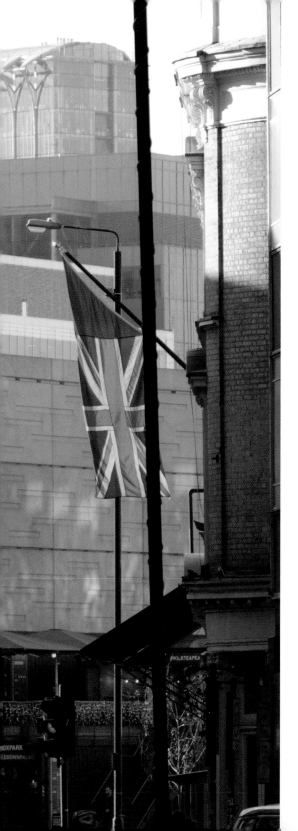

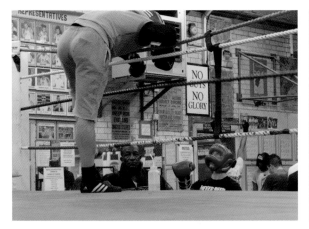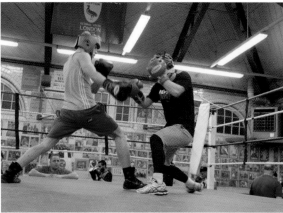
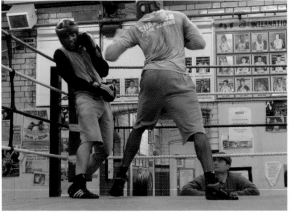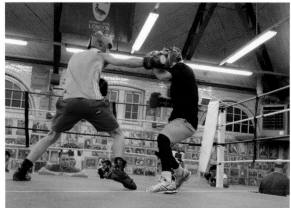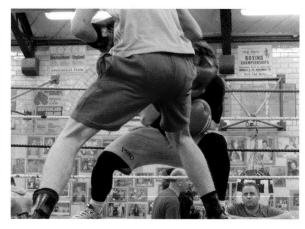
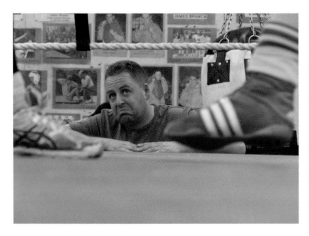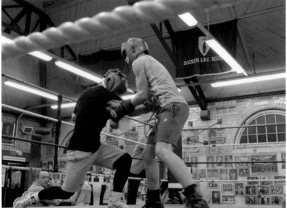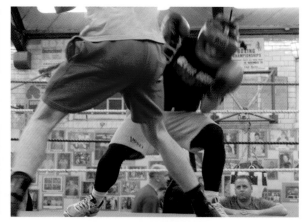

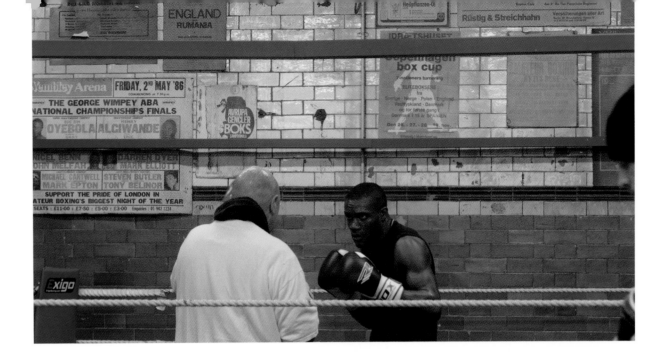

159

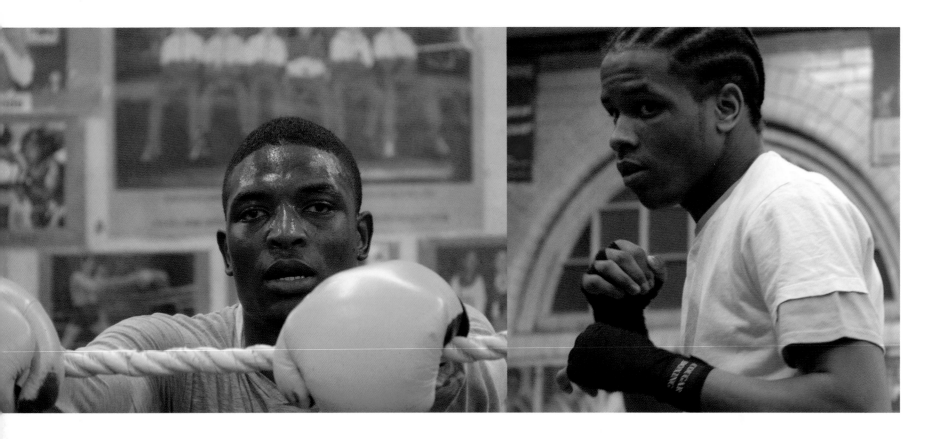

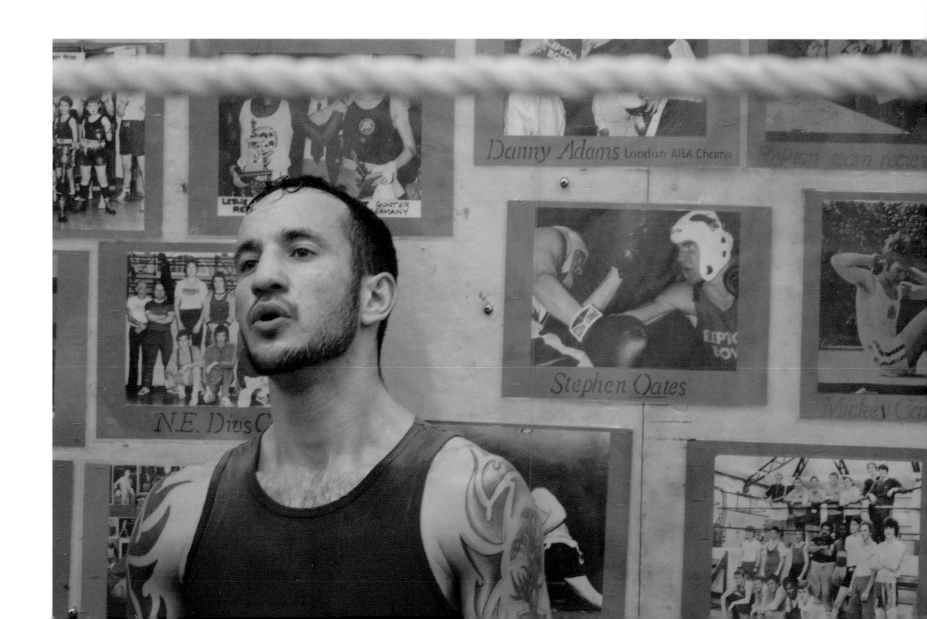

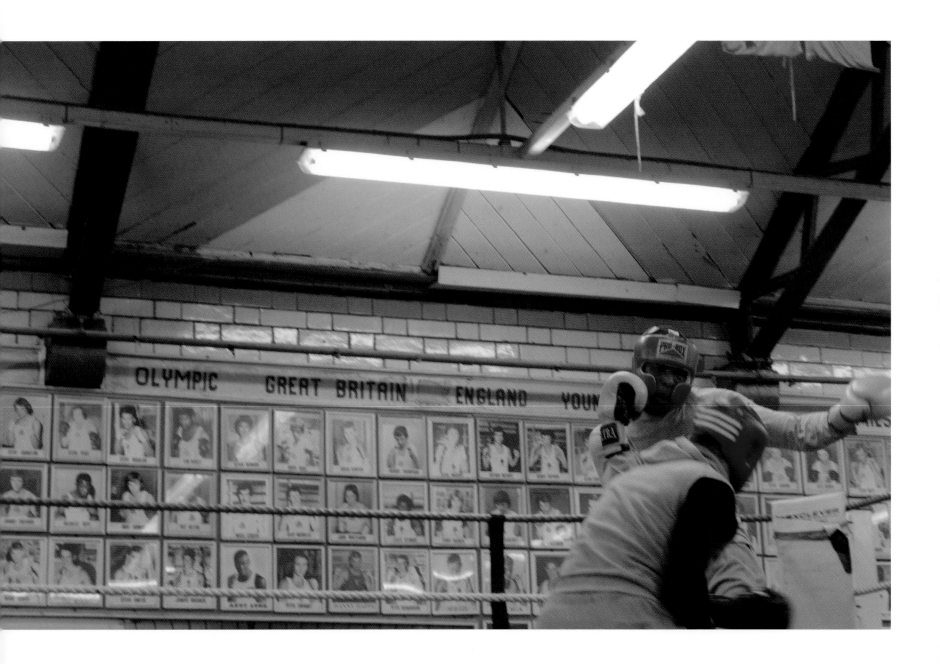

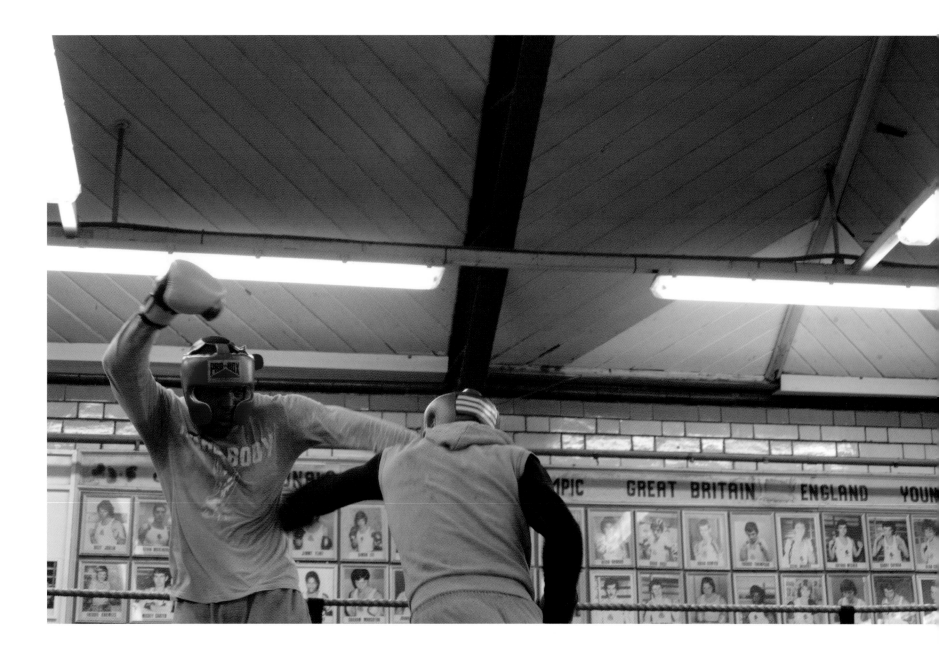

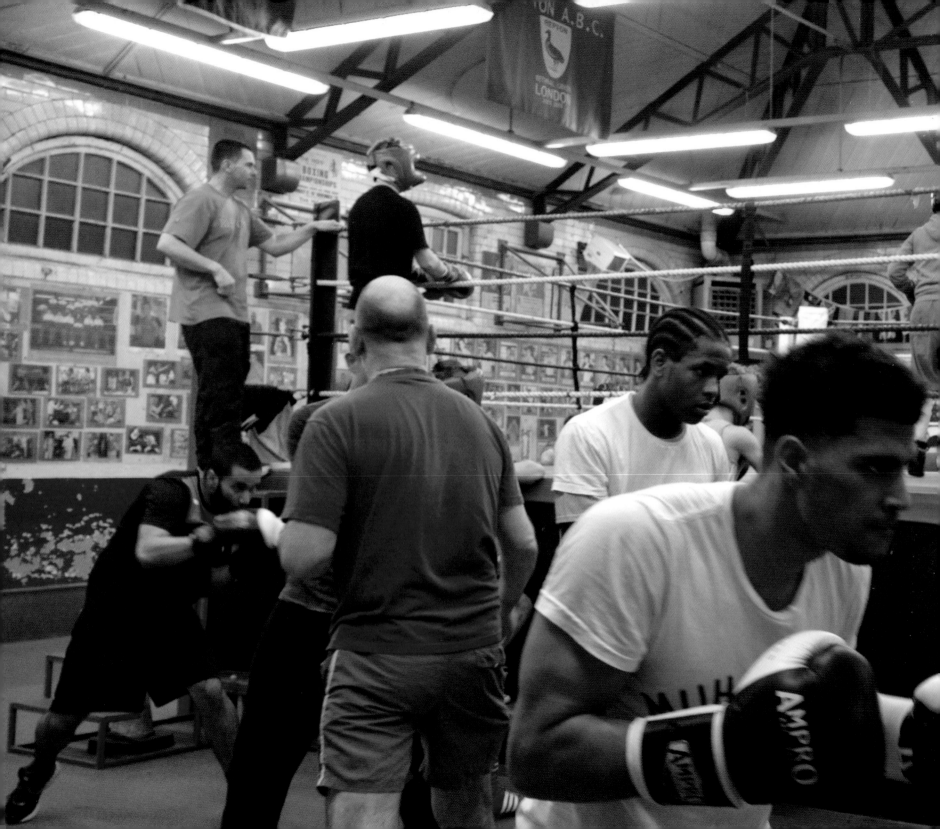

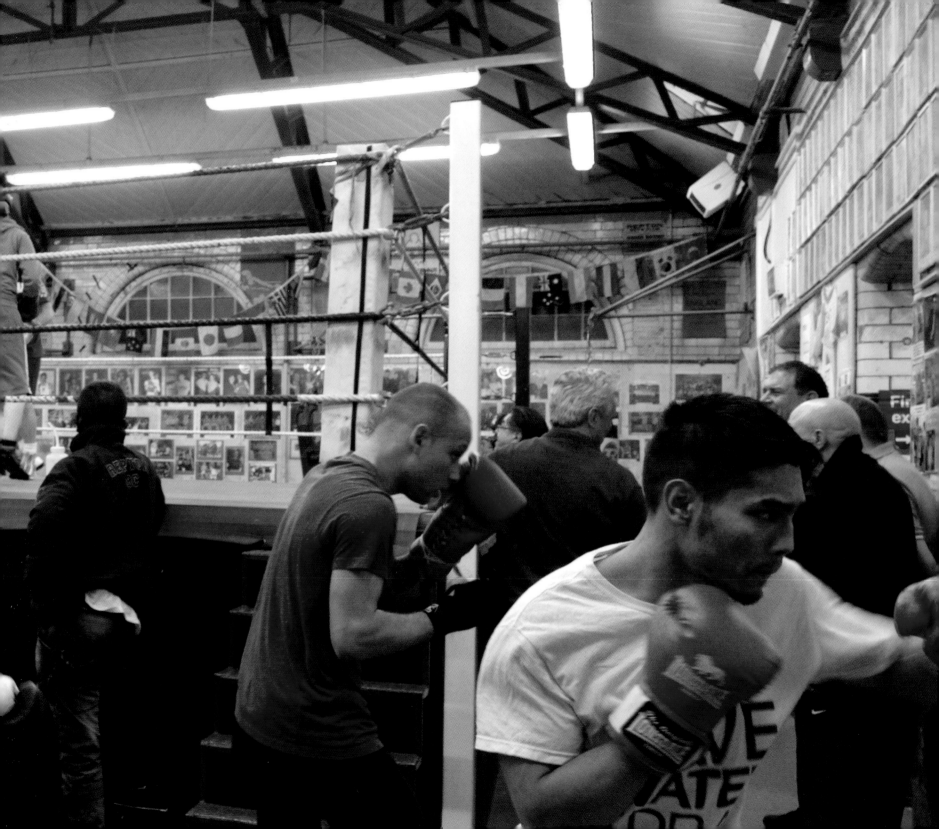

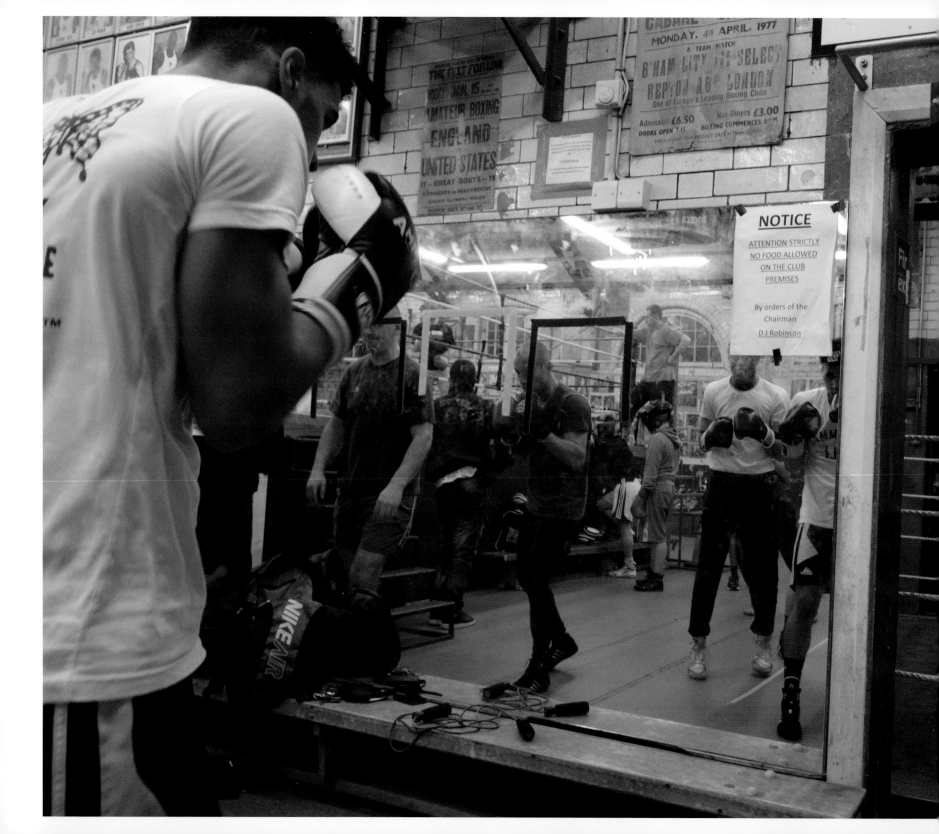

NO UNAUTHORISED PERSON
BEYOND THIS POINT UNLESS
CRB REGISTERED.

FIRE EXIT

FIRE
EXIT
Fire exit

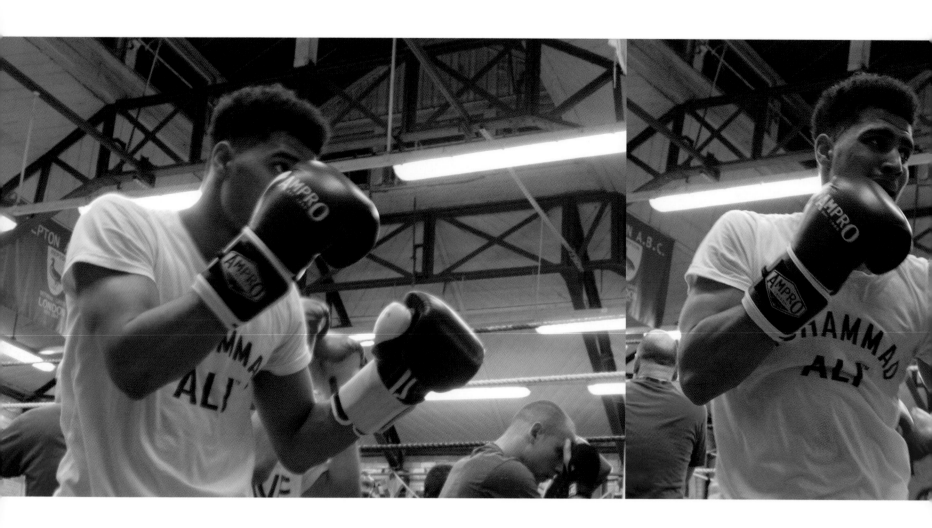

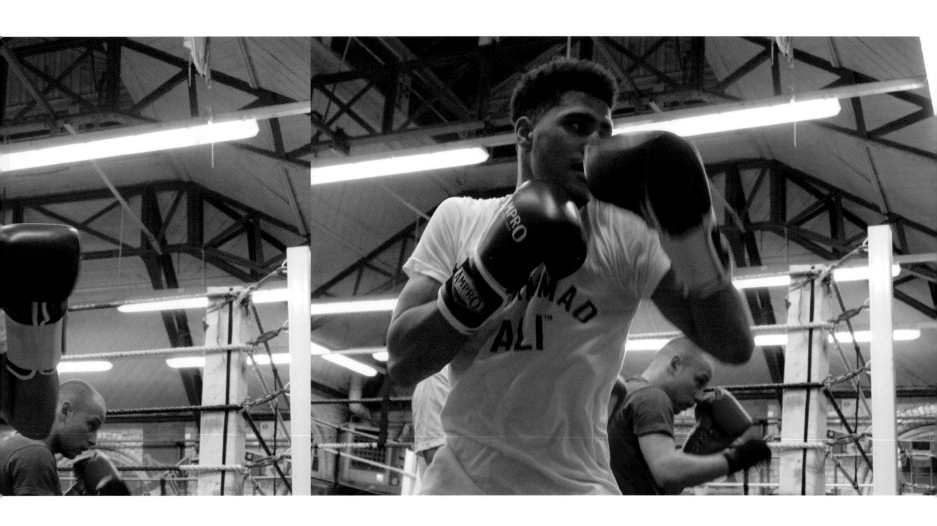

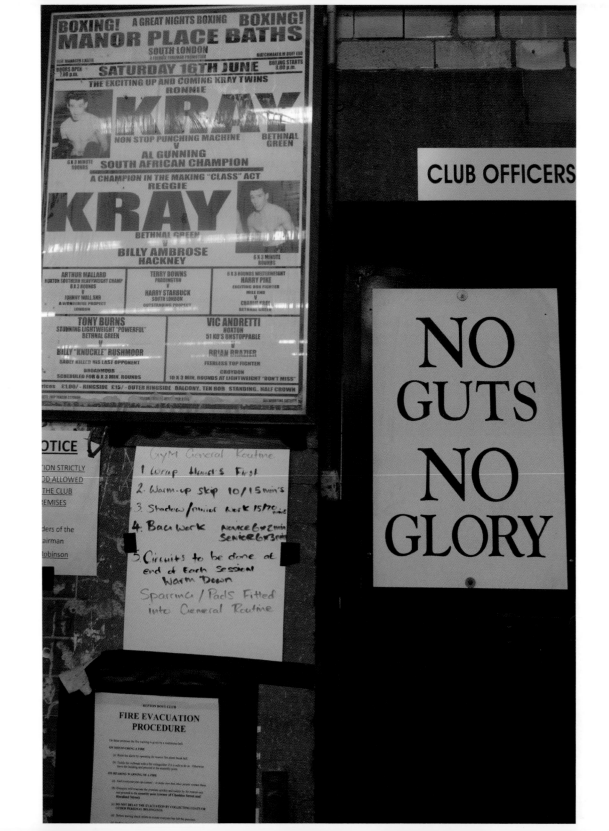

Repton Prayer

Don't quit
When things go wrong as they sometimes
will,
When the road you're trudging
seems all up hill,
When the funds are low and the debts
are high,
And you want to smile, but you have
to sigh,
When care is pressing you down a bit,
Rest, if you must, but don't quit.
Life is queer with its twists and turns,
As everyone of us sometimes learns,
And many a failure turns about
When he might have won had he stuck
it out:
Don't give up though the pace seems
slow-
You may succeed with another blow,
Success is failure turned inside out-
The silver tint of the clouds of doubt,
And you never can tell how close you
are,
It may be near when it seems so far;
So stick to the light when you're
hardest hit—
It's when things seem worst that you
must not quit.

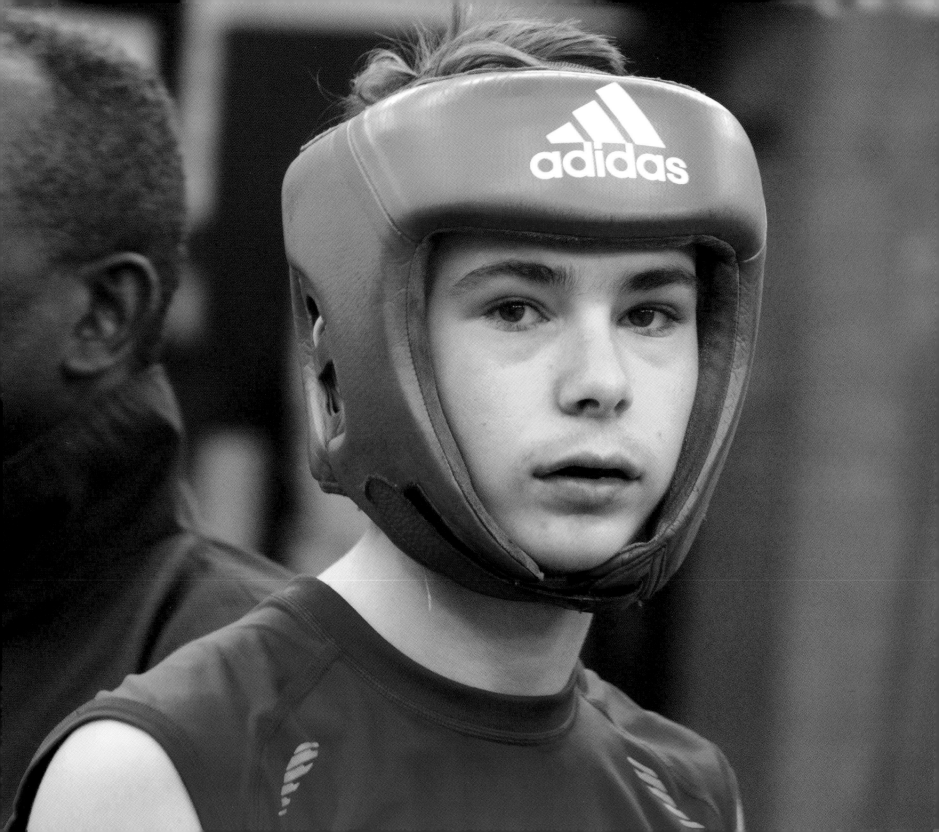

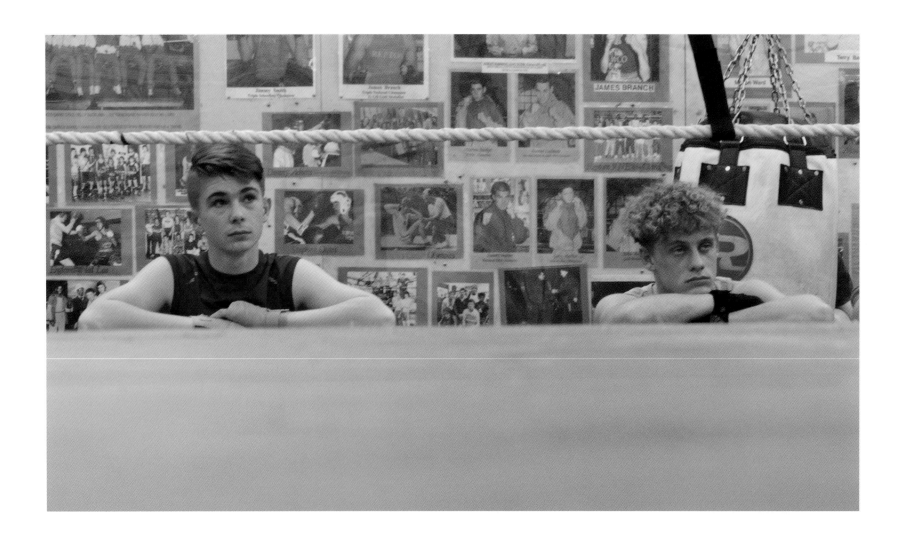

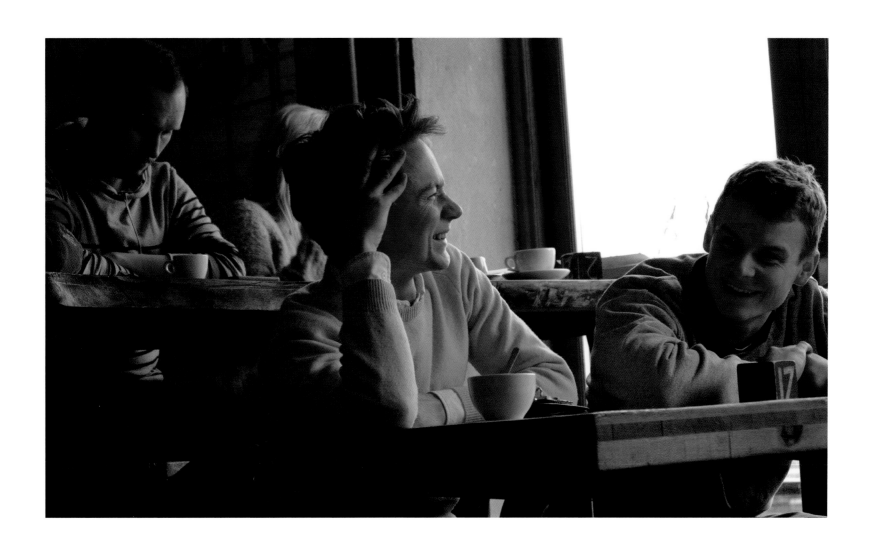

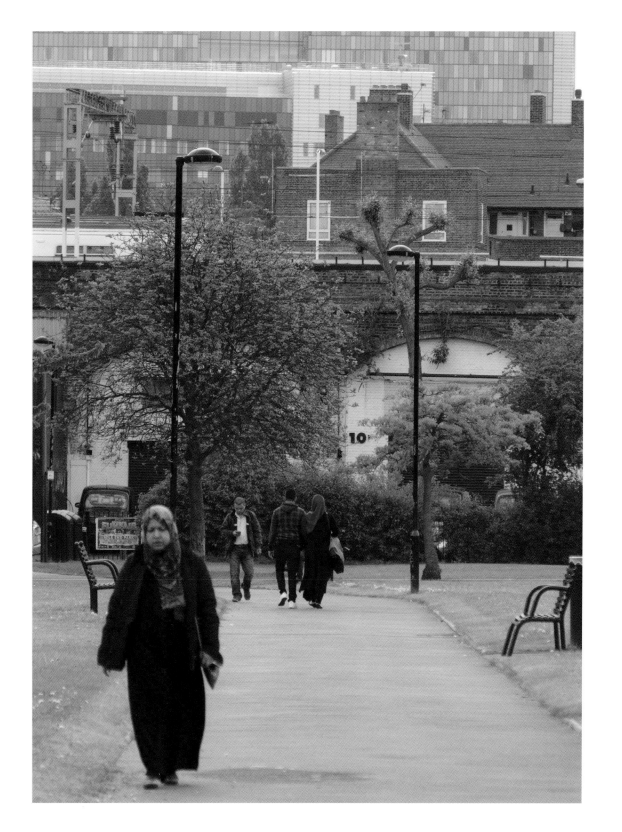

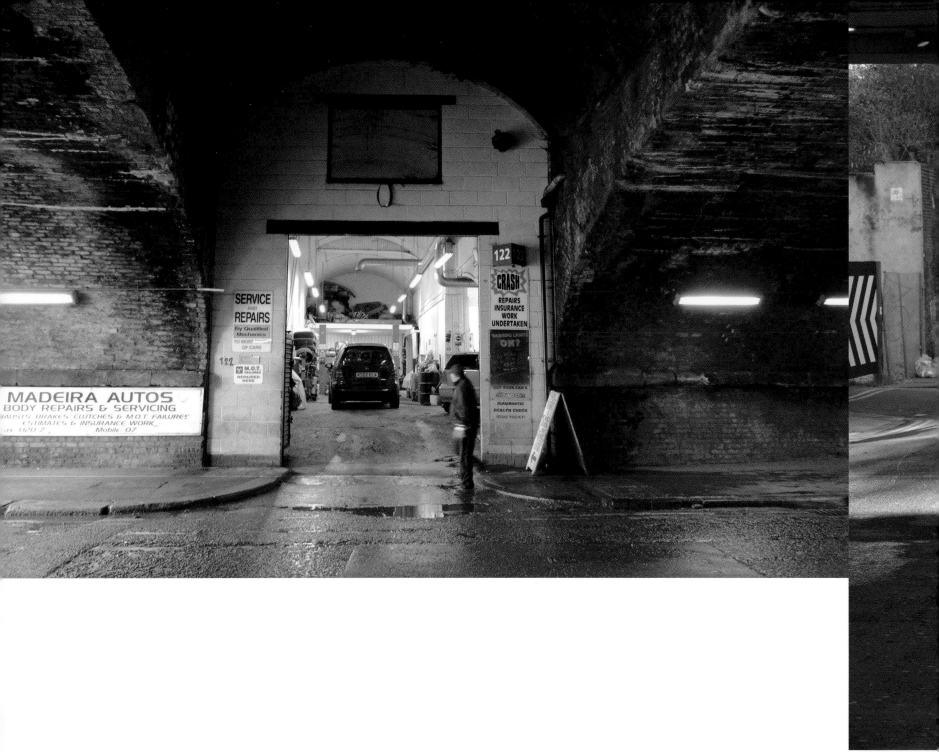

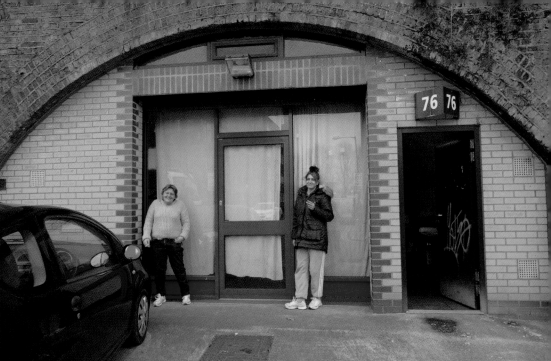

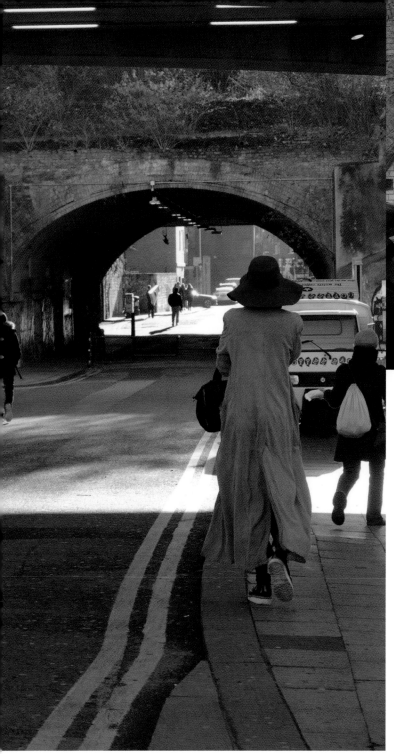

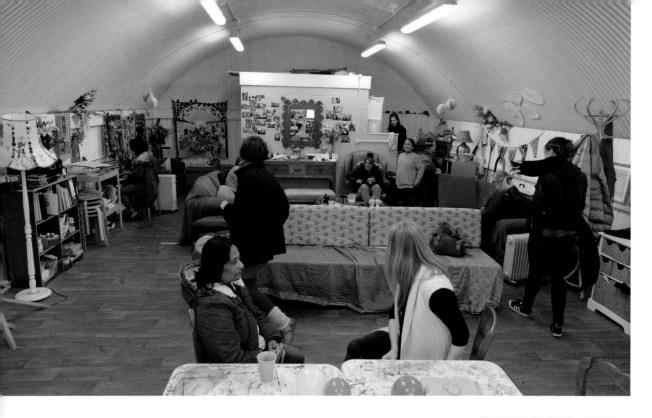

There is an old Arch on Dunbridge
Street
is the Place that I go and the People I
meet.
The train thunders across the bridge up ab
The Staff make us happy.
Its the atmosphere I Love
Mondays and Thursdays are the days to com
To make friends and chat the time Just
flies by
so underneath the Arch the train gives of a
thunderous Roar. We sit and we talk and its
The happiness we store.

Togetherness
ARCH 76
Peace &

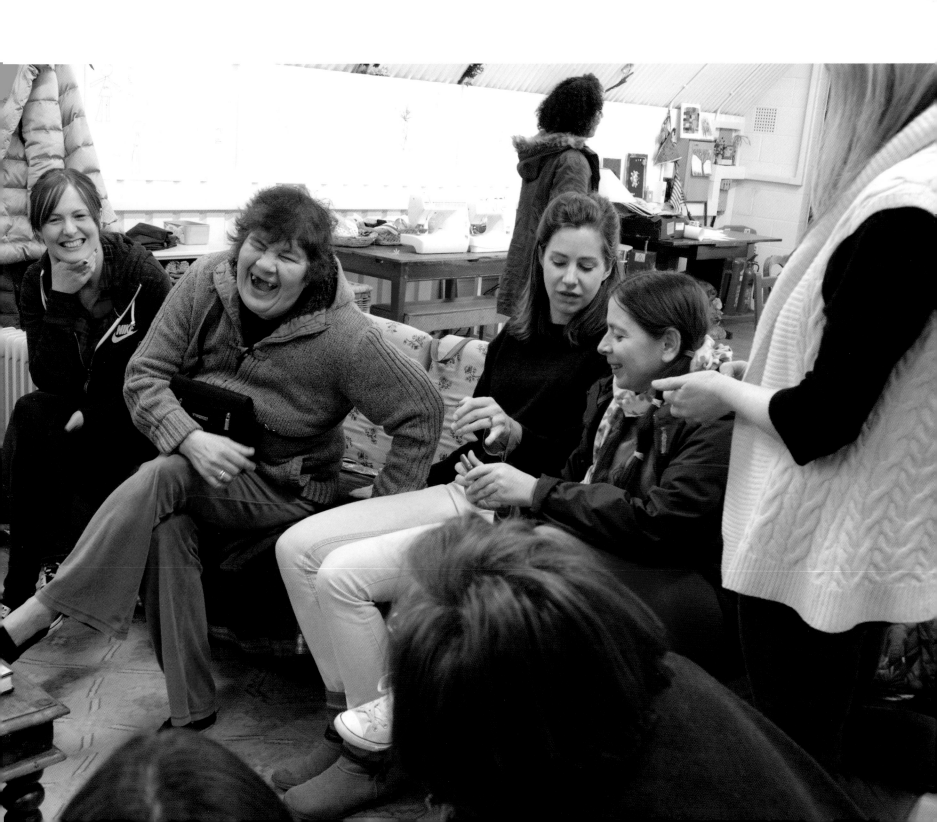

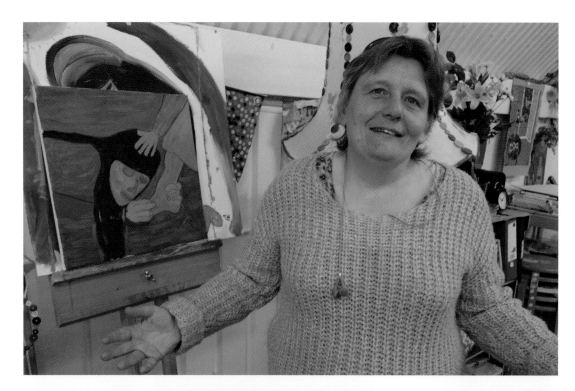

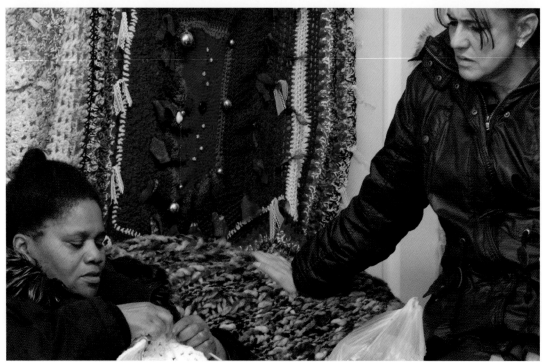

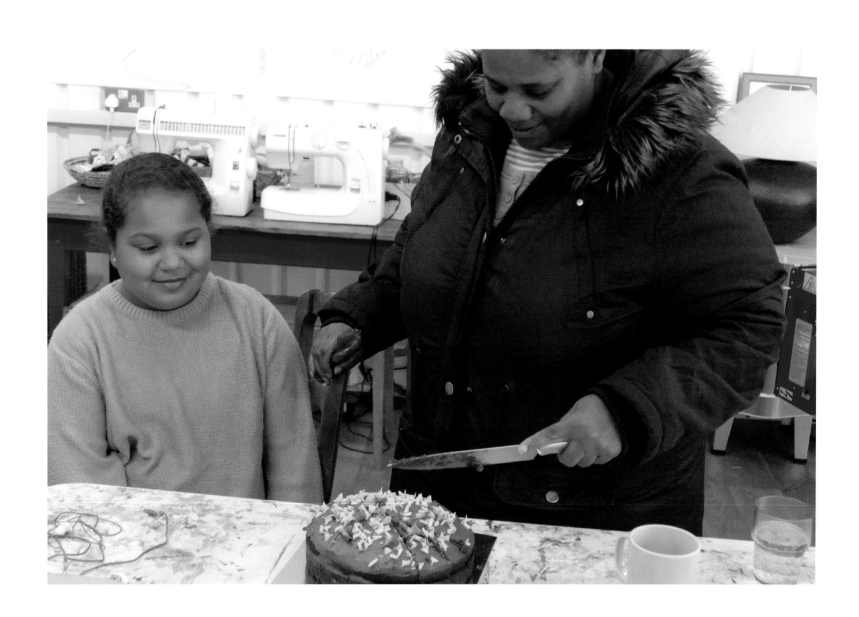

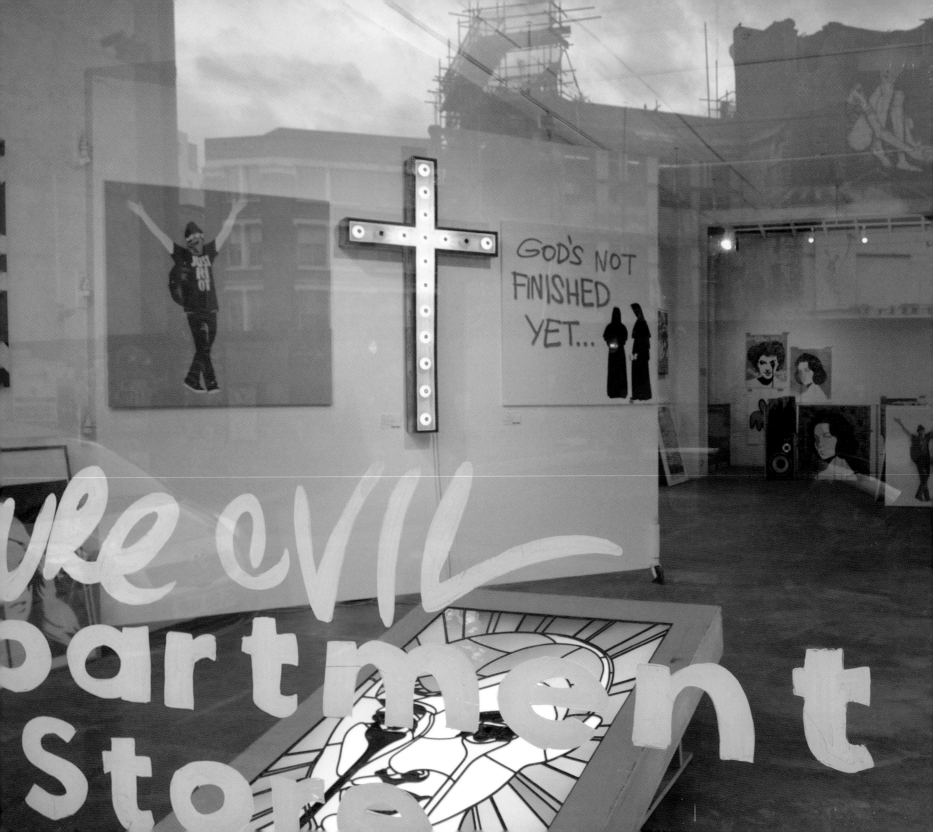

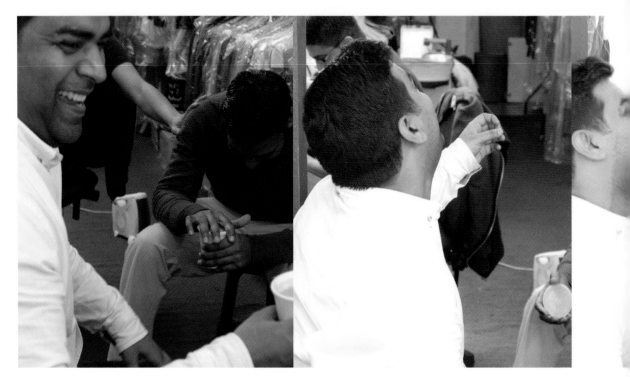

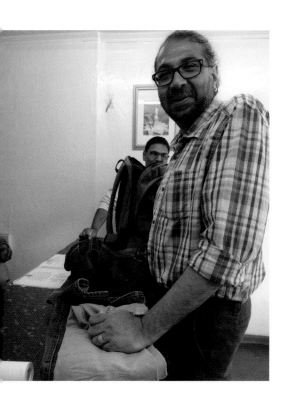

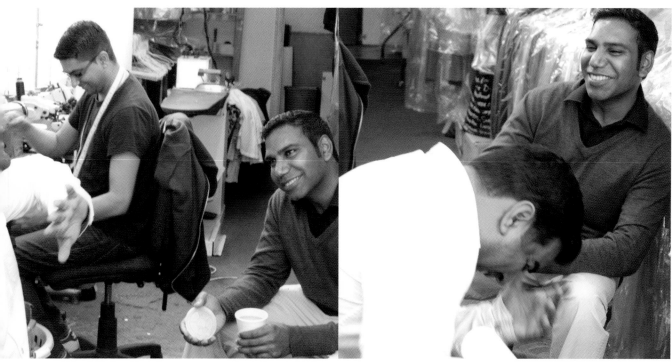

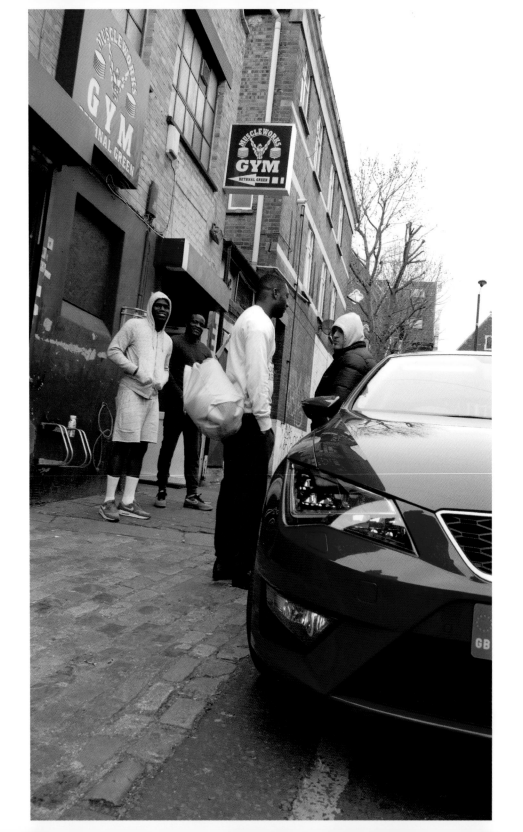

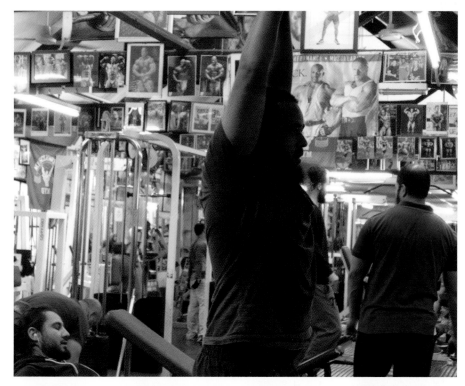
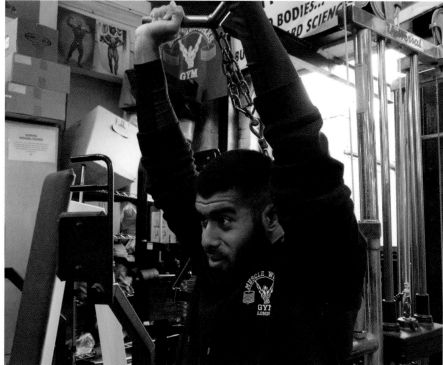
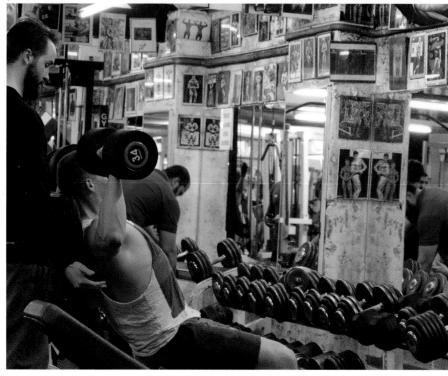
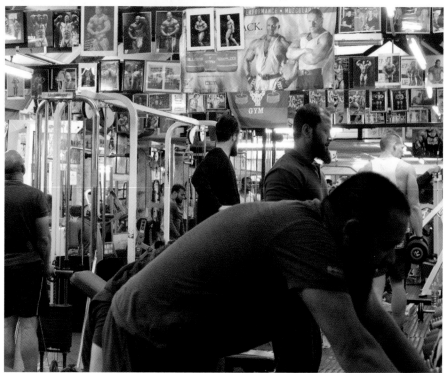

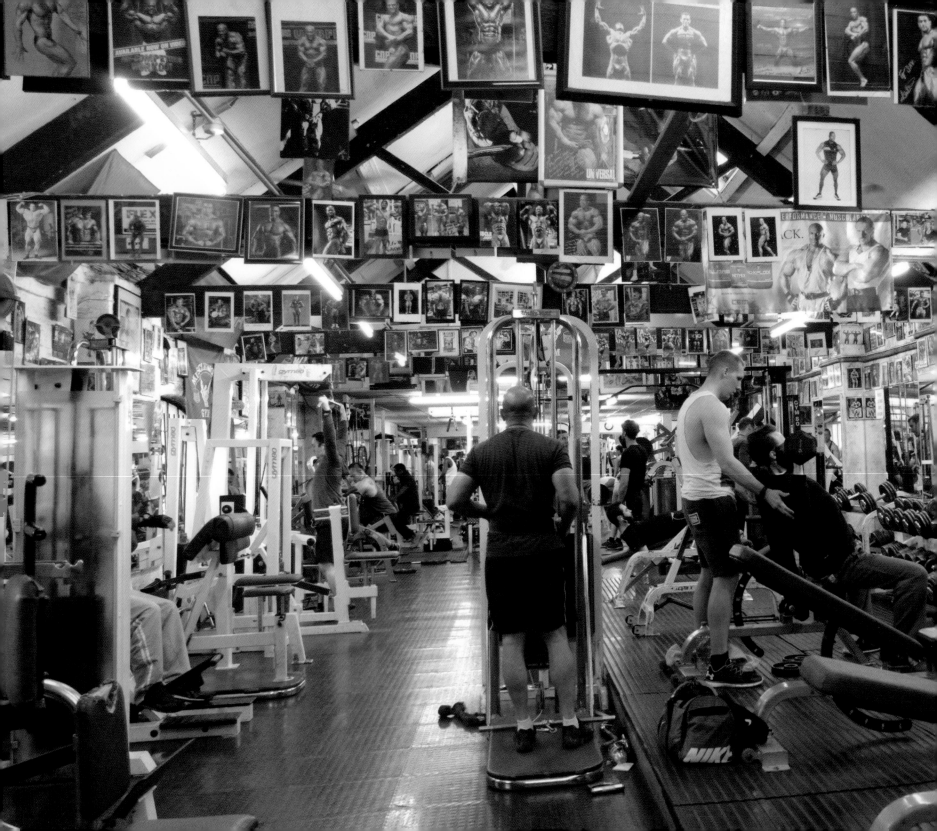

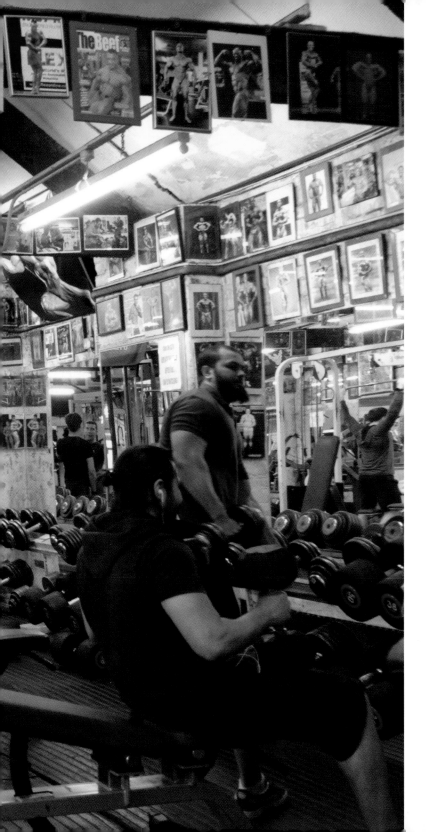

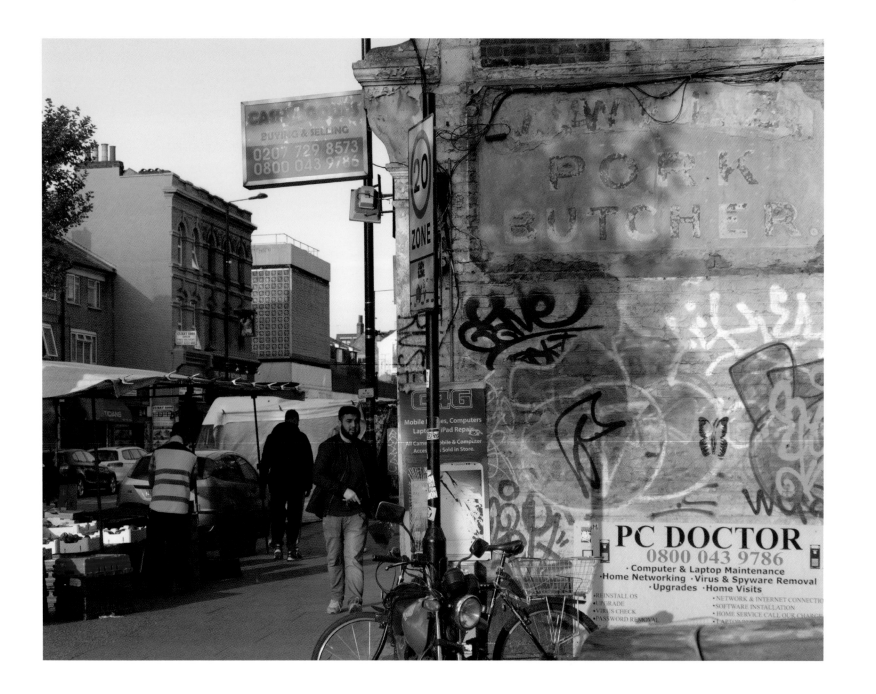

194

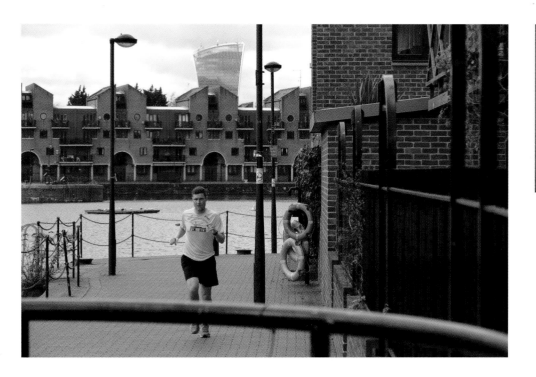

SHADWELL BASIN A.S.

PRIVATE FISHING

MEMBERS ONLY

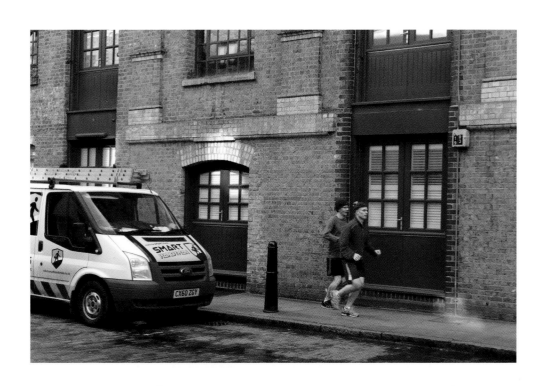

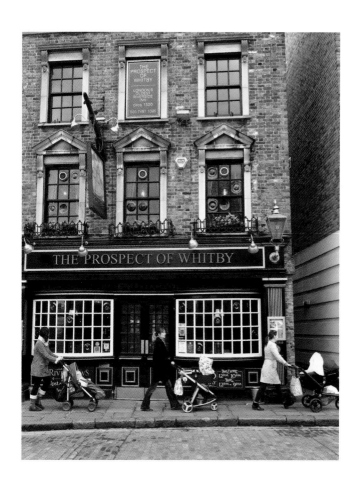

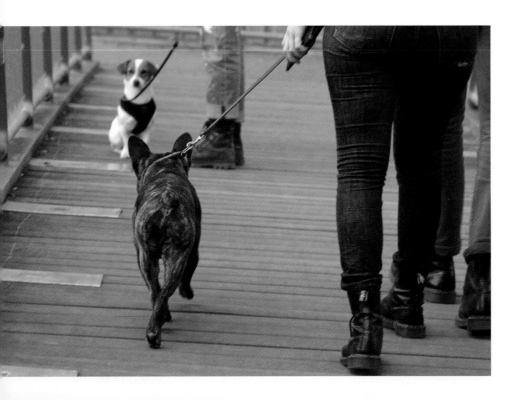

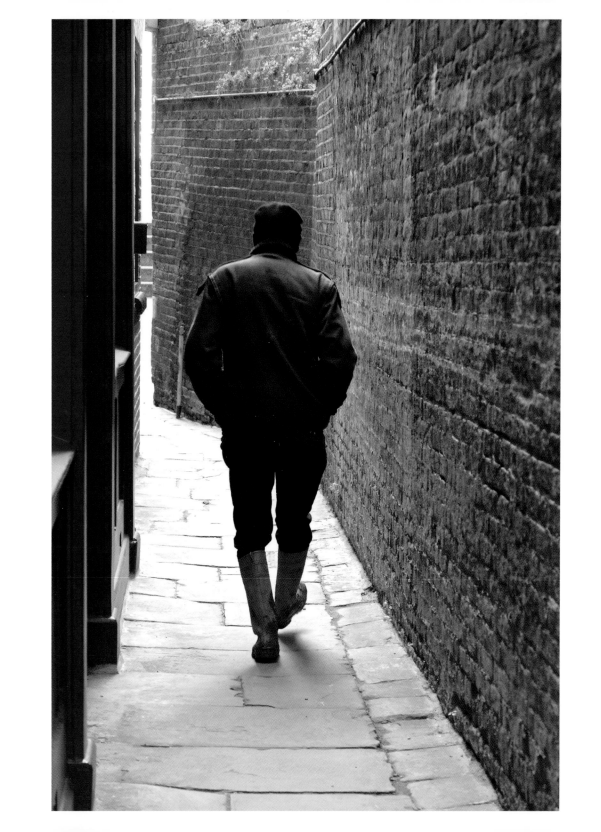

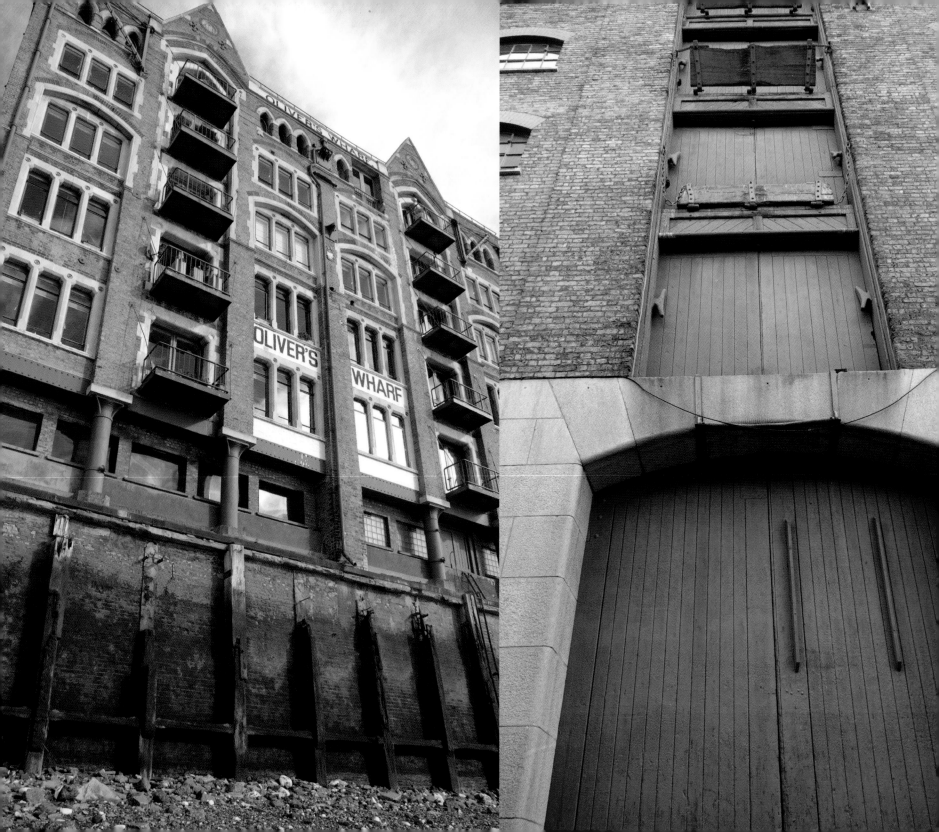

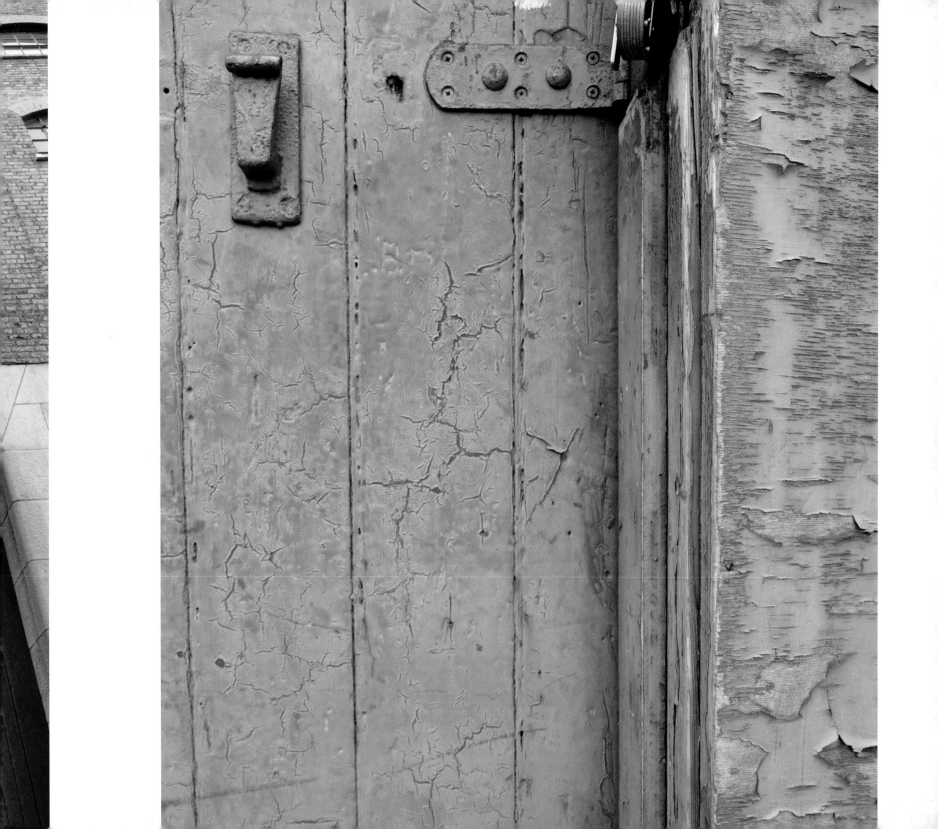

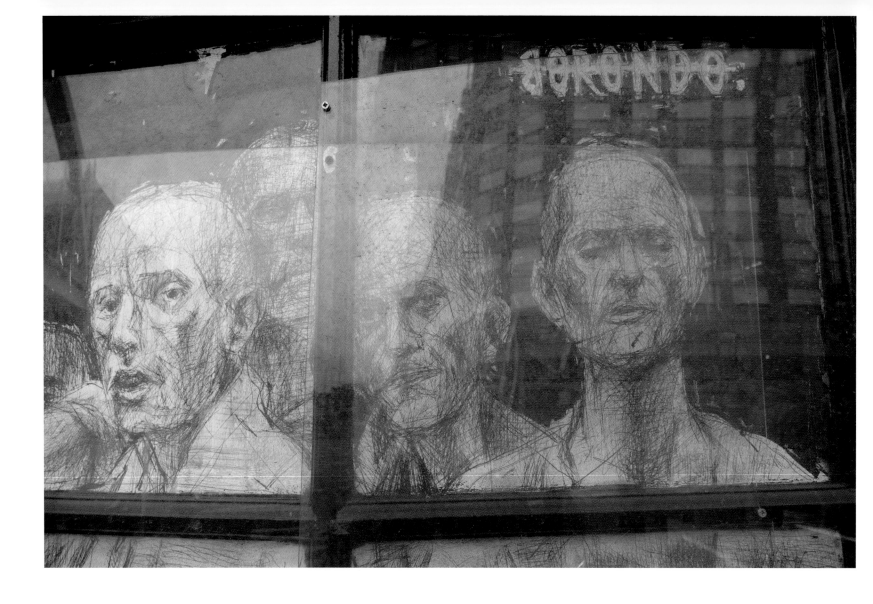

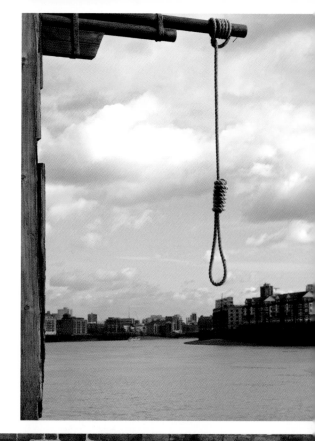

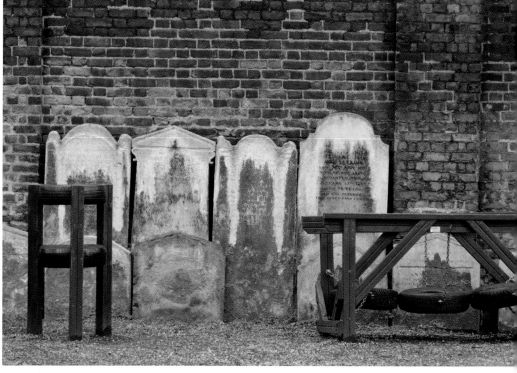

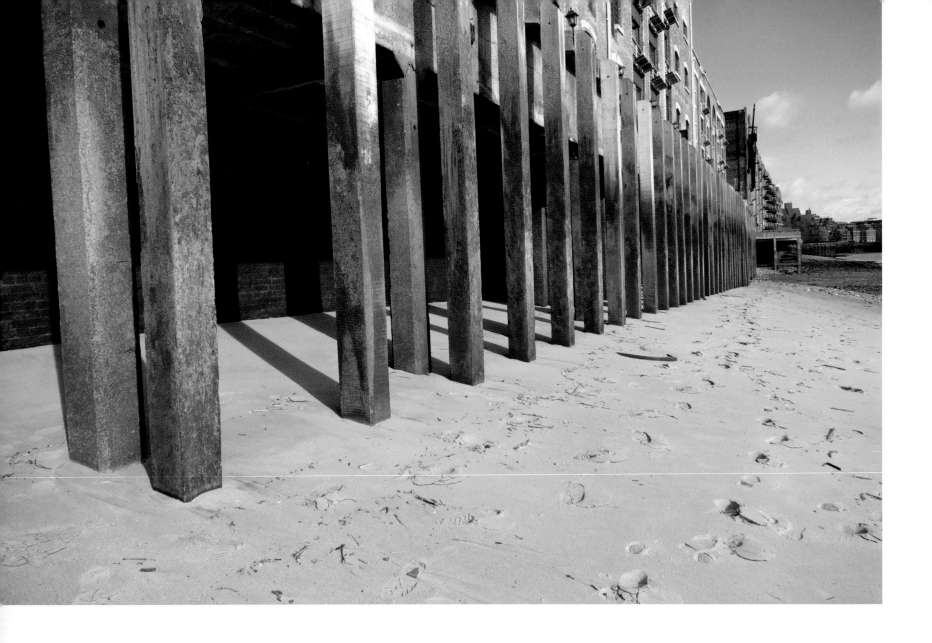

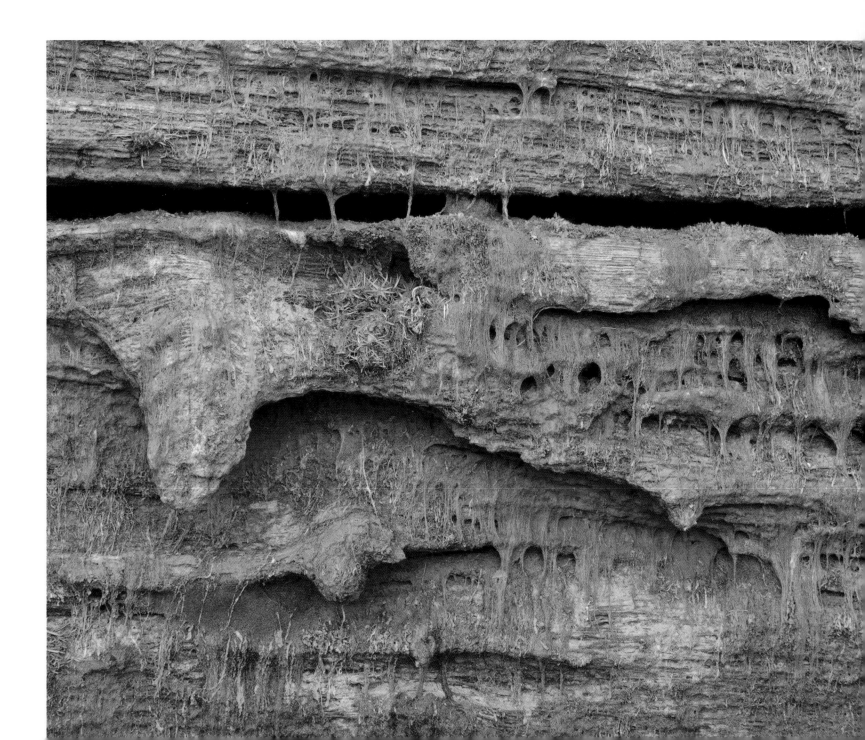

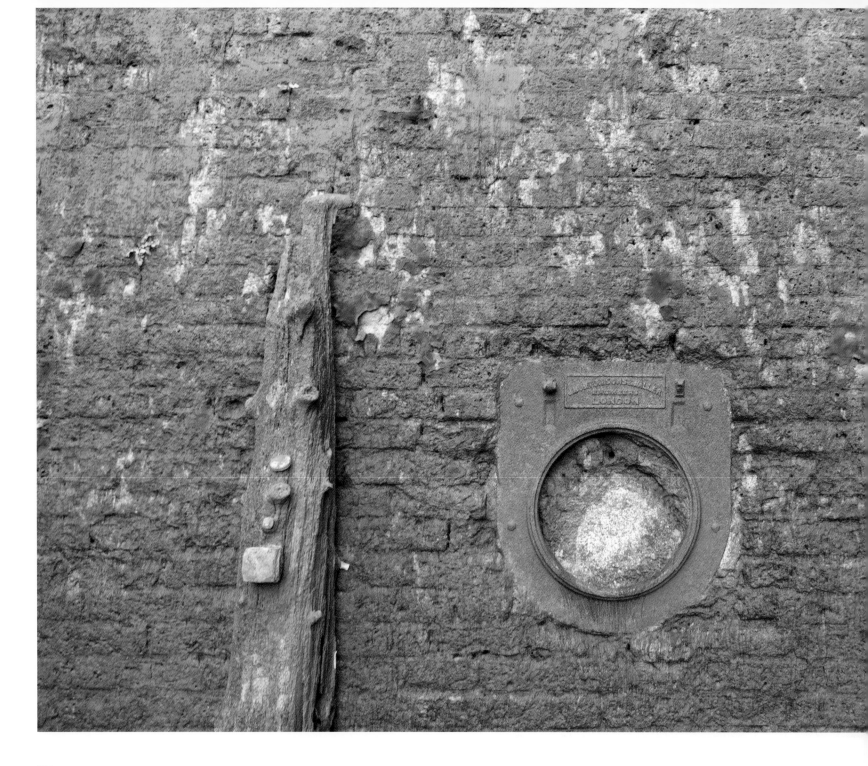

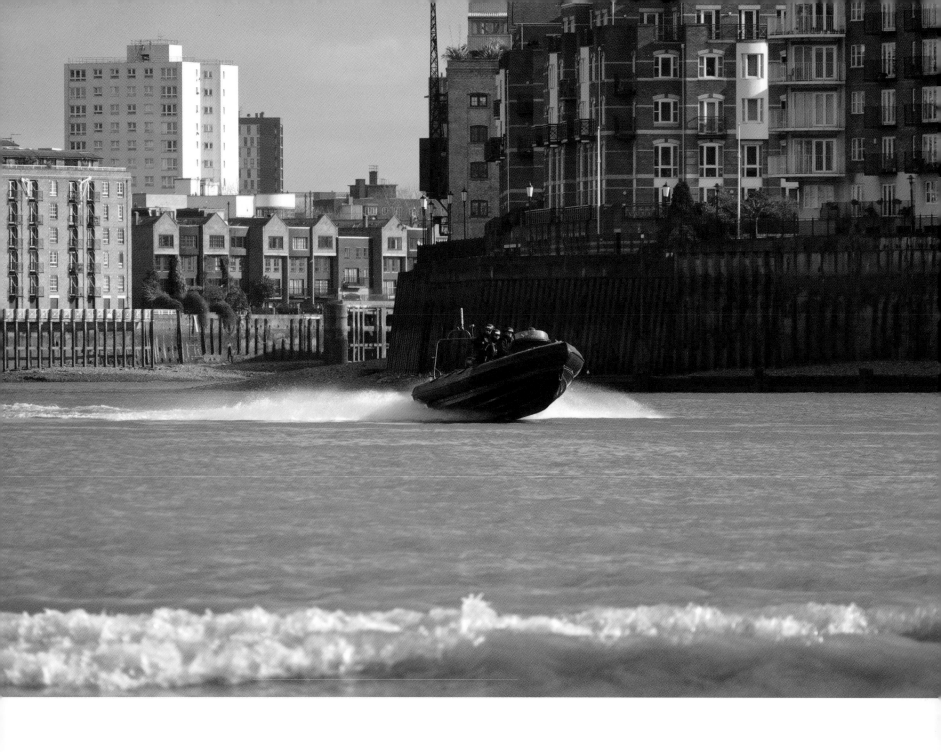

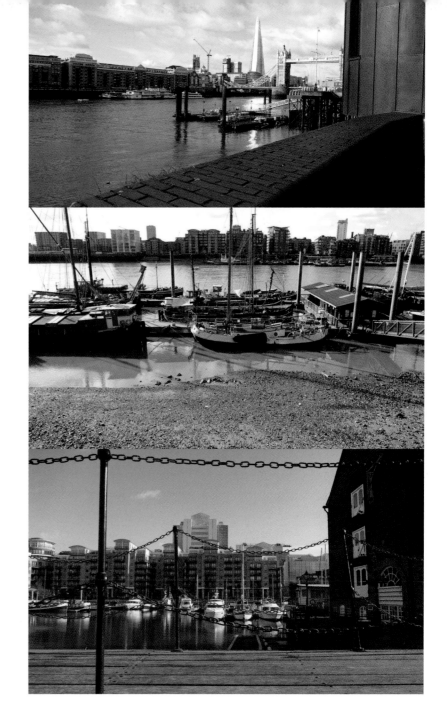

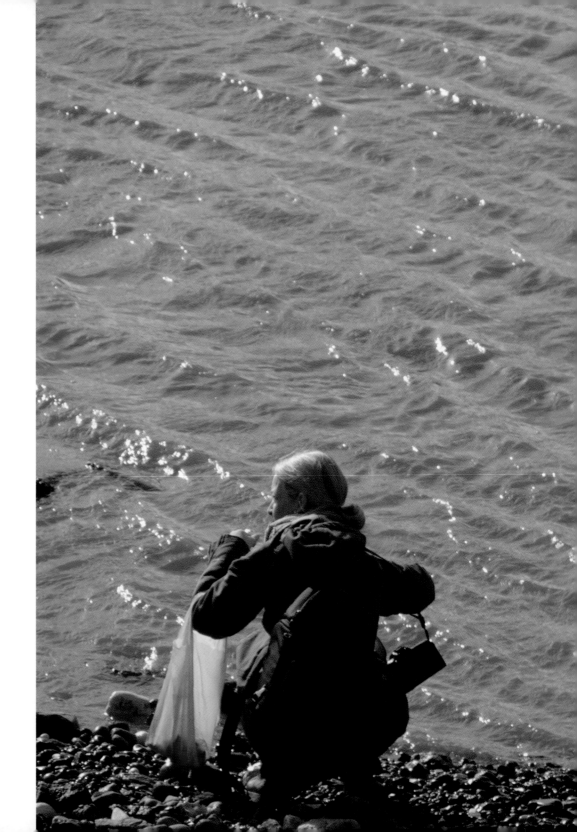

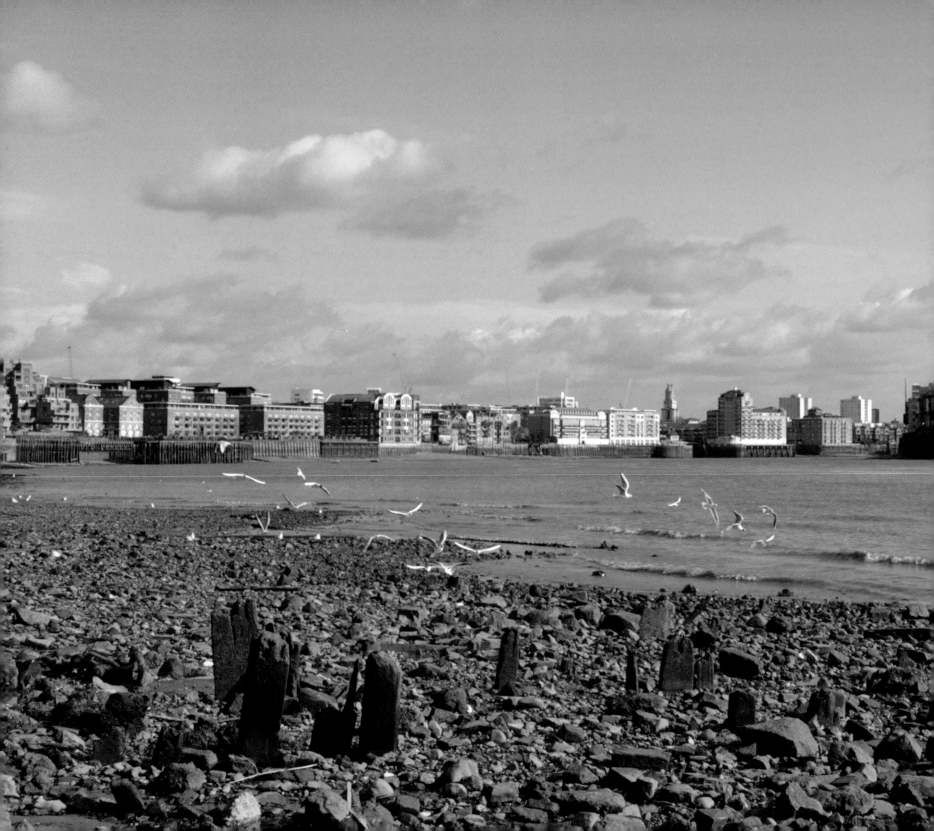

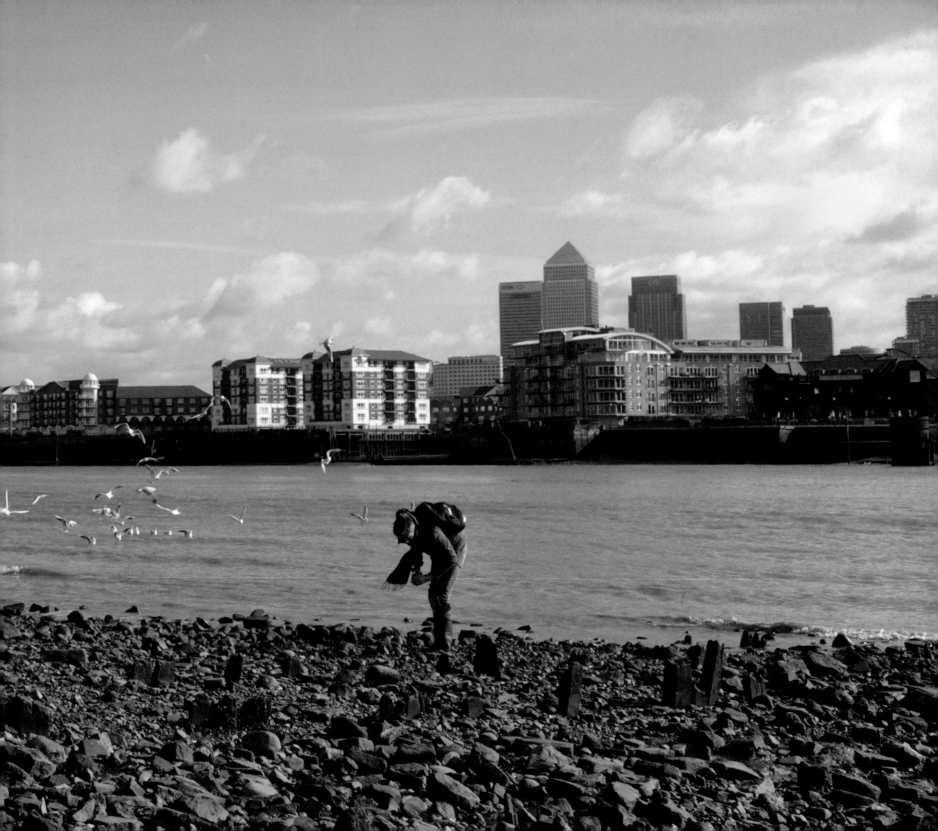

With many thanks

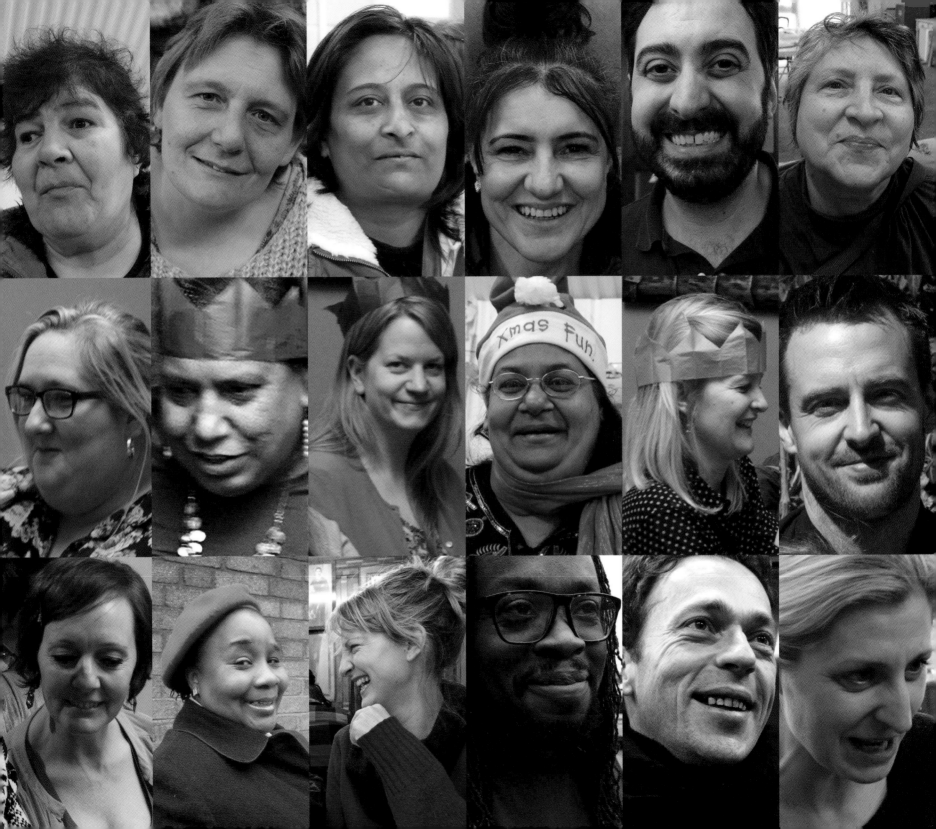

NOTES

8/9 The words in the 'stream of conversation' were said to me while photographing for this book. They relate to the images and people shown and reinforce the stories the pictures tell.

10/11 Damien Hirst's 'Cow and Cockerel' in formaldehyde which is on display in the Tramshed Restaurant, 32 Rivington Street, EC2A 3LX.

12/13 Barn-reared Indian Rock chicken with garlic sauce and chips £27.59.

14/15 '10 am Bloody Mary £6' Ezra Road off Columbia Road.

16 'So cheap could've dropped off the back of a lorry.' Columbia Flower Market.

17-19 Columbia Flower Market, Columbia Road, E2 7RG.

20 'Je suis Charlie.' Columbia Road.

21-24 Columbia Flower Market, Columbia Road, E2 7RG.

25 'Free Range chicken from the spit £16' 27A Mile End Road, Whitechapel, E1 4TP. Tracey from Arch 76.

26 Man met on the Teen Challenge Bus, Whitechapel.

27 'They served shepherds driving their flocks to the City of London.' The Eel Shop, Broadway Market, Hackney E8. Bob's grandfather, Fred Cooke, started selling jellied eels here in 1900. Market renewed in 2004 and Saturday market revived.

28 'He speaks Bengali.' Whitechapel Market.

29 Ridley Market, Dalston.

30 'Have lived here all our lives.' Mile End Road.

31 'Stole a train' Tina from Arch 76 tells the story of when she was young and one of seven children. 'We were feral, four of us jumped onto the engine of a train in Liverpool Street Station and drove off. In those days, you just pushed the button!'

31 'Fastest buffalo hunter' Shoba from Arch 76 was born in Tasmania, where she was known as the fastest buffalo hunter in the village.

32/33 The ladies of Arch 76 setting off for their Christmas Lunch Party. ARCH 76, www.arch76.co.uk. A charity based art project to create a safe place for vulnerable women. 'There is a sense of fun and belonging at the Arch although some days can be tough.'

 'I know we can't do everything, and that can be hard. We have to be really honest. We can't do their housing, we can't do their benefits, but we can be there for each other through all that. Its what friends are for.'

34 Tina Worral giving instructions in the East End Manner! 'My life is a rollercoaster and a journey and I'm still searching for a place to fit.'

35 Canary Wharf where the lunch was being held at Garfunkel's.

36 Vanessa: 'Someone who has no small talk and gives it as she sees it.'

37 Devrika: 'Still coping. Managing day to day walking. Feel good when I go out. Do Tai Chi. Being active helps me be strong.'

83 Whitechapel Mission.

84/85 Gibraltar Walk, Squirries Street, Bethnal Green, Wapping.

86 Haggerston Park.

88/89 'A bitterly cold Monday night.' Teen Challenge Bus, Whitechapel. **wwwteenchallenge.org.uk** Support for people trapped by addiction of drugs and alcohol, gang life and prostitution. Flexible use of buses converted into coffee shops. Teams of workers walk the streets looking for the opportunity to help and organize food for those who need it.

90 'Glimmer of hope.' Teen Challenge Bus, Whitechapel.

92/93 'Handing out leaflets.' Whitechapel.

94 On the Undgerground.

95 Bethnal Green.

96 'The Gap'.

97 The old and the new Royal London Hospital, Whitechapel. 'It was where we went when we needed help, sometimes it was just for sheets. We knew where the cupboards were.' Lady from the Arch.

98 Whitechapel.

99 Whitechapel.

100/1 Last working warehouse in Wapping. Hackney Wick, Allen Gardens, Bethnal Green.

102 Bethnal Green.

103 Bethnal Green.

104/5 Shoreditch. Redchurch Street. Whitechapel.

107 Brick Lane.

108/9 Shoreditch. Bethnal Green. Shoreditch.

110/11 Shoreditch. Bethnal Green. Bethnal Green. Shoreditch.

112 Poppies Fish & Chips, 6-8 Hanbury Street, Spitalfields, E1 6QR.

113 'Pop' has been in the business since 1950's. 'Started as an 11-year-old, cutting newspaper to wrap the portions.'

114/15 Curry 2000, Bethnal Green Road.

116/17 S. R. Kelly, Bethnal Green Road since 1915.

118 Wapping.

119 Dishoom, 7 Boundary Street, Shoreditch E2 7JE.

120/1 'A visit to Narnia' Callooh Callay, 65 Rivington Street, Shoreditch, EC2A 3AY.

122/3 Whitechapel.

124/5 Whitechapel Market.

126 Ridley Market, Dalston.

127 Whitechapel Market.

Bethnal Green . Whitechapel . Bow . Canary Wharf . St Katherine Docks . Shadwell . Wapping . Shoreditch

A painting needs a wall to object to
An image needs a text to protect it
And every text needs someone to decode it

Marlene Dumas

Dalston . Hackney . Hackney Wick . Bethnal Green . Whitechapel . Bow . Canary Wharf . St Katherine Docks